wedding and studio
portrait photography

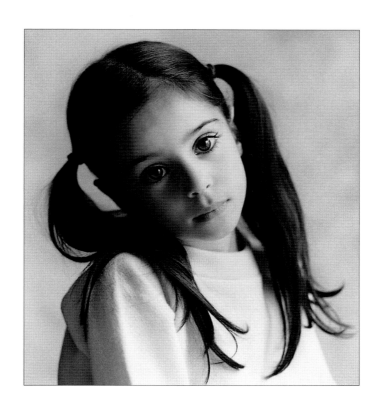

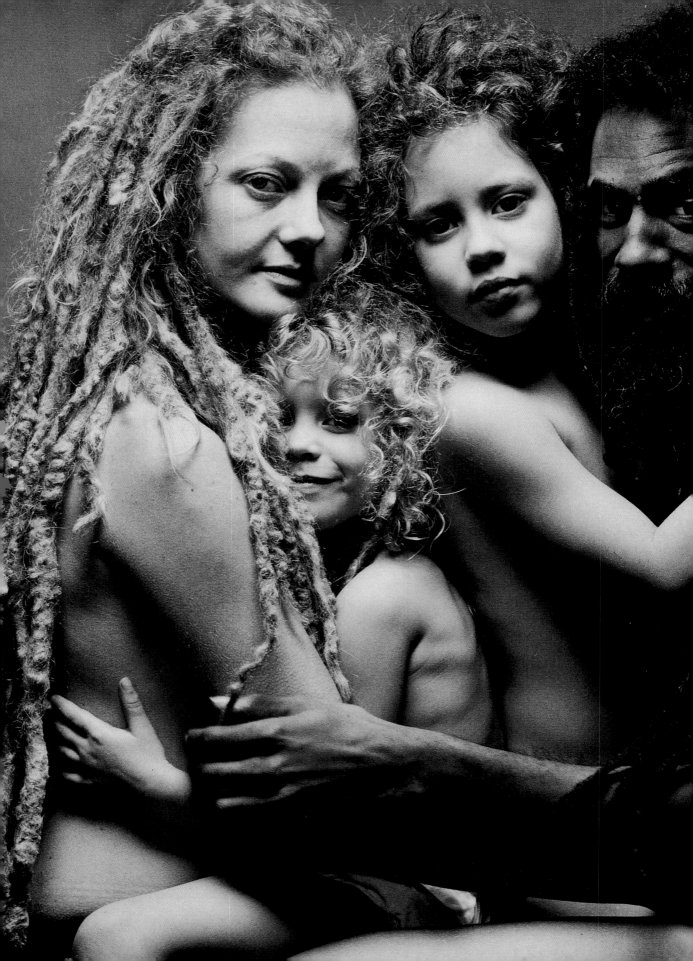

wedding and studio
portrait photography

the professional way

JONATHAN HILTON

RotoVision

A Rotovision Book

Published and distributed by Rotovision SA
Route Suisse 9
CH-1295 Mies
Switzerland

Rotovision SA, Sales & Production Office
Sheridan House 112/116a Western Road
HOVE BN3 1DD East Sussex, UK
Tel: 44-1273-7272-68
Fax: 44-1273-7272-69
ISDN: 44-1273-7340-46
Email: sales@rotovision.com
Website: www.rotovision.com

Distributed to the trade in the United States:
Watson-Guptill Publications
1515 Broadway
New York, NY 10036

ISBN 2-88046-743-8

This book was designed, edited and produced by
Hilton & Kay
63 Greenham Road
London N10 1LN

Design by Phil Kay
Picture research by Anne-Marie Ehrlich

DTP in Great Britain by
Hilton & Kay
Production and separation in Singapore by ProVision Pte Ltd
Tel: +656 334 7720
Fax: +656 334 7721

Photographic credits
Front cover: (main image) Majken Kruse, (top left) Mann and Man
Back cover: (clockwise) Philip Durell, Steve Pike, Desi Fontaine,
Jos Sprangers

CONTENTS

CONTENTS

INTRODUCTION

The Weddings

In the calendar of life events, a wedding ranks very near the top of the list in terms of its significance. And in the weeks, months, and years following the marriage day, it is the portfolio of wedding photographs that most vividly recalls the happiness and fun of the day.

At least one planning meeting with the couple is essential. At this meeting, it is important to discuss when the photographic coverage is to start – at the wedding venue, for example, or earlier at the bride's home. Some couples may also ask for studio or location shots.

Make sure at this meeting that you confirm the time and location of the wedding ceremony, and of the reception if you are covering that as well.

It is also a good idea to agree beforehand a detailed shot-list of the 'can't-be-missed' photographs, such as the set-piece shots of the bride arriving at the wedding, the couple taking their vows, and signing the marriage register.

The cost of the photography is often determined by the number of pictures the clients want you to produce, but if anything in the discussions leads you to believe that an additional fee will be likely, then agree this contingency in advance and in writing.

The wedding chapters in this book are arranged in the approximate order of events on a typical day, with extra chapters integrated into the sequence that look in more detail at different types of approach. The preparations on the day

of the wedding are shown, and this is followed by a chapter that concentrates on the bride and groom – the leading players – photographed in the days before the actual wedding.

Next is a series of photographs featuring the supporting cast – the best man, bridesmaids, page boy, and all those who play vital roles on the wedding day. The next two chapters deal with the actual ceremony, from the arrival of the bride at the church to the newlyweds leaving afterwards for the reception. A range of different approaches to the set-piece shots is shown, such as cutting the cake, the speeches from the head table, and the bride and groom taking to the floor for the first dance.

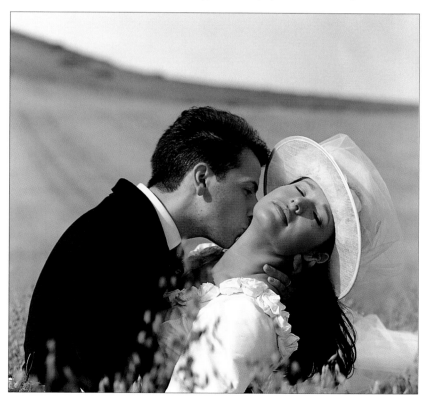

PHOTOGRAPHER:
Van de Maele

CAMERA:
6 x 6cm

LENS:
180mm

EXPOSURE:
½₅₀ second at f8

LIGHTING:
Daylight only

◀ *If the newlyweds have the time on their wedding day, and a suitable location is not too far away, then photographs such as this make a welcome change from the more formal type of coverage. More likely, however, is a photographic session a day or two before the ceremony.*

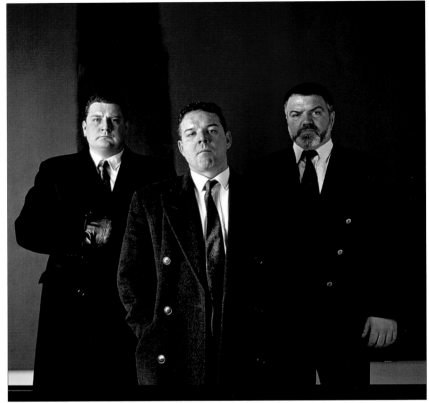

PHOTOGRAPHER:
Anthony Oliver
CAMERA:
6 x 6cm
LENS:
105mm
EXPOSURE:
¹⁄₆₀ second at f22
LIGHTING:
Studio flash x 2

◄ *Three nightclub doormen are the subjects for this group portrait, which forms part of a study commissioned by the National Portrait Gallery in London. The stark style of the studio lighting, using undiffused flash units, accentuates the sense of menace given off by the men.*

The Portraits

The many different approaches to, and treatments and interpretations of the subject make portrait photography a rich and varied field of interest. The term portrait photography is a broad one that encompasses everything from tightly cropped images of the face to full-length portraits of subjects seen in a wide range of settings. The emphasis here is overwhelmingly on studio work, but this has been taken to include photographs shot not only in professional studios, but also more informal set-ups in the home and pictures taken in the workplace.

From the record that has come down to us through the efforts of artists living throughout all the ages of our history –

those involved in painting, drawing, or sculpture – it is clear that the representation of the human face has been an enduring theme. Even in the early days of photography – when lenses and photographic emulsions were so slow that exposure times of many minutes in bright sunlight were necessary to record any type of image at all – there were more photographs taken of people than of any other subject. The studios of the early portrait photographers looked more like torture chambers. Seats were fitted with clamps to hold the body rigid while the photographer stood, watch in hand, counting off the minutes, before slipping the dark slide home to protect the plate on which the light-sensitive emulsion was

coated. This, no doubt, accounts for the painfully stiff poses seen in photographs surviving from those days, as well as for the unrecognisably blurred faces of those who could not keep perfectly still in the embrace of those tortuous clamps.

Today, life is much easier for the portrait photographer, and for those in front of the lens as well. Modern films are thousands of times more sensitive than those first, primitive emulsions; lenses are engineered with such precision that there is virtually no distortion and only minimal light dispersal; and when supplementary illumination is needed for a photograph, then modern studio flash units deliver enough light in bursts as short as 1/10,000 second, or even less.

Topics in the Elements of Portraiture chapter include the uses of shape and form as ways of adding to the information conveyed by a photograph, and the different ways in which the frame can be employed to create interest, movement, and vitality in the photograph.

There are many ways to categorize portraits, and one of the most fruitful is to divide them, broadly, into Four Ages. The chapter with that title covers babies and toddlers, youth and young adulthood, maturity and middle age, and, finally, old age. It is fascinating to study the faces of the subjects in these different categories and see how the bland innocence of inexperience changes as the subjects mature and take on the features

and characters that reflect their different lifestyles and histories.

Couples and Groups, the chapter that follows the Four Ages chapter, shows how groups can present a variety of challenges to the portrait photographer. However, in each case, it can be useful to identify one of the key elements of successful group portraiture. This element hinges on how the subjects are arranged within the space allowed them by the angle of view of the lens. Different group dynamics can be established by such things as eye line, the placement of arms, or the tilt of the subjects' heads. Lighting, too, is often far more complicated to arrange when dealing with more than one subject.

Once you move into the world of Special Effects, the following chapter of the book, you begin to realize that the image produced by the camera, rather than being the end product, may be merely the starting point.

The Portfolios
The final chapter, Portfolios, looks at the work of five very different photographers. Three wedding photographers illustrate different ways in which the wedding day can be photographed from beginning to end. Two portrait photographers are also shown – a traditional portrait photographer and a corporate photographer who creates very company-specific impressions.

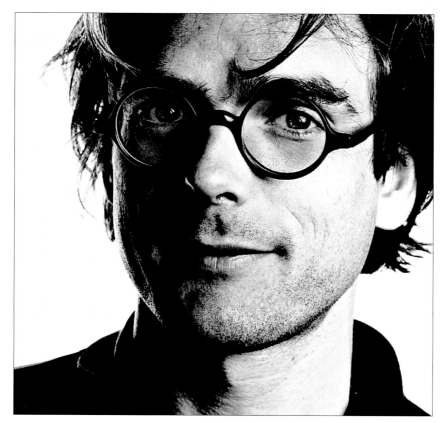

PHOTOGRAPHER:
Anthony Oliver

CAMERA:
6 x 6cm

LENS:
180mm

EXPOSURE:
$\frac{1}{125}$ second at f8

LIGHTING:
Studio flash x 2

◀ *By framing the subject in this fashion, the photographer has deliberately introduced the picture edges as part of the overall composition. The lighting, which has been set to give a contrasty, half-lit/half-dark face, is relieved only by a little light spilling into the subject shadows from the background paper.*

Medium-format Cameras

Traditionally, the camera-type most often used by both wedding and portrait photographers is the medium-format rollfilm camera. This camera format, of which there are many variations, is based on 120 (for colour or black and white) or 220 (mainly black and white) rollfilm.

The three most popular sizes of medium-format cameras are 6 x 4.5cm, 6 x 6cm, and 6 x 7cm models. The number of exposures per roll you can typically expect from these three cameras are:

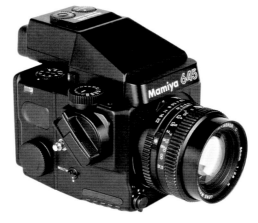

◀ The smallest of the medium-format cameras, producing rectangular negatives or slides measuring 6 x 4.5cm.

Camera type	120 rollfilm	220 rollfilm
6 x 4.5cm	15	30
6 x 6cm	12	24
6 x 7cm	10	20

The advantage most photographers see in using medium-format cameras is that the large negative size – in relation to the 35mm format – produces excellent quality prints, especially when big enlargements are called for, and that this fact alone outweighs any other considerations. The major disadvantages with this format are that, again in relation to the 35mm format, the cameras are heavy and slightly awkward to use, they are not highly automated (although this can often be a distinct advantage), they are expensive to buy, and you get fewer exposures per roll of film.

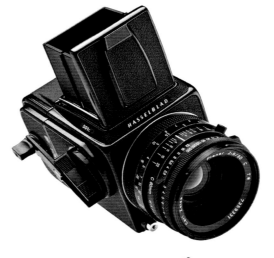

◀ This is probably the best known of all the medium-format cameras, producing square-shaped negatives or slides measuring 6 x 6cm.

35mm Single Lens Reflex Cameras (SLRs)

Over the last few years, the standard of the best-quality lenses produced for 35mm SLR cameras have improved to the degree that results for average-sized enlargements, say 20 x 25cm (8 x 10in), are superb.

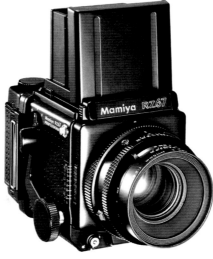

◀ This is the largest of the popular medium-format cameras, producing rectangular negatives or slides measuring 6 x 7cm. (A 6 x 9cm format is also available.)

The 35mm format is the best supported of all the formats, due largely to its popularity with amateur photographers. There are at least six major 35mm manufacturers, each making an extensive range of camera bodies, lenses, dedicated flash units, and specialized as well as more general accessories. Cameras within each range include fully manual and fully automatic models. Lenses and accessories made by independent companies are also available. Compared with medium-format cameras, 35mm SLRs are lightweight, easy to use, generally feature a high degree of automation, and are extremely flexible working tools. For big enlargements, however, medium-format cameras have an edge in terms of picture quality.

All 35mm SLRs use the same size of film cassette, of either 24 or 36 shots, in colour or black and white, positive or negative. Again, because of this format's popularity, the range of films available is more extensive than for any other camera.

LENSES

When it comes to buying lenses you should not compromise on quality. No matter how good the camera body is, a poor-quality lens will take a poor-quality picture, and this will become all too apparent when enlargements are made. Always buy the very best you can afford.

One factor that adds to the cost of a lens is the widest maximum aperture it offers. Every time you change the aperture to the next smallest number – from f5.6 to f4, for example – you double the amount of light passing through the lens, which means you can shoot in progressively lower light levels without having to resort to flash. At very wide apertures,

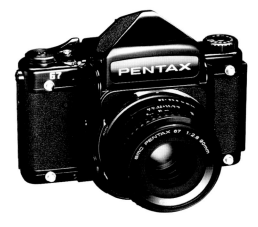

◀ This type of 6 x 7cm medium-format camera looks like a scaled-up 35mm camera, and many photographers find the layout of its controls easier to use than the type on page 10.

however, the lens needs a high degree of optical precision to produce images with minimal distortion, especially towards the edges of the frame. Thus, lenses offering an aperture of f1.4 cost much more than lenses with a maximum aperture of f2.8.

You will probably find that you need lenses ranging from wide-angle (for showing the setting as well as the subject – whether for weddings or studio portraits) through to moderate telephoto lenses (to allow you to concentrate on the face, or head and shoulders, of your subject). For 35mm cameras, the most useful lenses are a 28 or 35mm wide-angle, a 50mm standard, and about a 90 to 135mm telephoto.

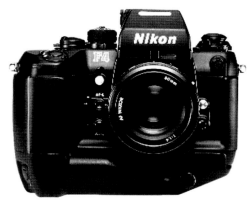

As an alternative, you could consider using a combination of different zoom lenses. For example, you could have a 28-70mm zoom and another covering the range 70-210mm. In this way you have, in just two lenses, the extremes you are likely to use, plus all the intermediate settings you could possibly need to "fine-tune" subject framing and composition.

There is less choice of focal lengths for medium-format cameras. They are also larger, heavier, and more expensive to buy, but the same lens categories apply – in other words, wide-angle, standard, and moderate telephoto. There is also a limited range of medium-format zoom lenses to choose from.

◀ This top-quality professional 35mm camera, here fitted with a motor drive, features a rugged die-cast body; a choice of three different metering systems; interchangeable viewing screens and finders; exposure lock and exposure compensation; and a choice of aperture- or shutter-priority, fully automatic, or fully manual exposure.

Accessory flash

The most convenient artificial light source for a wedding photographer, or a portrait photographer working on location, is undoubtedly an accessory flashgun. Different flash units produce a wide range of light outputs, so ensure that you have the one that is most suitable for the type of area you need to illuminate.

Tilt-and-swivel flash heads give you the option of bouncing light off any convenient wall or ceiling. In this way, your subject will be illuminated by reflected light, which produces a kinder, more flattering effect. You need to bear in mind, however, that some of the power of the flash will be dissipated as a result.

The spread of light leaving the flash head is not the same for all flash units. Most are suitable for the angle of view of moderate wide-angle, normal, and moderate telephoto lenses. However, if you are using a lens with a more extreme focal length, you may find the light coverage inadequate. Some flash units can be adjusted to suit the angle of view of a range of focal lengths, or adapters can be fitted to alter the spread of light.

Long-life lighting

One of the problems of using accessory flash is the number of times the flash will fire before the batteries are exhausted. There is also the problem of recycling

▶ *"Hammer-head" style accessory flash units are capable of producing high light levels and so are often used with heavy-duty battery packs. Always choose a model with a tilt-and-swivel head facility for a variety of lighting effects.*

speed – the time it takes for the batteries to build up sufficient power in order to fire once more. With ordinary batteries, after as few as 30 firings recycling time may be so long that you need to change batteries (the fresher the batteries, the faster the recycling time). This is not only expensive, it is also time-consuming. The solution to these problems is to use a battery pack. With some types of pack, when fully charged, you can expect as many as 4,500 firings and a flash recycling time as low as ¼ second – which is fast enough to use with a camera and motor drive. These figures do, of course, assume optimum conditions, such as photographing a nearby subject, with plenty of reflective surfaces close by to return the light, and with the flashgun set to automatic.

Studio flash

For studio-based photographs, by far the most widely used light source is studio flash. Working either directly from the mains or via a high-voltage power pack, recycling time is virtually instantaneous and there is no upper limit to the number of flashes.

A range of different lighting heads, filters, and attachments can be used to create virtually any lighting style or effect, and the colour temperature of the flash output matches that of daylight, so the two can be mixed in the same shot without any colour cast problems.

When more than one lighting head is being used, as long as one light is linked to the camera's shutter, synchronization cables can be eliminated by attaching slave units to the other lighting heads. Another advantage of flash is that it produces virtually no heat, which can be a significant problem when using studio tungsten lighting. To overcome the problem of predicting precisely where subject shadows and highlights will occur, which cannot normally be seen because the burst of light from the flash is so brief, each flash head should be fitted with a "modelling light". The output from these lights is low and won't affect exposure, but it is sufficient for you to see the overall effect with a good degree of accuracy.

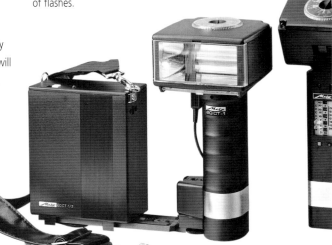

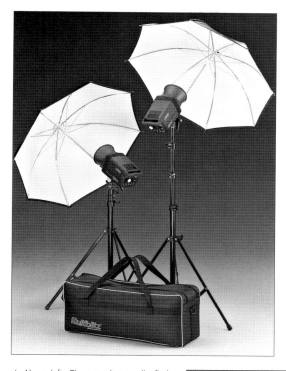

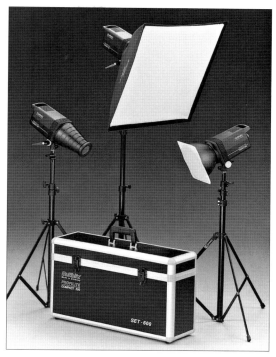

▲ Above left: *These modern studio flash units have been designed with location work in mind. This set-up, comprising two lighting heads, umbrellas, and lighting stands, packs away into the flexible carrying bag illustrated.*

▲ Above right: *For a wider range of lighting effects, this set-up has three lighting heads, with add-on softbox, snoot, and scrim, and three lighting stands. It all packs away into the case illustrated, which would easily fit into the boot or back seat of a car.*

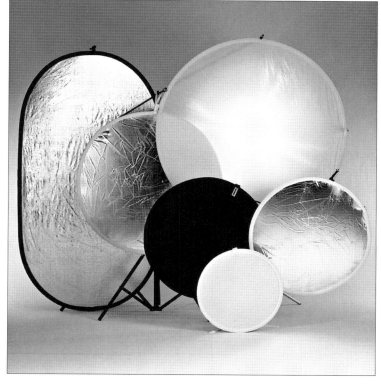

▶ *Reflectors can be made out of pieces of cardboard – white for a neutral effect or coloured for more unusual results. But professional reflectors, made from materials with different reflective qualities, allow you a greater degree of control, either in the studio or at a wedding or other location.*

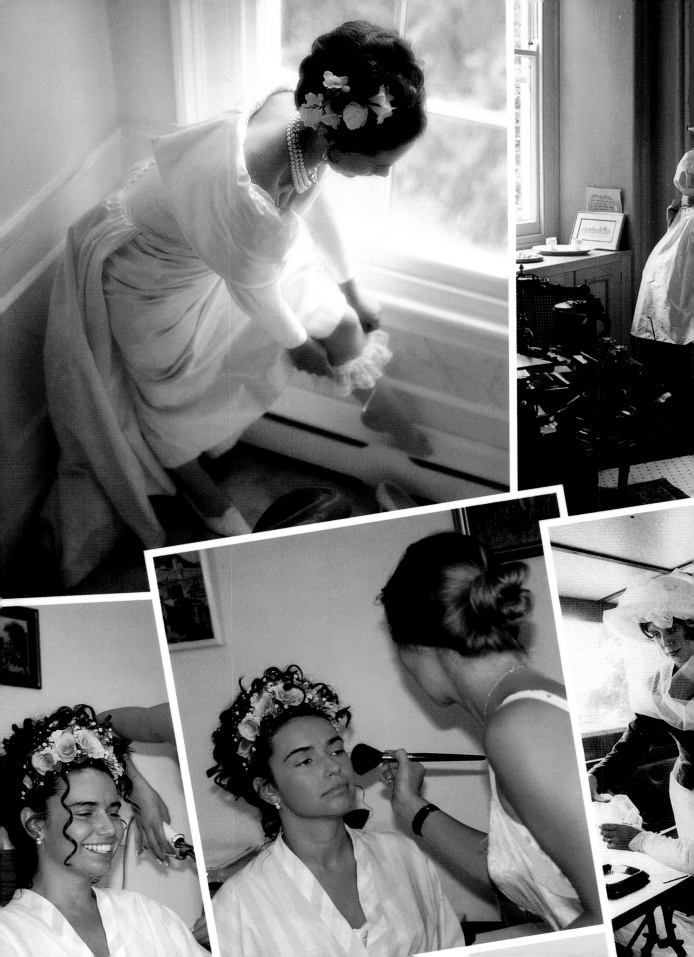

WEDDING PREPARATIONS

A COMPLETE MAKE-OVER

Preparations for the bride on the day of the wedding itself must start many hours in advance of the actual ceremony. You can imagine, however, that the last thing anybody wants is somebody in the house with a camera and lights getting in the way when there is so much to do – and when nerves are perhaps getting a little frayed. You, therefore, need to explain to clients that, in the long term, they will probably be happier with their wedding portfolio if they have a record of at least some of those manic, behind-the-scenes preparations.

If it is a sunny day and the house you are photographing in is bright with lots of windows, you may be tempted to rely on natural light. Often, this is a mistake. Window light is almost always too contrasty for the type of detailed shots required, and if your subject happens to be shown against a window then the camera's light meter will almost certainly set an exposure that renders the subject as a silhouette. It is a better idea to rely instead on flash for the main illumination and use any available daylight as fill-in light.

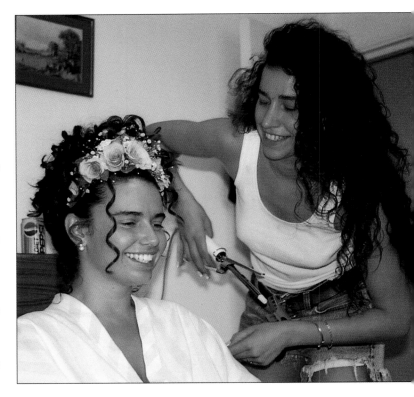

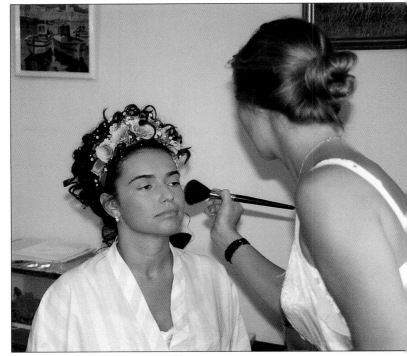

◄ The first stage of preparing the bride for the big day is styling her hair. If the style involves an elaborate flower headdress, as here, you should have at least an hour or more in which to take your shots. Once the bride's hair has been styled, the next stage is to apply her make-up (see below left). On an occasion like this, a professional make-up artist is likely to be used to ensure that the bride looks flawless. Make-up should take between 20 and 35 minutes.

► Always keep your wits about you, since you never know when a good picture opportunity is going to arise. This amusing candid shot occurred when the bride's helper suddenly plunged underneath the bridal gown to sort out a problem with one of the underskirts.

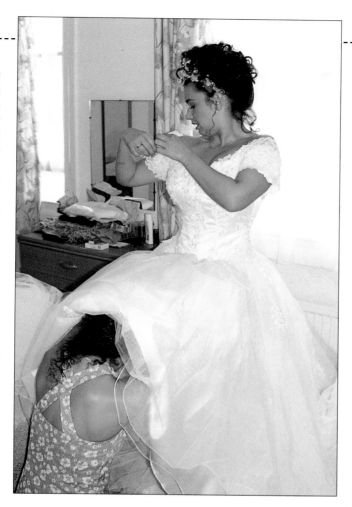

Applying make-up

The aim of applying make-up is to accentuate the subject's best facial features while minimizing any irregularities or blemishes. The first step is to use a moisturizer to improve skin quality. This is then followed by a foundation product, concealer (if needed), and a dusting of translucent powder. With the broad areas of the face made up, you next concentrate on the details. Starting with the eyes, paint fine lines around the upper and lower lids, followed by eye shadow. Next, define the brows using an eyebrow pencil and then apply mascara to both the top and bottom eyelashes. To bring out the bone structure around the cheeks, blusher can be applied with a large, soft brush. The final stage is the lips. Here, you can first outline the shape of the lips with a pencil or brush, using a shade slightly darker than that used on the lips themselves. For better control, use a brush to apply the lipstick colour, and, finally, an application of lip gloss.

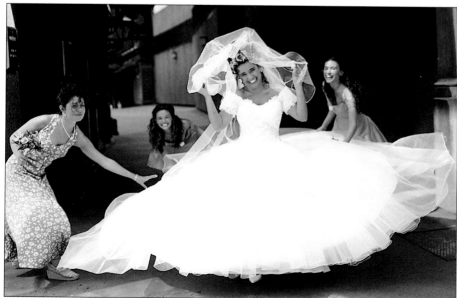

◄ This picture was taken just before setting off for the ceremony. Everybody wanted a bit of fun to let off steam and calm any jangling nerves.

Equipment checklist

● **35mm SLR camera** When conditions are cramped and the action is moving too fast for a tripod to be used, a lightweight 35mm SLR, which can be easily hand held, has distinct advantages over medium-format cameras.

● **Power winder** Many modern 35mm SLRs have built-in autowinders or power winders to advance the film after each exposure. If not, use a camera that allows you to add one as an accessory.

● **Flash** Even if your camera has a built-in flash, it is still better to use an add-on model to avoid the potential problem of "red-eye". Use a flash model with a swivel and tilt head to allow you to bounce light off the walls or ceiling.

● **Film and batteries** Always have more spare film and extra batteries for both the camera and flash than you think you will need.

PHOTOGRAPHER:
Majken Kruse

CAMERA:
6 x 6cm

LENS:
120mm

EXPOSURE:
⅟₆₀ second at f16

LIGHTING:
Daylight and heavily diffused flash

▶ *Arriving at the church looking confident and happy – hair, make-up, and gown all looking perfect for the camera.*

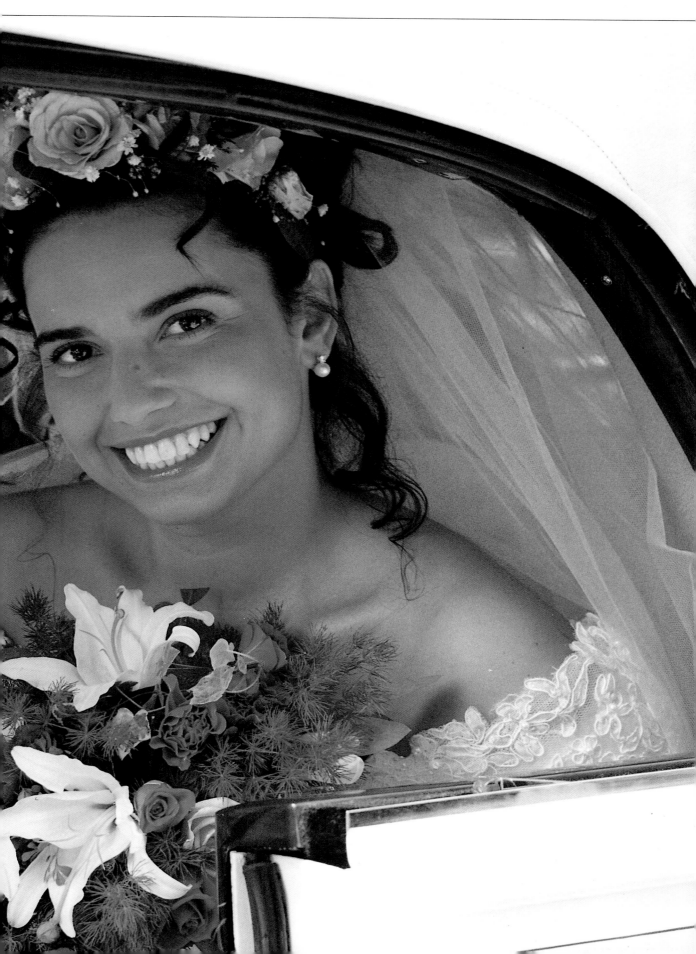

LAST-MINUTE ADJUSTMENTS -------------------------------

Many wedding albums only start with the groom and guests outside the church, registry office, or other building where the marriage is to take place, waiting for the bride to arrive. As you can see here, this is a great pity, since many informal yet memorable photographic opportunities may well be missed.

The hour or two before the bride leaves home for the ceremony can often be tense and full of activity. At this time, you will not be popular if you get in the way or ask people to stop what they are doing and pose for you.

You therefore have to work quickly, quietly, and professionally, seizing your opportunities as and when they arise for more candid coverage.

TTL (through-the-lens) camera metering systems are a great boon, but many of these do not perform reliably well when there is a wide exposure difference between the shadow areas and the highlights contained in the same scene. Knowing this, the photographer' has to make the decision about which part of the picture to expose for. In such a situation, it may be wise to use a hand-held exposure meter.

PHOTOGRAPHER:
Trevor Godfree

CAMERA:
35mm

LENS:
80mm

EXPOSURE:
$\frac{1}{125}$ second at f4

LIGHTING:
Daylight only

▲ *The contrast levels in the bedroom where the bride was dressing were very wide, and this is the type of situation where you might want to use a hand-held meter to ensure that exposure is spot-on. For the photograph illustrated here, the photographer determined that the skin tones of the bride's face were the most important part of the frame, and so the light reading was taken from there.*

▶ *Exposure was difficult in this situation because of the range of contrasts within the scene. It was important to ensure that not only the bride's face was well exposed, but also that just enough detail could be seen in the helper's face to stop it completely disappearing in shadow.*

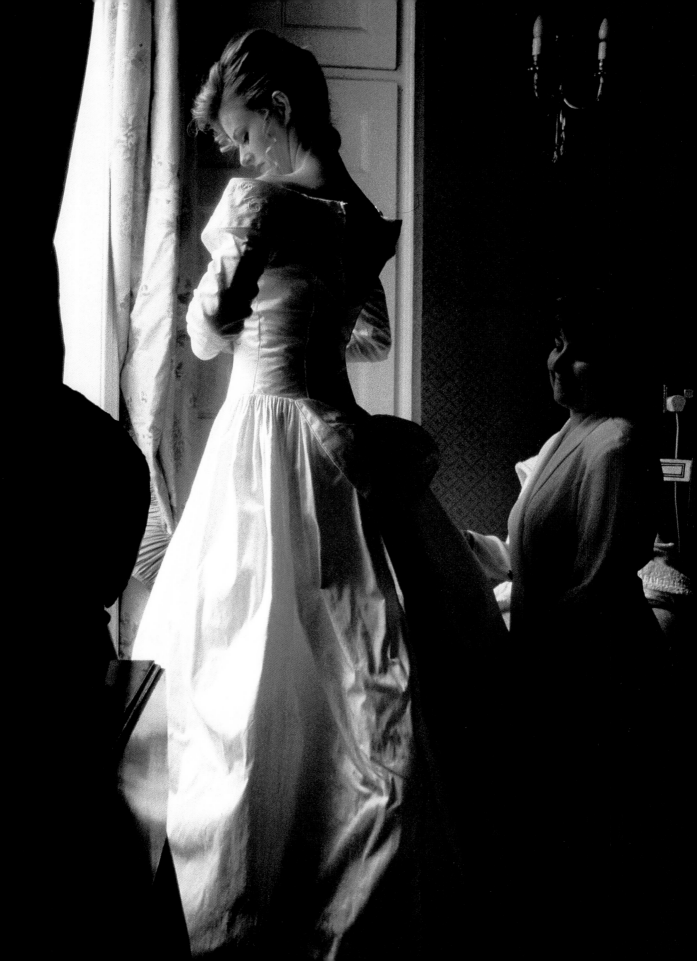

FILLING THE FRAME ----------------

All of the supporting cast of players on the bride's side can be seen in this wedding album photograph. The bride's mother is on the far side of the group, made up of the bridesmaids and the young ring bearer, who is holding the cushion on which the rings will be placed during the ceremony. This group has been purposely rendered just slightly out of focus by the photographer's choice of a large aperture, which was also necessary because the only illumination for this shot was natural daylight entering the room through the window. The bride is the only sharply rendered element in the picture. This helps to imply that although she is part of the proceedings and the activity, she is also feeling slightly apart from it – an aloofness that is reinforced by her veil being down. Perhaps she is taking this last opportunity to calm her nerves before leaving for the ceremony.

PHOTOGRAPHER:
Richard Wilkinson

CAMERA:
35mm

LENS:
70mm

EXPOSURE:
⅛₀ second at f4

LIGHTING:
Daylight only

Hints and tips

● Most autofocus camera lock onto anything in the target area, usually found in the centre of the frame. In the picture here, this would have rendered the background group sharp and the bride slightly out of focus.

● To overcome this problem, frame the shot with the bride in the centre of the frame, wait for the lens to focus, and lock the focus setting into the camera.

● Then, recompose the shot with the bride off to one side of the frame, with the original focus setting still locked into the camera.

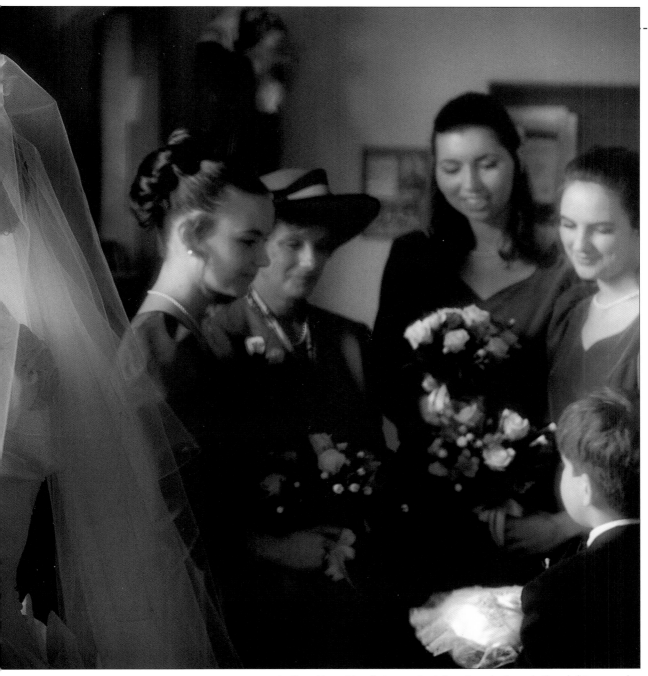

▲ To achieve this effect, the photographer selectively focused on the bride to ensure that she appeared sharp, and then chose an aperture that rendered the others in the room behind slightly soft. The difference between the clarity of the two main elements in the picture helps to establish depth and distance, as does the contrast between the bright white of the bridal gown and the deep purple of the bridesmaids' dresses.

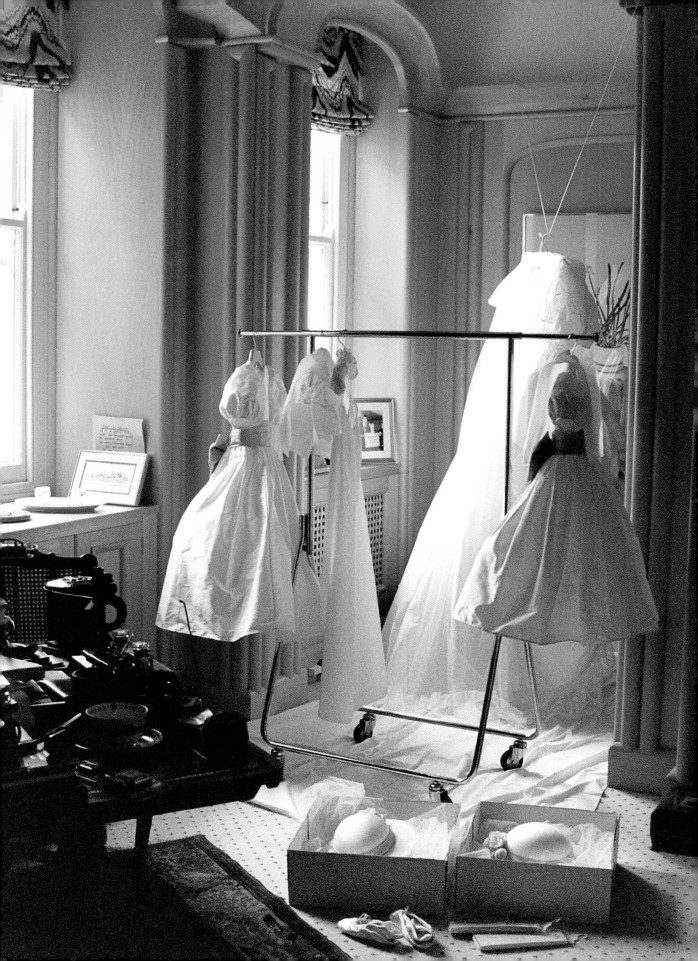

TEMPORARY LULL

Wedding pictures don't always have to feature people or be of the wedding or reception venue itself. Weddings, of any culture, are full of symbolism – details that are peculiar to that particular event, such as colours, flowers, accessories, and clothes. And it is clothes that have become the subjects of the still-life studies below and opposite.

Part of the magic of photography is that it captures a frozen instant in time. It doesn't matter that just seconds before the picture of the dresses hanging up was taken the room was full of people and activity, and that seconds afterwards the perfect calm of the scene was shattered once again as people flooded back in. As it is, the lighting, repetition of shapes and colours, the contrasts between highlight and shadow all combine to create a composition that invites you to explore the frame in minute detail.

PHOTOGRAPHER:
Majken Kruse

CAMERA:
35mm

LENS:
50mm

EXPOSURE:
⅛₂₅ second at f11

LIGHTING:
Daylight only

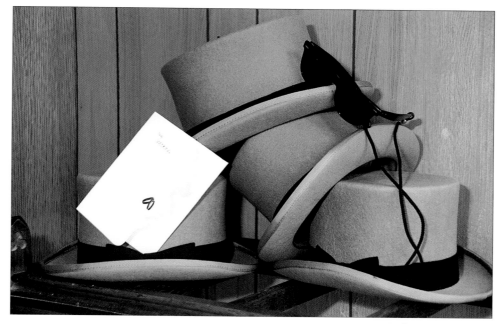

◀ The foreground silk shoes and hat boxes seem to act as stepping stones, taking the viewer's eye into the frame and toward the bridesmaids' dresses hanging in the middle ground and the bridal gown suspended at the rear. Exposure was calculated for the highlight side of the white clothing, which produced a shutter speed/aperture combination that lessened the visual impact of the table on the left of the picture without robbing it of all its interesting detail.

PHOTOGRAPHER:
Peter Trenchard

CAMERA:
35mm

LENS:
90mm

EXPOSURE:
⅟₆₀ second at f8

LIGHTING:
Bounced flash

▲ Top hats are one of the symbols of a formal Western-style wedding, and the invitation casually propped up against them makes the perfect finishing touch for the shot.

THE CAMERA DOESN'T LIE?

Depending on the camera angle and lens focal length you choose, the same scene may be interpreted in many different ways.

Although the pressure is always on the photographer to work quickly and efficiently, take a second or two to think before exposing the film and decide whether or not the elements in the viewfinder are telling the best story. Only when you are happy with what you can see, press the shutter release.

Two technical innovations on the photographer's side are the zoom lens, which allows you to fine tune framing, and automatic film advance, so you don't have to take your eye from the viewfinder to wind on.

PHOTOGRAPHER:
Majken Kruse

CAMERA:
35mm

LENS:
28-70mm zoom

EXPOSURE:
¹⁄₆₀ second at f8

LIGHTING:
Daylight only

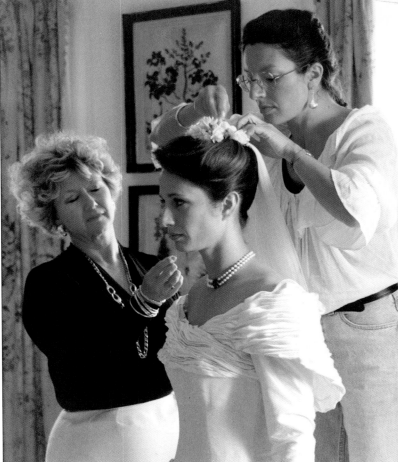

▶ *Taken from a different camera position and with the lens zoomed back to a slightly wide-angle setting, this version of the scene tells a very different story to the other below. Now we can see that what appeared to be all calm and order was, in fact, a cauldron of activity, with a line of seated bridesmaids all waiting their turn to have their hair attended to.*

PHOTOGRAPHER:
Majken Kruse

CAMERA:
35mm

LENS:
28-70mm zoom

EXPOSURE:
¹⁄₁₂₅ second at f8

LIGHTING:
Daylight only

▲ *Taken at the telephoto end of a 28-70mm zoom lens, this version of the situation, taken just a little while before setting off for the wedding ceremony, shows a scene of calm and orderly concentration. The bride is having the finishing touches applied to her hair while her mother stands by proudly admiring the results, and offering a few suggestions.*

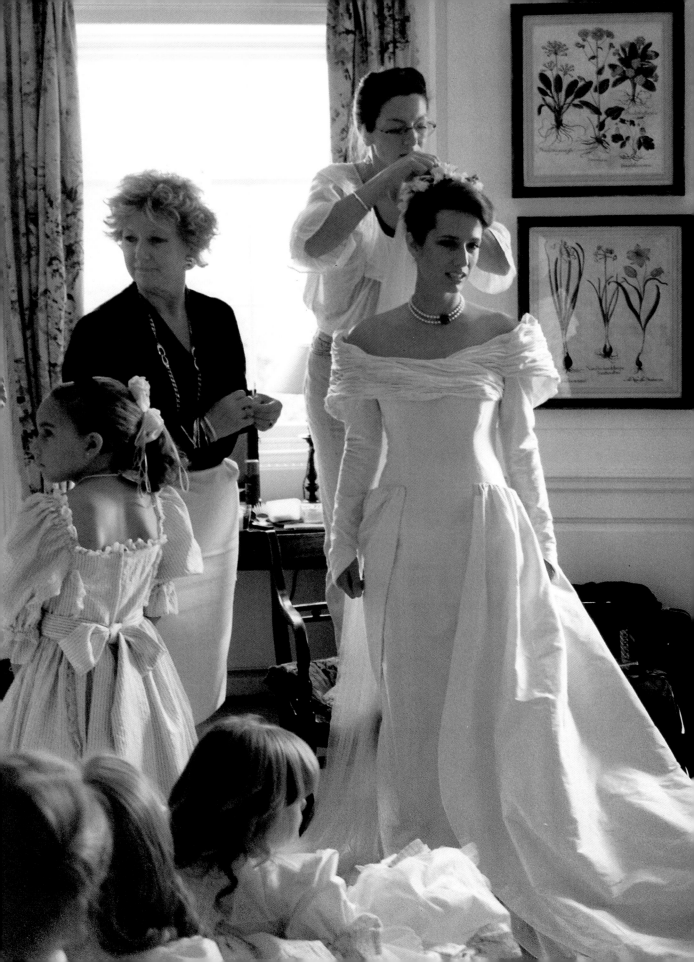

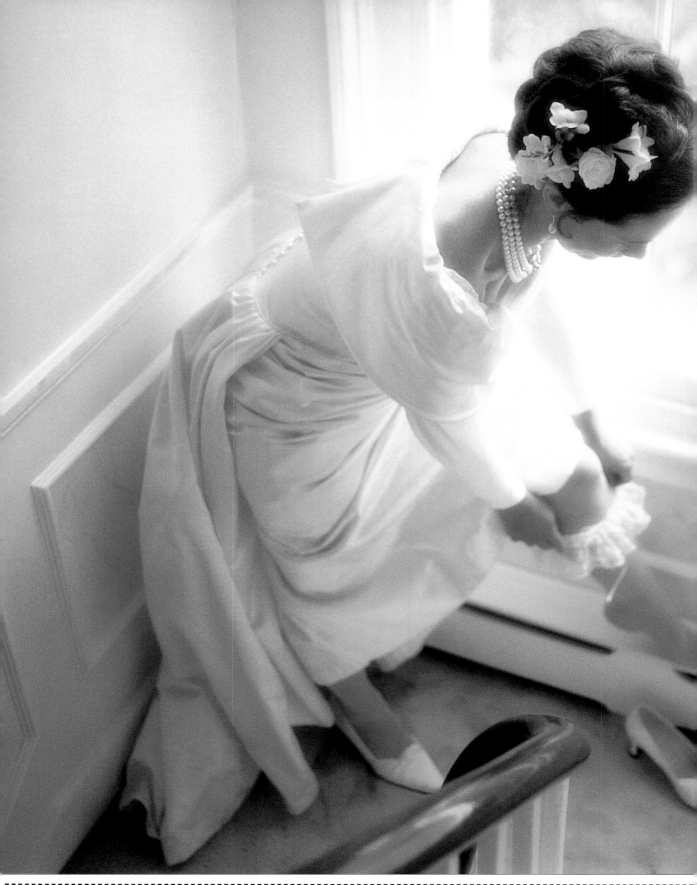

THE UNOBSERVED CAMERA

The appeal of some photographs has as much to do with the fact that they appear to have been taken without the subject's knowledge as they do with the actual content. The photograph here is such an example, showing the bride, on her way down the stairs to leave the house for the wedding ceremony, pausing briefly to slip a garter onto her leg – a personal act that the camera would not normally be there to record.

Time was critically short at this point in the proceedings, and the photographer had no time to set up a flash, and thus had to rely solely on whatever daylight was entering through the side window. As a result, a slow shutter speed and a large lens aperture had to be used, and the zone of sharp focus – the depth of field – was not extensive enough to encompass the whole figure. Instinctively, however, in the split second that was available for the shot, the photographer made the correct decision and focused on the bride's face. In almost all circumstances, the most crucial part of any portrait is the face – especially the eyes – which is something to bear in mind whenever you are in doubt about what to focus on if depth of field is restricted.

PHOTOGRAPHER:
Desi Fontaine

CAMERA:
6 x 6cm

LENS:
120mm

EXPOSURE:
⅟₃₀ second at f4

LIGHTING:
Daylight only

◀ *Light levels were not high in this stairway, and the photographer was forced to use what daylight was available. The wide aperture used on a moderate telephoto lens resulted in a restricted depth of field.*

SHOOTING IN BLACK AND WHITE

There is a fine line in commercial wedding photography between shooting only as much film as you need to in order to keep costs under control and ensuring that you take enough pictures to put together a top-class wedding portfolio. If the clients are agreeable, and indeed some clients even insist on it, one way of keeping costs down is to shoot all, or part, of the wedding in black and white. This film stock is less expensive than colour material, processing is quicker and cheaper, and the costs of prints offer a considerable saving. Clients may, for example, be quite happy to have a set of black and white prints covering the preparations before leaving the house and the reception, yet want a set of colour prints of the wedding ceremony part of the day.

Many people view black and white photography as being more of an art medium than colour. Once colour is removed from the calculation, the image is immediately simplified and, to a degree, abstracted. The two-dimensional photograph is already an abstraction of the three-dimensional world around us, but once colour is removed the process is taken much further. Photographers who specialize in black and white work often state that they prefer the freedom they have to interpret scenes and activities, rather than just making a life-like record of them.

PHOTOGRAPHER:
Nigel Harper

CAMERA:
35mm

LENS:
35mm

EXPOSURE:
1/125 second at f8

LIGHTING:
Daylight only

Hints and tips

● Black and white film costs, processing, and printing are all cheaper than in colour, so it is possible to shoot more images and produce a larger portfolio for the same cost.

● A wide range of lens filters can be used with black and white film to alter the tonal balance of the image.

● Black and white film has a very wide exposure latitude and is very forgiving of exposure errors.

● Black and white prints can be toned and tinted, overall or just locally, or printed on coloured paper, to produce a wide range of colour effects.

▶ *The emphasis of the image alters considerably when you remove colour, with shape, form, texture, and contrast becoming more significant factors. In this picture, note how important the tonal contrasts are between the bridesmaids' skirts and their jackets, the skin texture of the bride's back and the shapes created by her muscles and bones as she twists her body. The shapes made by the bridesmaids' hands, too, are fascinating – one manipulating the bride's hair and the other poised over the bride's outstretched arm.*

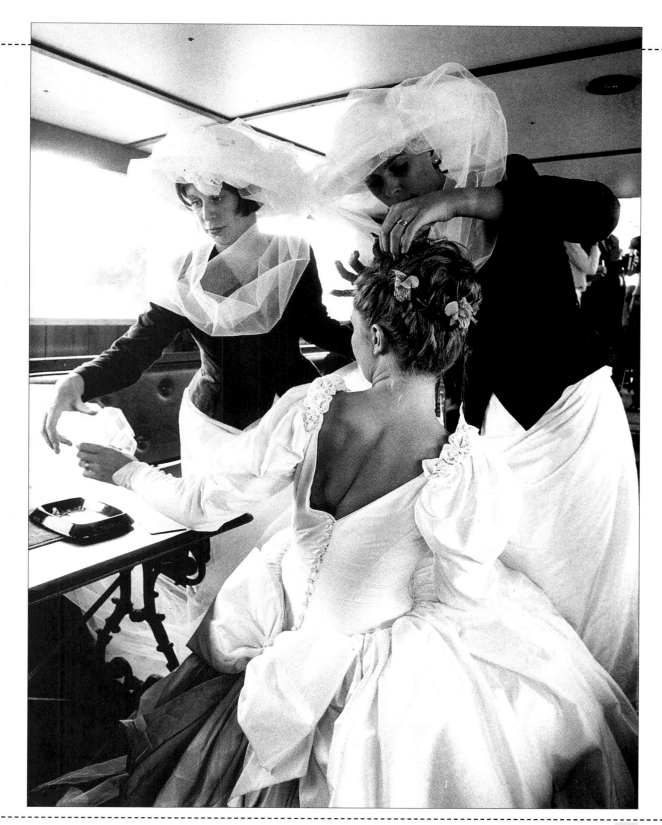

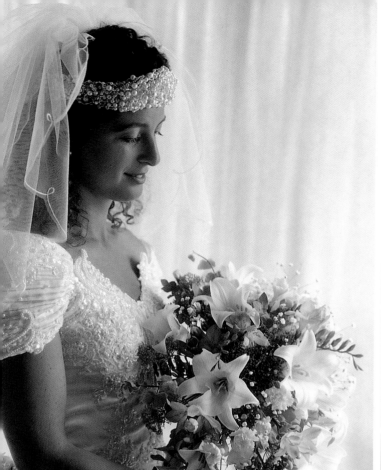

LEADING PLAYERS

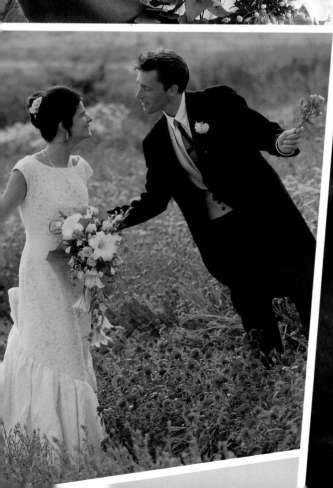

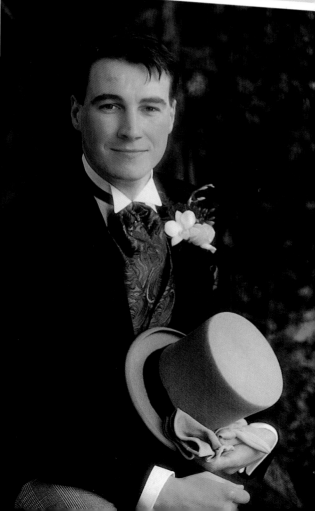

INDOORS OR OUTDOORS

Getting the wedding couple alone for a photographic session either before the wedding or at some stage on the wedding day – most likely at the reception – is often difficult. There will obviously be many demands on the time of the bride and groom and, being strictly practical, you will want to work as quickly and efficiently as possible within the fixed budget that has been agreed before the wedding. The quotation you give regarding costs will probably form part of a contract between both parties.

Take a few minutes before the couple are ready for you to have a quick scout around the venue chosen for the session to discover where its strong points lie. If the weather seems promising, look around the gardens or grounds and try to find a good combination of strong architectural and attractive garden features that you can take advantage of. If, however, the weather is not looking good, you may still be able to utilize a covered area adjacent to the building. Again, look for strong, uncluttered architectural features that would be worthwhile including in the photographs.

In order to achieve a good mix of shots, with plenty of changes of mood and pace, you will also hope to take some indoor portraits. On this point, much depends on what the venue has to offer, and how much lighting equipment you have available. If you are shooting the pictures on the day of the wedding, then try to incorporate at least some of the wedding decorations, floral displays, ribbons, and similar items. A lot of trouble goes into these aspects of the wedding so you should make the most of what has been provided. Bear in mind that it is exactly this type of detail that is important to the newlyweds and their families, and it is they who will be ordering the reprints from you.

PHOTOGRAPHER:
Desi Fontaine

CAMERA:
6 x 6cm

LENS:
75mm

EXPOSURE:
¹⁄₂₅ second at f8

LIGHTING:
Daylight supplemented by bounced flash and reflectors

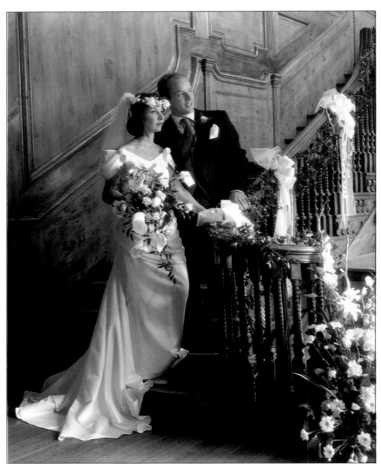

▲ The rich wood panelling, handrail, and balusters, plus the floral decorations from the couple's reception, proved to be an irresistible combination for this wedding day portrait. Although there was quite a lot of natural illumination available from large windows opposite, light levels had to be boosted with some bounced flash and reflectors.

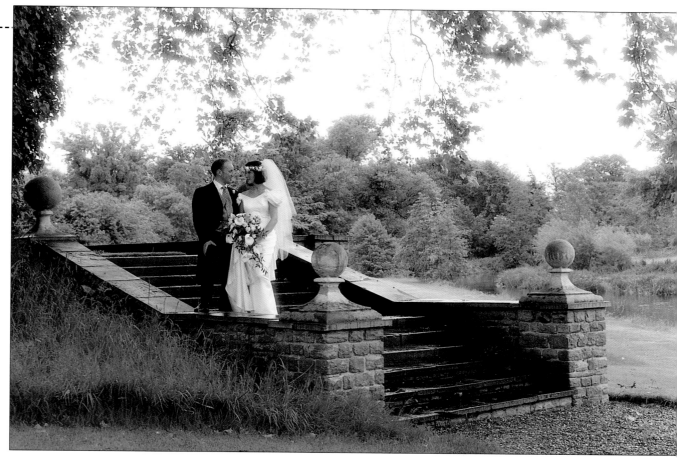

▲ Although the weather was overcast and there had already been some rain that day, the sky was still bright and there proved to be plenty of daylight to work with. These broad stone steps, which led down through the grounds of the reception venue toward the river, proved to be an ideal location for a formal portrait of the newlyweds. The overhanging foliage in the foreground not only makes a romantic frame for the composition, it also helps to draw the viewer's attention away from what would have been a large expanse of unattractive and featureless grey sky.

▲ When you are combining flash and daylight, be careful to avoid producing two set of conflicting shadows. To avoid this, align the flash light with the daylight, as you can see here. Light from the reflectors is not strong enough to cast shadows; it is used to lighten, just fractionally, the area around the bottom of the bride's gown.

EXPOSURE:
¹⁄₃₀ second at f22

LIGHTING:
Daylight only

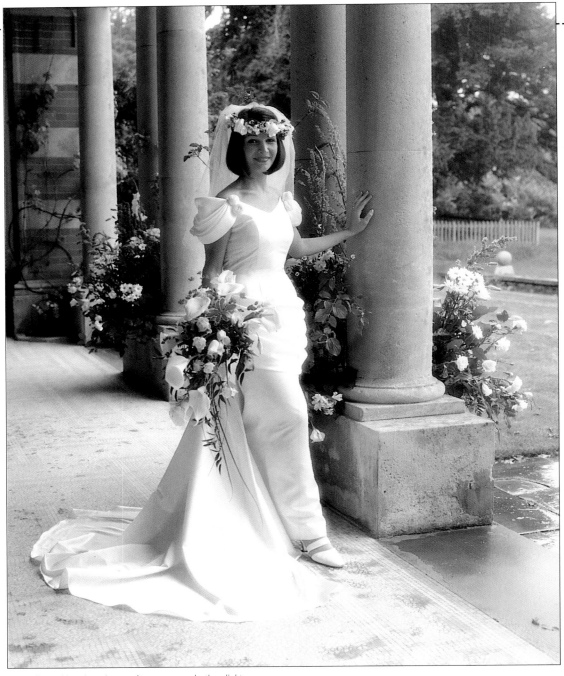

▲ The flower-fringed porch at the side of the reception venue was surprisingly bright considering the weather. The rain-soaked step leading onto the grass and the light-coloured tiled floor inside both helped bounce a little extra light into the area selected for this portrait of the bride.

EXPOSURE:
¹⁄₆₀ **second at f11**

LIGHTING:
Daylight only

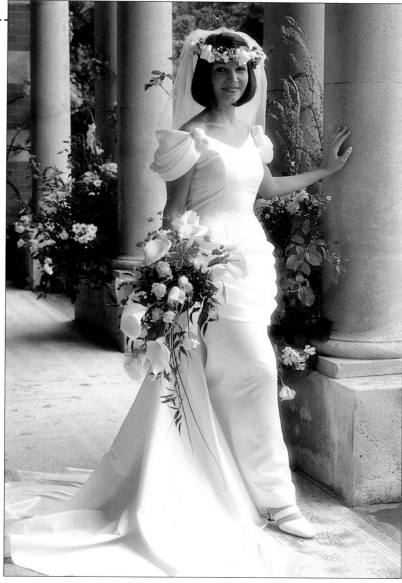

◀ It is better if you can make all cropping decisions before taking the picture so that each negative can be printed full frame. Sometimes, however, this is not possible, and even if it were, there is often more than one way of showing the same scene. In this version, which has been cropped from the full-frame image opposite, the view of the garden has been removed, as has much of the window in the rear wall. It is not necessarily any better or worse than the original framing, but it does have an entirely different atmosphere.

◀ Make two L-shaped cardboard shapes like those shown here. You can then position them over any print leaving the area in the middle isolated from its surroundings. This will help you judge the merits of a particular crop before going to the time and expense of having it printed.

LOOKING RELAXED

When you are dealing with people who are not used to being in front of the camera – as will be the case with most wedding couples – there is always a tendency for them to go "wooden" on you. Part of your job is to make them unwind and relax, both before and during the photo session, by talking and joking with them, for example, or by getting them to talk to you about their interests, their plans for the wedding and what they will be doing afterwards, the house or apartment they will be moving to, their jobs, and so on. The quicker you can build up a friendly rapport with your subjects, the better the photographs are likely to be.

Even after you have overcome most the subjects' nerves and they are moving and holding themselves in a more relaxed manner, any vestiges of nervousness they may still have tend to show themselves in their hand and feet. Feet, for example, can take on a life of their own, sticking out at awkward angles, and hands can form into fists or be held with the fingers rigidly straight. Watch out for these sorts of details – it is very easy to overlook them when taking the pictures, but they will scream out of the photographs at you when it is too late to do anything about it.

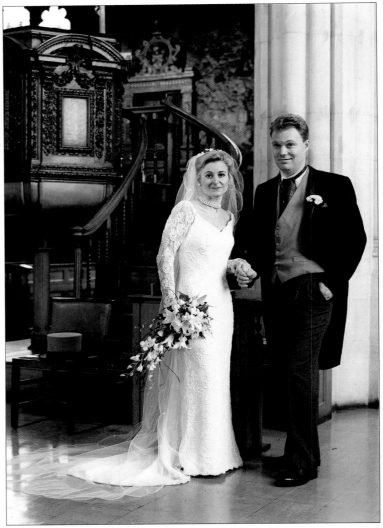

▲ Here the photographer has coached the subjects to get them to look less wooden. The church setting and the pulpit behind are attractive features and their joined hands, although a little tense-looking, is a natural gesture. The bride's other hand is taken care of by the bouquet and the groom's has been kept out of sight in his pocket. The bride's gown hides her feet, and the groom's legs and feet look relaxed.

PHOTOGRAPHER:
Hugh Nicholas

CAMERA:
6 x 7cm

LENS:
70mm

EXPOSURE:
1/60 second at f8

LIGHTING:
Flash supplemented by daylight

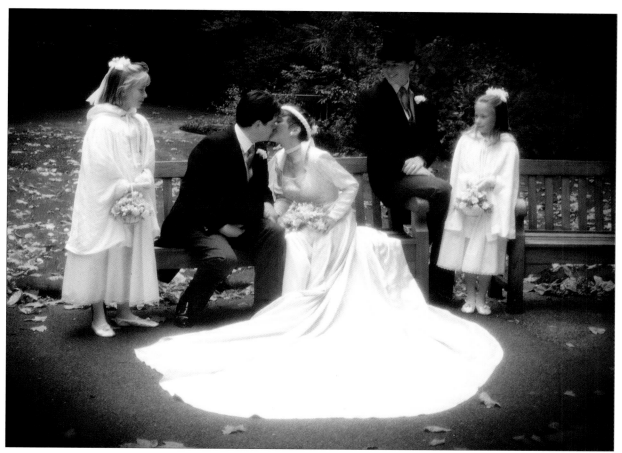

▲ This picture contains many elements that could spoil the shot if they don't look right. Note that both bridesmaids' hands have been positioned holding their floral baskets, while those of the best man are naturally at ease. One of the groom's hands is occupied with his hat, while his other hand is holding that of his bride's.

PHOTOGRAPHER:
Hugh Nicholas

CAMERA:
6 x 7cm

LENS:
70mm

EXPOSURE:
¹⁄₂₅ second at f11

LIGHTING:
Daylight supplemented by flash

Hints and tips

● The more friendly and outgoing you can be with your clients, the more relaxed they are likely to look in the resulting photographs.

● Talk to your subjects about their interests and try to get them to respond to your questions. Once they start talking and asking you questions, the more animated and natural they will look in their pictures.

● If your subjects' hands look awkward, suggest that they use a prop – such as holding a hat, gloves, flowers, their partner's hand, and so on – to make them feel more comfortable.

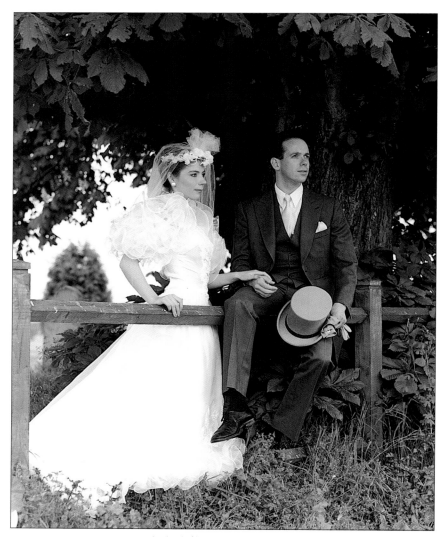

▶ The bride and groom look relaxed and happy in this garden setting. The bride's hands are out of sight behind the bouquet and the groom's visible hand is occupied with holding his hat and gloves.

▲ The detail of how this couple hold themselves has been well thought through. The wooden rail on which the groom is perched forces his legs and feet into a natural-looking position, and while one hand holds his hat and gloves the other is supporting his bride's hand. Her free hand is at ease, resting on the rail.

PHOTOGRAPHER:
Hugh Nicholas

CAMERA:
6 x 7cm

LENS:
120mm

EXPOSURE:
½₅₀ second at f5.6

LIGHTING:
Daylight supplemented by flash

PHOTOGRAPHER:
Mandi Robson

CAMERA:
6 x 6cm

LENS:
80mm

EXPOSURE:
⅟₆₀ second at f11

LIGHTING:
Daylight supplemented by flash

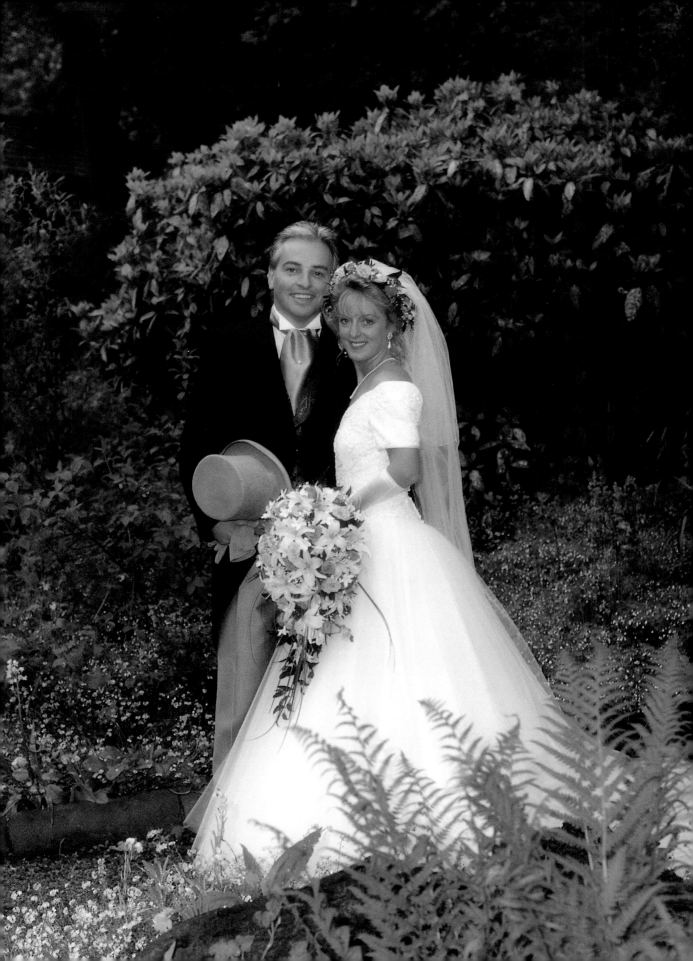

WITH OR AGAINST THE LIGHT

The usual advice given to photographers working in natural daylight – or indoors using studio lights – is that they should position themselves so that the sun (or studio light) is at their back and, thus, shining directly onto the subject. This is known as shooting with the light, or frontlighting. Indeed, so commonly is this advice adhered to that the majority of camera autoexposure systems are calibrated to give their most consistently accurate readings only in this general type of lighting situation.

▼ With the sun shining onto the side of the subjects facing the camera, the resulting frontlit image is richly detailed. The surface qualities of the bride's dress and the groom's suit are well recorded and colours are bright and intense.

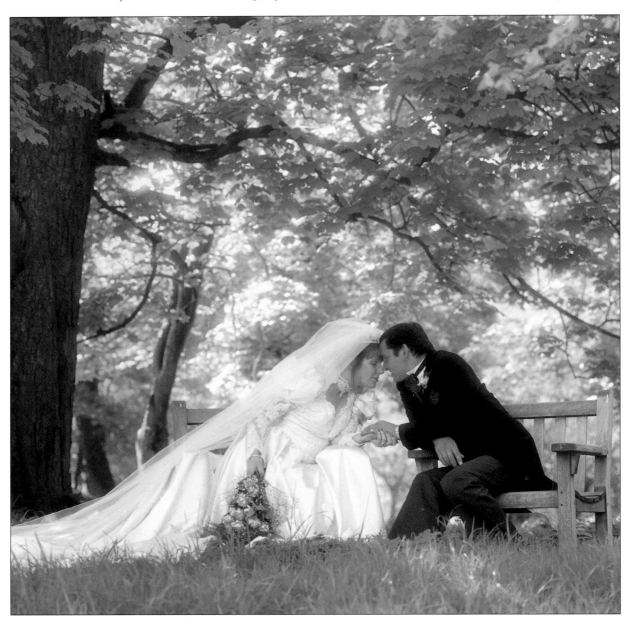

PHOTOGRAPHER:
Desi Fontaine

CAMERA:
6 x 6cm

LENS:
75mm

EXPOSURE:
⅟₅₀₀ second at f8

LIGHTING:
Daylight only

▼ *Taken from the other side of the couple, this picture records the shadow side of the subjects facing the camera. Because a shadow light reading was taken in order to produce this backlit exposure, the brightly lit scene beyond the subjects is massively overexposed, creating a romantic type of effect in a landscape that seems to shimmer with an* intense heat. *The exposure difference between the subjects and the landscape also helps to isolate them from the setting, creating a strongly three-dimensional effect. Colours, too, are more subdued than in the frontlit version opposite – an effect that can sometimes be extremely useful when a more monochromatic type of image is required.*

EXPOSURE:
⅟₆₀ second at f8

LIGHTING:
Daylight only

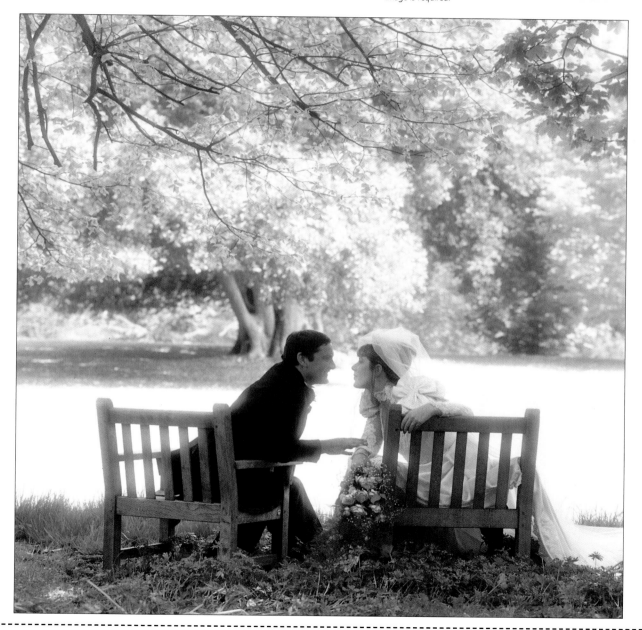

At the other lighting extreme you have what is known as shooting against the light, or backlighting. In this situation, the sun is at the subject's back, shining toward the camera, and so the side of the subject facing the photographer is effectively in shadow.

In most situations, frontlighting produces images that are richer in detail than images that are backlit, and colours, too, tend to be stronger and more intense. As has already been mentioned, a major advantage of shooting with the sun behind the photographer is that TTL (through-the-lens) exposure metering systems produce more consistently accurate results, since they are designed to measure the light reflecting off the subject.

What, then, are the advantages of backlighting? First, in order to appreciate the special qualities inherent in backlit scenes, you need to take particular care with getting the exposure right. If you just point the camera at the general scene, the meter will register a huge amount of light because it is facing in the direction of the sun, and it will set an aperture/shutter speed combination accordingly. Most often, an exposure taken with this type of setting will show your subject as a partial or total silhouette. If you don't want this result, simply move in close up to the subject, take an exposure reading that excludes the brightly lit general scene, lock that reading into the camera, and then move back and recompose the picture before shooting.

▲ *In frontlighting, the sun is at the photographer's back and the light falls on the side of the subjects facing the camera. Any shadows cast thus fall behind the subjects, and away from the camera.*

▼ *In backlighting, the sun is at the subjects' back and the light falls on the side of the subjects away the camera. Any shadows cast thus fall in front of the subjects, toward the camera.*

▶ In this backlit scene, the photographer has decided not to compensate fully for the extra light entering the lens, and the exposure shows the subject's faces slightly underexposed. However, the light pouring through the bride's translucent veil creates a dramatic and eye-catching contrast.

PHOTOGRAPHER:
Van de Maele

CAMERA:
6 x 6cm

LENS:
180mm

EXPOSURE:
½₅₀ second at f4

LIGHTING:
Daylight only

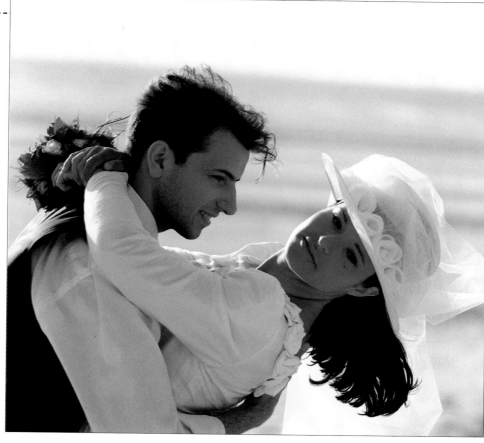

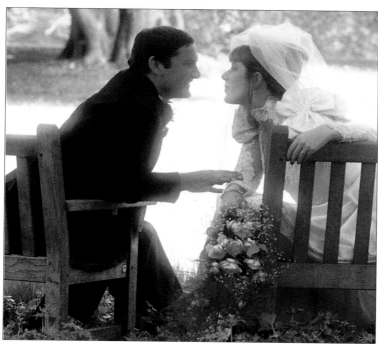

◀ Note how the shape of the figure seems to be "eaten away" as the intensely bright light of the scene beyond flares around his dark outline.

UNUSUAL SETTINGS......

Before departing radically from what is normally expected from a set of wedding pictures, in terms of their style, setting, and so on, you need to discuss the matter in detail with the couple involved in order to enlist their willing support. Although the couple featuring in these photographs opted for a traditional white wedding, they were looking for a set of pictures that stood out from the crowd – a portfolio that makes you stop and take notice.

PHOTOGRAPHER:
Jonathan Brooks

CAMERA:
6 x 7cm

LENS:
80mm

EXPOSURE:
¹⁄₆₀ second at f22

LIGHTING:
Daylight only

▶ The poses of both the bride and groom here have been carefully thought through by the photographer. The train of the bride's dress has been arranged so that it creates a repeating scalloped-edge effect as it meets each step, and her arm and hand emphasize the diagonal thrust of the railing. Again, the strong feeling of movement evident in the picture has been further rein-forced by the shape of the groom's body, which echoes the diagonal lines in the frame.

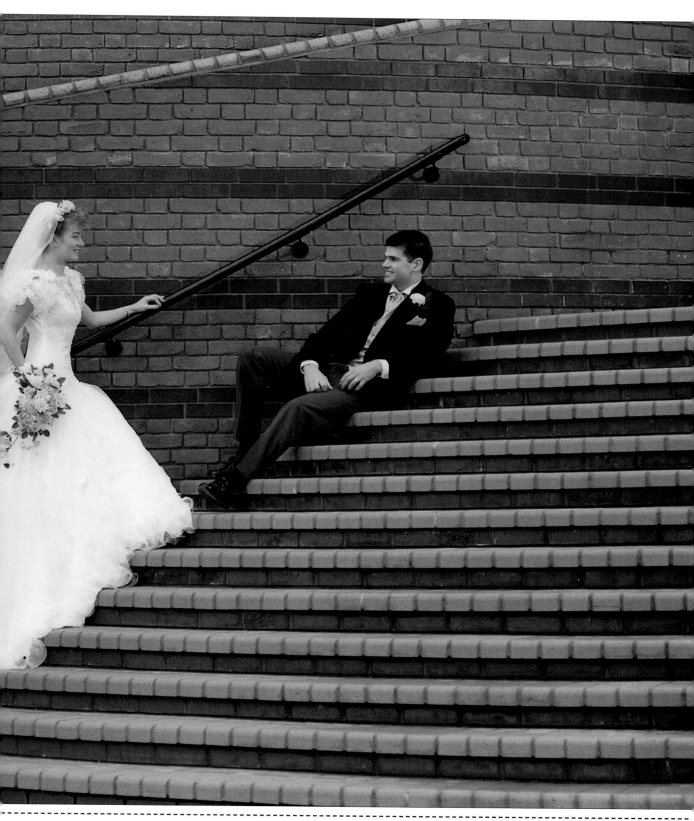

PHOTOGRAPHER:
Jonathan Brooks

CAMERA:
6 x 7cm

LENS:
120mm

EXPOSURE:
¹⁄₃₀ second at f11

LIGHTING:
Daylight only

▶ *The industrial canal-side setting for this picture has been used to excellent advantage by the photographer, creating a most unusual image – one that is full of interesting shapes and textures. His use of reflections helps to tonally lift the foreground as well, which helps prevent the reddish-brown colour of the brickwork dominating the scene.*

▲ *It is possible to introduce a strong sense of movement into a picture, even though the subjects are completely still. In the canal-side photograph, note how the photographer has framed the couple toward one edge of the frame. This makes it a very active composition and introduces a degree of tension. If they had been centre frame, the whole feel of the picture would be very different. In both pictures you can also see the use that the photographer has made of diagonal lines. Including these immediately add vitality to the imagery, implying strong movement, and drawing the eye through the scene.*

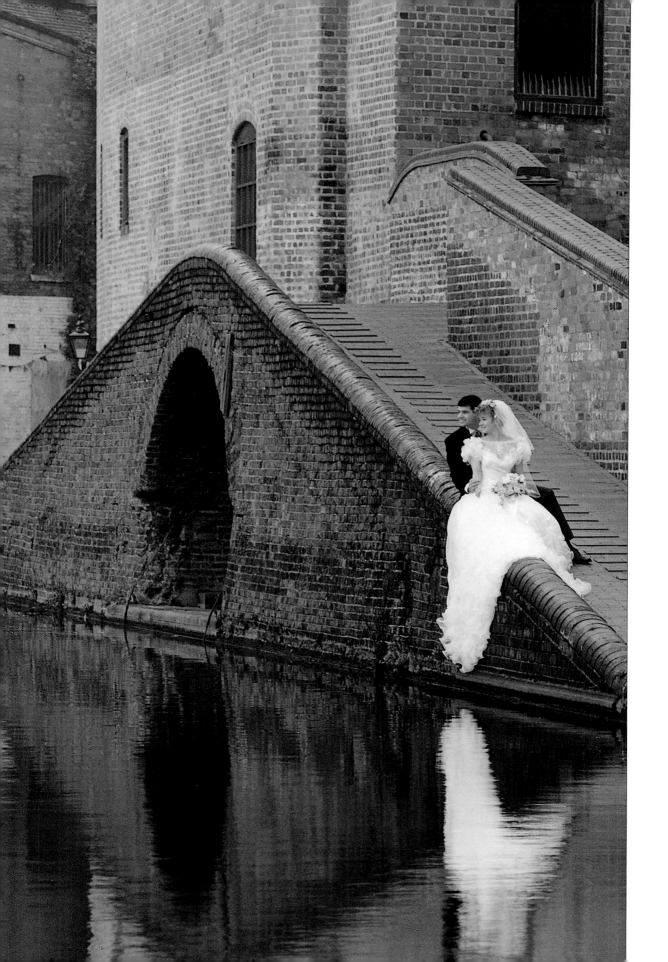

SELECTING IMAGES

There aren't many rules in photography that can't be broken, but one of the golden rules of wedding photography is that you should always shoot more film than you think you could possibly need. It is true that buying film stock and then developing and printing can work out to be expensive, but you need to bear in mind that to the participants, and their immediate families, a wedding is one of the most important occasions of their lives. It is a one-off event, and you get only one chance at taking the pictures.

If you are a friend of the family and have been asked formally to take the pictures at the wedding, or if you are a professional photographer working on a commission basis, explain that it is better to have more pictures than you will eventually want enlarged so that the completed wedding portfolio contains only the very best work. In the context of the entire wedding expense, most people will not want to skimp on this aspect.

▶ *Sheets of images printed the same size as medium-format negatives are large enough to see clearly and make decisions about which should be enlarged. Images from 35mm negatives may be a little too small, however, and it is best to order enlarged contact sheets. Don't worry if the colour balance of each image is not perfect – this can be corrected when the negatives are individually printed.*

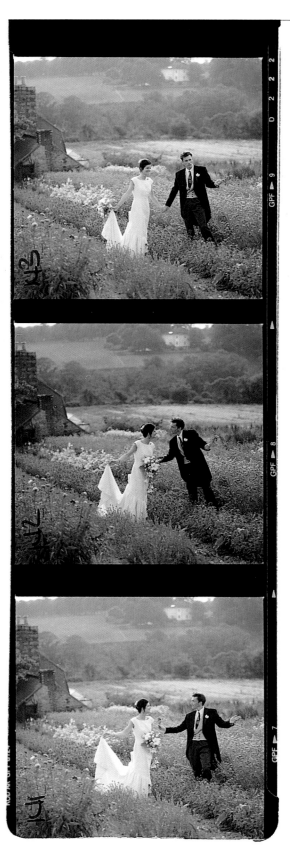
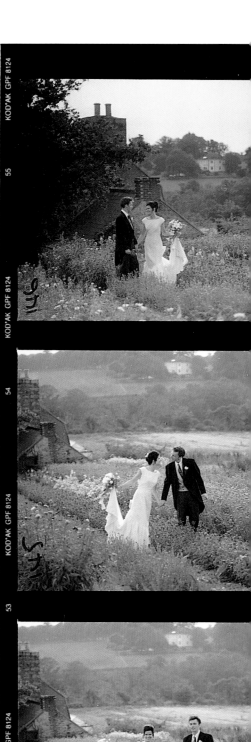
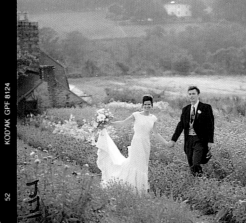

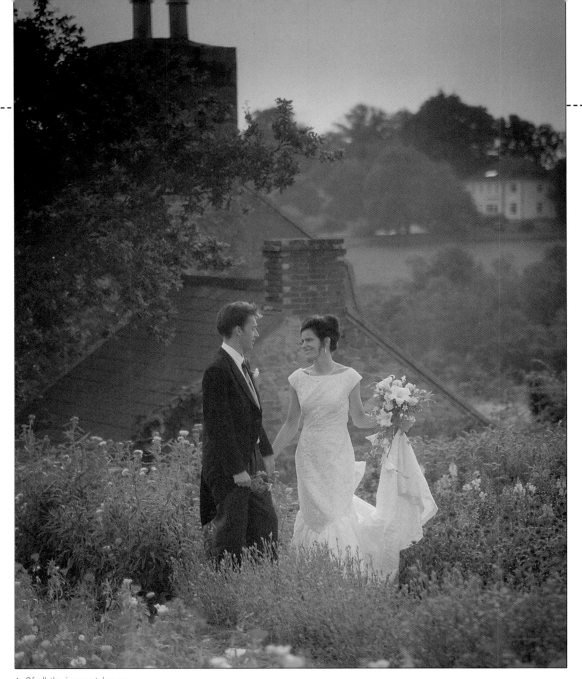

▲ Of all the images taken on this photographic session, conducted a few days before the wedding, this is the only one that managed to capture the romantic rosy quality of the afternoon sunlight. The carpet of wild flowers also makes a fitting foreground and background for the couple.

PHOTOGRAPHER:
Peter Trenchard

CAMERA:
35mm

LENS:
28-70mm zoom

EXPOSURE:
⅛₂₅ second at f11

LIGHTING:
Daylight only

EXPOSURE:
⅛₀ second at f11

LIGHTING:
Daylight only

▶ This image was selected because it is the one that shows the groom in the most relaxed posture. In others from that set, his back appears unnaturally stiff or his hands are held uncomfortably. Unless you take lots of nearly identical images, you may have to enlarge less-than-perfect shots.

▶ *This image is the best example of facial expressions and pose. The exposure, too, is better than in the others of this set, some of which are just a little overexposed. Slight underexposure tends to make colours look richer and can create quite dramatic lighting effects.*

EXPOSURE:
¹⁄₂₅₀ second at f11

LIGHTING:
Daylight only

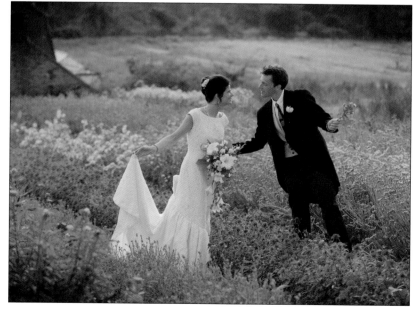

FLASH AND DAYLIGHT

The extreme portability of accessory flash units (as opposed to studio flash) has made them an indispensable tool for any photographer today who is involved in location and non-studio work. The most obvious use of flash for wedding photographers is indoors – in the church, registry office, or other building where the ceremony is taking place – where light levels will probably be low unless subjects are positioned in the immediate vicinity of any windows.

When used indoors, as the sole or predominant light source, the effective range of flash, as quoted by the manufacturers, assumes that there are likely to be walls, a ceiling, and other reflective surfaces to contain the light and reflect it back onto the subjects.

Another popular use for accessory flash is outdoors where, instead of being the main light source, it is used to supplement natural daylight. Flash produces a burst of light that has, as far as the film is concerned, the same colour content as daylight, and so colour casts are not a problem. On many occasions, wedding photographers will be confronted with dull and overcast daylight, and pictures taken straight will be lacking in contrast and appear flat. Under these conditions, flash can be used to boost light levels locally, adding a bit of sparkle in order to give the impression of a sunnier day.

At the opposite lighting extreme, when daylight is very contrasty, with dense shadows and intense highlights adjacent to each other, flash can be used to lighten localized shadows to varying degrees and so preserve some subject detail there that would otherwise be completely lost.

Suppressing a background

Although flash used outdoors is very limited in range, it can have a dramatic effect on overall exposure. By positioning your subjects close to the flash source you can add enough local light to allow a shutter speed/aperture combination that underexposes the surroundings. For example, an ordinary light reading for your subjects and their surroundings may suggest an aperture of f5.6 and a shutter speed of $\frac{1}{25}$ second. By adding flash light into the calculation, the new settings for the subjects alone could be f16 or f22 at $\frac{1}{25}$ second. By using these settings to take the picture, there would be a two- to three-stop difference between the subjects and their surroundings.

PHOTOGRAPHER:
Richard Wilkinson

CAMERA:
35mm

LENS:
90mm

EXPOSURE:
$\frac{1}{25}$ second at f8

LIGHTING:
Daylight supplemented by flash

▶ *Flash was used here to exploit the exposure difference that already existed between the groom and the shadowy forest behind. The flash was carefully positioned so that its light reached only the subject, thus creating about a 3½-stop difference between him and the background.*

Hints and tips

● To isolate your subjects from their setting using flash, make sure that there is a sufficiently wide separation between the two to prevent light spilling over and illuminating anything other than the subjects themselves.

● If the surroundings are slightly shadowy to begin with, then using flash to illuminate the subjects alone can have an even more dramatic effect.

● Dedicated flash units – those designed to be used in conjunction only with a specific camera, or a range of cameras from the same manufacturer – measure the total amount of light reaching the film, and so ensure a high rate of successful exposures when mixing daylight and flash in the same shot.

PHOTOGRAPHER:
Nigel Harper

CAMERA:
6 x 7cm

LENS:
120mm

EXPOSURE:
⅟₆₀ second at f4

LIGHTING:
Daylight supplemented by flash

▶ *The bride and groom in this photograph were so far away from their background surroundings that the position of the flash was not that critical, although a large aperture was required to limit depth of field – the zone of sharp detail surrounding the point focused on.*

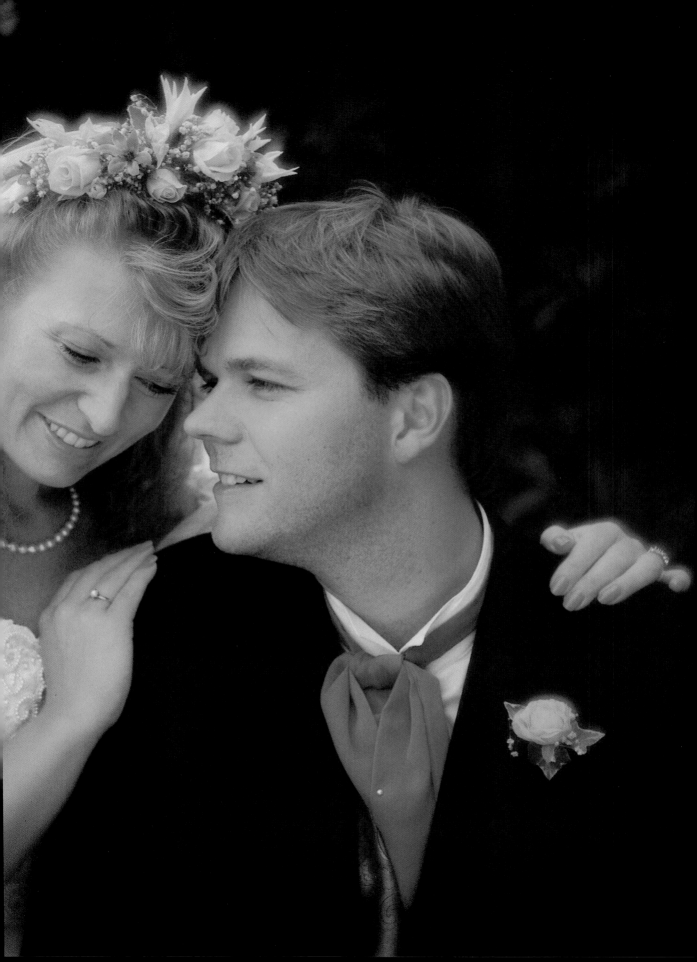

▲ Window light, diffused by translucent curtains, is the principal light source here. The photographer took an exposure reading from the shadowy side of the subject to ensure that the image was light and bright.

PHOTOGRAPHER:
Gary Italiaander

CAMERA:
35mm

LENS:
70mm

EXPOSURE:
¹⁄₁₂₅ second at f4

LIGHTING:
Daylight only

HIGH-KEY PORTRAITS

One extremely effective way of creating an appropriate type of atmosphere in a bridal picture is to emphasize the lighter tones or colours of the subject, thus creating what is known as a high-key portrait. A "normal" subject is made up of a mixture of light and dark tones or colours, and an average exposure reading will endeavour to accommodate both. However, by selectively metering, or by using your camera's exposure-override facility, you can alter the picture's balance to suit your requirements.

We all associate particular colours with certain moods. Yellows and reds, for example denote heat and passion, white is for purity, and blues and greens are considered cool, reserved colours. With black and white images, predominantly dark-toned photographs are often associated with enclosed and menacing feelings, while mainly light-toned ones can seem open, airy, and full of space.

To take a high-key portrait with an averaging exposure meter, first take the reading as you would normally and then set the camera controls to give about an extra stop's exposure – either open the aperture by one f stop (from f8 to f5.6, say) or use the next slower shutter speed (1/125 instead of 1/250 second, for example). If you can take a selective exposure reading, perhaps by using a spot meter, fill the meter's sensor area with a darker-than-average colour or tone. This way, the meter will recommend or set the aperture and shutter speed you require to produce a predominantly light-toned image.

▲ Here the photographer used flash and high levels of domestic tungsten lighting to produce a high-key image. The only solidly dark tone is the bride's hair, all others being either white or light grey. Black and white film does not respond adversely to the colour components of different light sources, and so flash and tungsten can be mixed in the same photograph.

PHOTOGRAPHER:
Hugh Nicholas

CAMERA:
35mm

LENS:
55mm

EXPOSURE:
1/60 second at f8

LIGHTING:
Flash and tungsten

PERSPECTIVE

Perspective in photography is represented by the visual indicators that give the flat, two-dimensional print the appearance of having the third dimension – that of depth and distance. There are many different indicators of perspective, and the two main ones present in this photograph are linear perspective and diminishing scale. In linear perspective, lines appear to converge as they grow further from the camera, something that is very obvious when you look at the trees bordering both sides of the path. Diminishing scale is an indicator of depth and distance because we know from experience that objects appear to become smaller the further away they are – again evident in the steadily diminishing size of the tree trunks. Once you are aware of things such as perspective in photography, you can start using them to create more powerful compositions.

PHOTOGRAPHER:
Nigel Harper

CAMERA:
35mm

LENS:
70mm

EXPOSURE:
½₅₀ second at f8

LIGHTING:
Daylight only

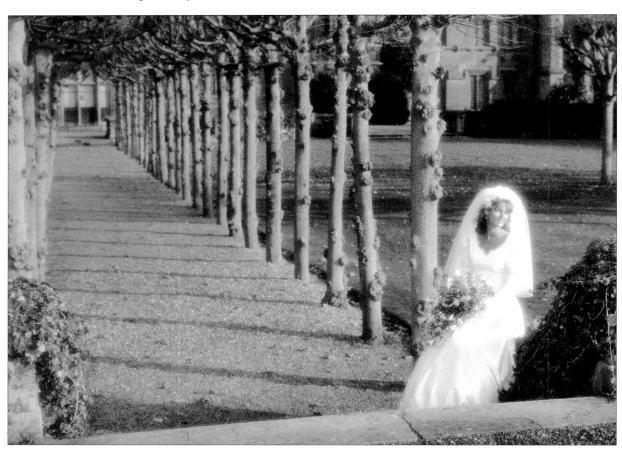

▲ In this version of the photograph, linear perspective and diminishing scale are tending to work against the composition. Your eye alights on the path and is drawn along it away from the bride, who is the main subject, even though she is tonally very different to the rest of the picture.

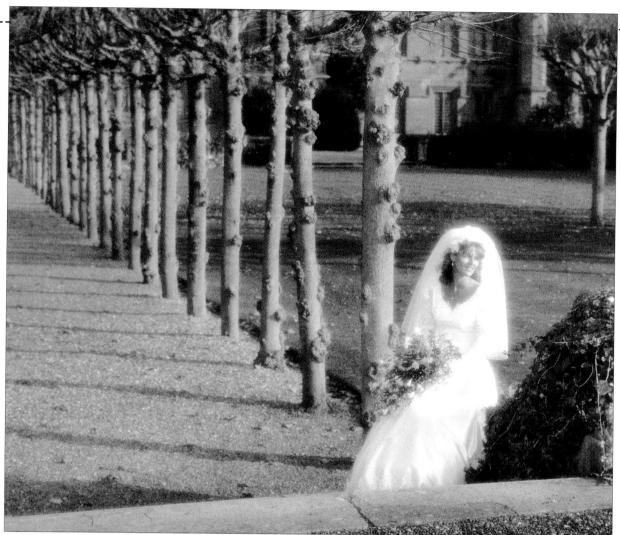

▲ In this second version, a portion of the left-hand side of the image has been cropped off during printing. At once you can see that perspective now works in favour of the composition. Instead of your eye being drawn away from the subject, as in the full-frame image, it travels from the background of the picture to the front, and comes to rest on the bride.

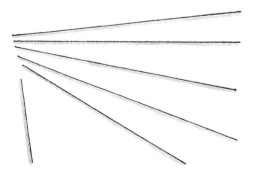

Linear perspective

Diminishing scale

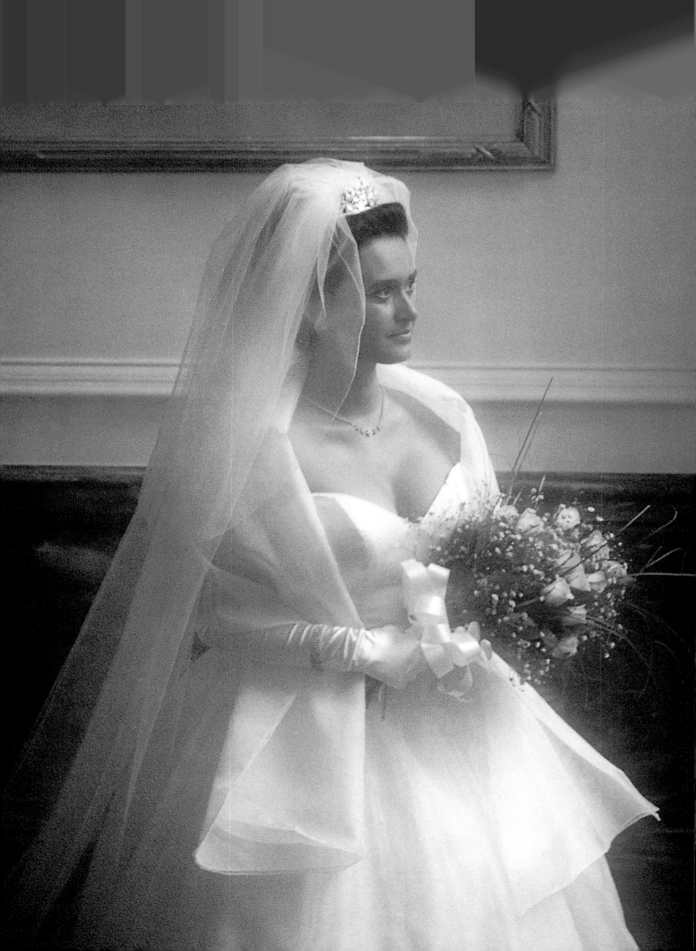

SOFT-FOCUS EFFECTS

Of the huge range of special-effects lens filters available, most intrude on the image so heavily that their use is strictly limited. One of the few generally usable special-effects filters is a diffusion filter, which is designed to soften the photographic image a little to give a slightly dream-like quality to the picture.

Diffusion, or soft-focus, filters work in one of two ways. One type has a series of concentric circles engraved on the glass of the filter. Light passing through the glass is slightly scattered, which causes details to be recorded as less sharp and for highlights to smear. The second type of diffusion filter has a slightly obscure, milky appearance, and is often referred to as a fog filter. When light passes through this type of filter, it is again scattered and the darker tones tend to become grey in colour rather than black.

◀ A fog filter was used when taking this bride's portrait in the lobby of the reception venue. The effect of the filter is to spread the highlights, such as the light reflecting from her gown, and to mute the impact of the shadows.

PHOTOGRAPHER:
Gary Italiaander

CAMERA:
6 x 7cm

LENS:
80mm

EXPOSURE:
⅟₆₀ second at f5.6

LIGHTING:
Flash only

Fog filter

Soft-focus filter

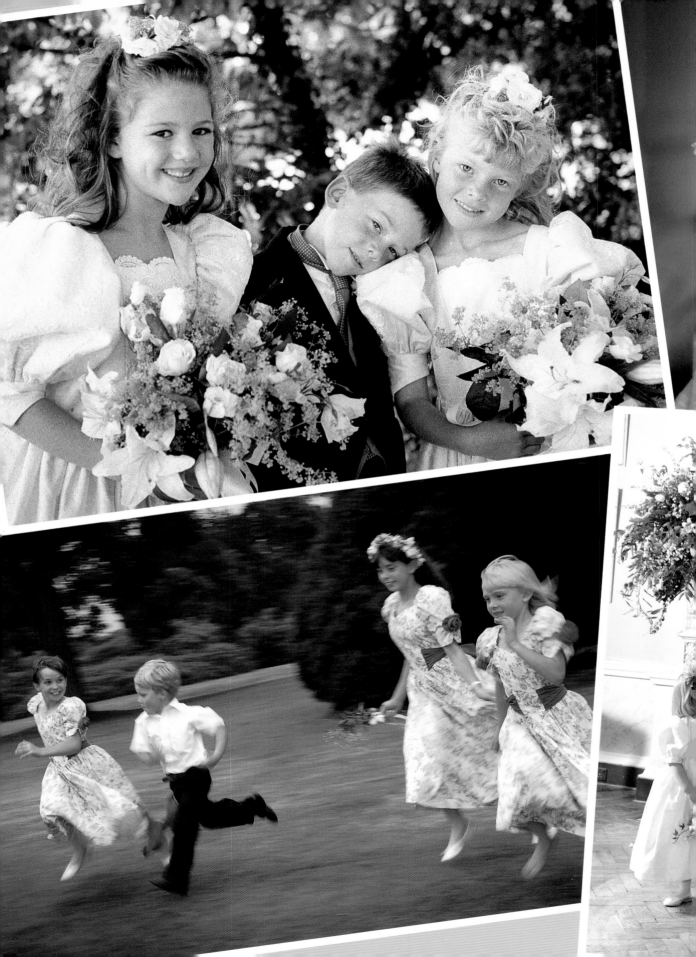

SUPPORTING CAST

RELAXED AND INFORMAL

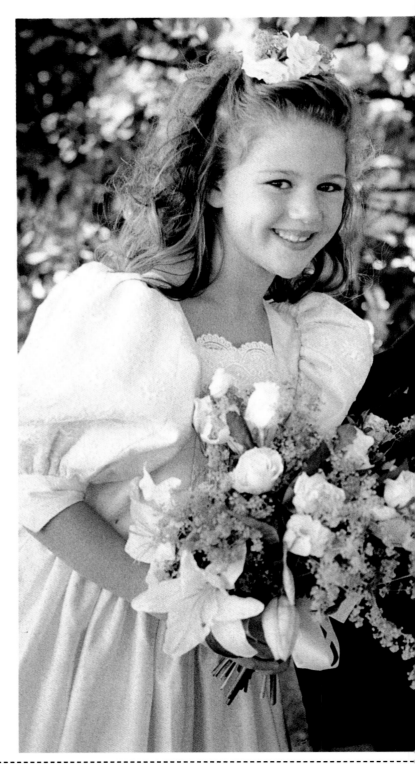

Don't fall into the way of thinking that a group portrait needs to be somehow rigid and unrelaxed, with the subjects posed in a very formal type of way. Better informal pictures often result when you leave it to the subjects to organize themselves in a way that feels most comfortable for them. Obviously, this approach is not practical when you are dealing with a large group shot of wedding guests, since chaos may ensue. But for the three young stars of this portrait, all that was needed was the usual photographer's instruction to smile and look at the camera just before releasing the shutter.

Children tend to be a little unpredictable in front of the camera; you are never sure whether they are going to stand there wooden-like and unmoving or play up to the lens in some outrageous manner. These three were old enough, however, to realize the importance of the occasion and were mindful of the job they, and the photographer, had to do.

PHOTOGRAPHER:
Nigel Harper

CAMERA:
35mm

LENS:
135mm

EXPOSURE:
1/500 second at f4

LIGHTING:
Daylight only

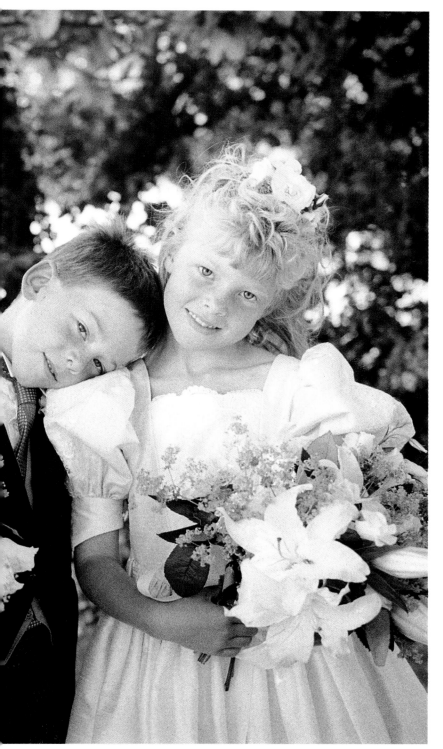

◀ The original of this photograph was taken on black and white film stock. After the print was processed, it was bleached to remove some of the black silver image, and the print was then treated with special toning chemicals to produce an old-fashioned sepia colour. This gives the image a "period" feel, which is in keeping with the style of the bridesmaids' dresses and the pageboy's wing collar, tie, and tails.

Hints and tips

● If you are worried that the background to a picture may be too intrusive and compete for attention, try selecting a large lens aperture. The larger the lens aperture, the more likely it is that the background will appear soft and out of focus in the resulting print.

● If you choose a large lens aperture to show the background out of focus, make sure that you pose your subjects a long way in front of it. If they are too close to the background, both may appear sharp.

● When you use a large lens aperture, you often need a fast shutter speed to compensate for the extra light entering the camera and reaching the film. Most camera's today have exposure systems that can automatically cope with this type of situation, but you may have to select "aperture-priority" mode first.

PRETTY IN PINK

When there is a great discrepancy in height between the subjects of your photograph, you need to devise some way of getting everybody comfortably in the frame without moving back so far that you miss out on all the rich detail the scene may have to offer. One way to achieve this is to elevate the smallest member of the group, here the young bridesmaid, so that her head is about on the same level as everybody else's in the group. Outdoors, you could do this by sitting her on a wall, for example, or the back of a chair or sofa indoors, and then have the others arranged around her. Or, alternatively, you can bring everybody else down to the height of the smallest member of the group. The trick is to carry this off in such a way that the group still looks relaxed and not too obviously posed.

A bedroom was chosen for the setting of this shot because it allowed the best arrangement of the people concerned in the most appropriate setting. The bride's gown is unfussy with classically clean lines, and the bridesmaids' outfits, too, are uncluttered in simple pink and white stripes. The floral-printed fabrics and furnishings in the room, therefore, represent no clash, especially since a widish lens aperture was selected to ensure that not all the pattern in the room was too sharply focused.

▲ *A flash unit pointing at a neutral-coloured wall or ceiling (to avoid a colour cast) returns a soft light, which often is a more flattering illumination than using direct flash.*

PHOTOGRAPHER:
Desi Fontaine

CAMERA:
6 x 6cm

LENS:
80mm

EXPOSURE:
1/60 second at f4

LIGHTING:
Daylight supplemented by bounced flash

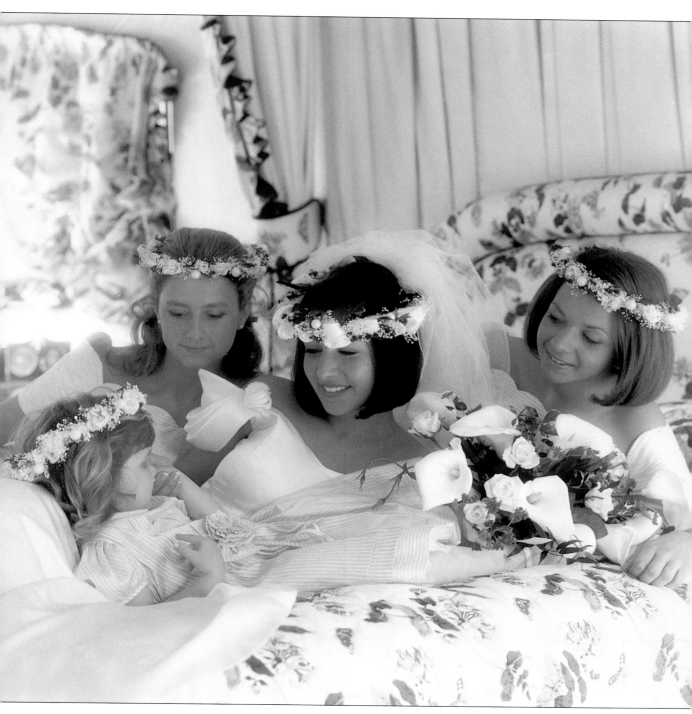

▲ There was a slight danger here that because the young bridesmaid was so small, the floral print of the bedcovers may have been a little overpowering. To prevent this, the photographer posed the little girl against the white material of the bride's dress and carried a fold of the same material under the girl's upper body to give a plain background.

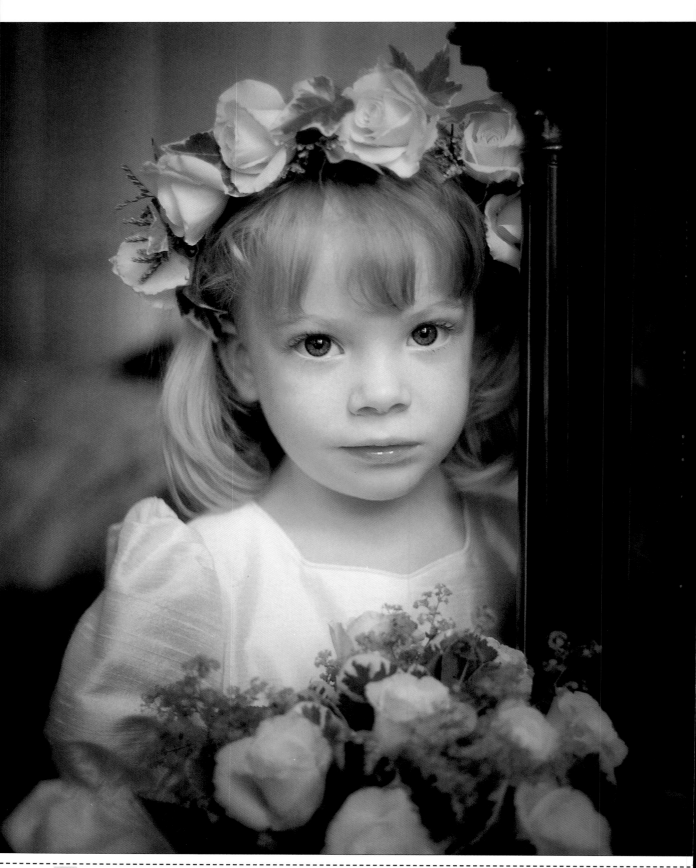

MANIPULATING DEPTH OF FIELD

You can draw added attention to the subject of your photograph by ensuring that he or she is the only element in the frame that is in sharp focus. It is not always desirable to be able to see clearly every detail from the immediate foreground to the far distance, unless these details are making a worthwhile and positive contribution to the photograph as a whole. Indeed, backgrounds and foregrounds are sometimes distracting, and so it is useful to have some way of minimizing their impact as far as possible.

In the example here, the young bridesmaid's face is pin sharp, whereas the foreground flowers are slightly out of focus, and the background to the room has merged into a single, generalized tone. Every time you focus a lens there is a zone extending both in front of and behind that point of focus that is also acceptably sharp. This zone is known as the "depth of field". It is not a static zone, however, and varies in extent depending on the focal length of the lens and the lens aperture used. Wide-angle lenses have a greater depth of field at any given aperture than do standard or telephoto lenses, and small lens apertures produce a greater depth of field than large ones.

◀ *When depth of field is shallow, as here, it is vital that the subject's face is critically sharp. If you are in any doubt about where to focus, it is best to choose the eyes – if these are only slightly out of focus, the picture will be unacceptable.*

PHOTOGRAPHER:
Nigel Harper

CAMERA:
35mm

LENS:
135mm

EXPOSURE:
⅟₆₀ second at f2.8

LIGHTING:
Daylight supplemented by flash

f2.8 f8 f22

▲ *You need to bear in mind that small f numbers, such as f2.8, equal large lens apertures, while large ones, such as f22, equal small lens apertures. Moving the lens aperture one full f number either halves or doubles the amount of light reaching the film. You can compensate for this by selecting the next shutter speed, which either doubles or halves the length of time the light acts on the film.*

IS THAT THE TIME?

The time spent outside the wedding venue awaiting the bride's arrival can become tense. The usual doubts flash through your mind: Why is she so late? Do you think she's coming? Is that the time? Try to capitalize on this by enlisting the help of the groom and his friends to produce a light-hearted portrait. Obviously, you can't rely on this approach for the bulk of the wedding portfolio, but a shot like the one shown here may make a welcome change of mood when seen in the context of all the more orthodox pictures taken on the day.

▶ *The success of a humorous picture such as this depends on the facial expressions of everybody in the shot and the clarity with which they can be seen. Therefore, either move in close with the camera if you are using a standard lens, or shoot from further back using a telephoto, to bring the faces up as large as possible in the frame. Take two or three versions of the group in quick succession and choose the one with the best expressions afterwards.*

▲ *The danger when taking the type of shot illustrated here is that the faces of the people in group will appear in shadow and their expressions will not be clear, which would make a nonsense of the picture. To prevent this, you can use flash to supplement the existing daylight, or position reflectors low down on either side of the group to reflect some light upward into their faces.*

PHOTOGRAPHER:
Peter Trenchard

CAMERA:
6 x 6cm

LENS:
120mm

EXPOSURE:
½₅₀ second at f11

LIGHTING:
Daylight supplemented by reflectors

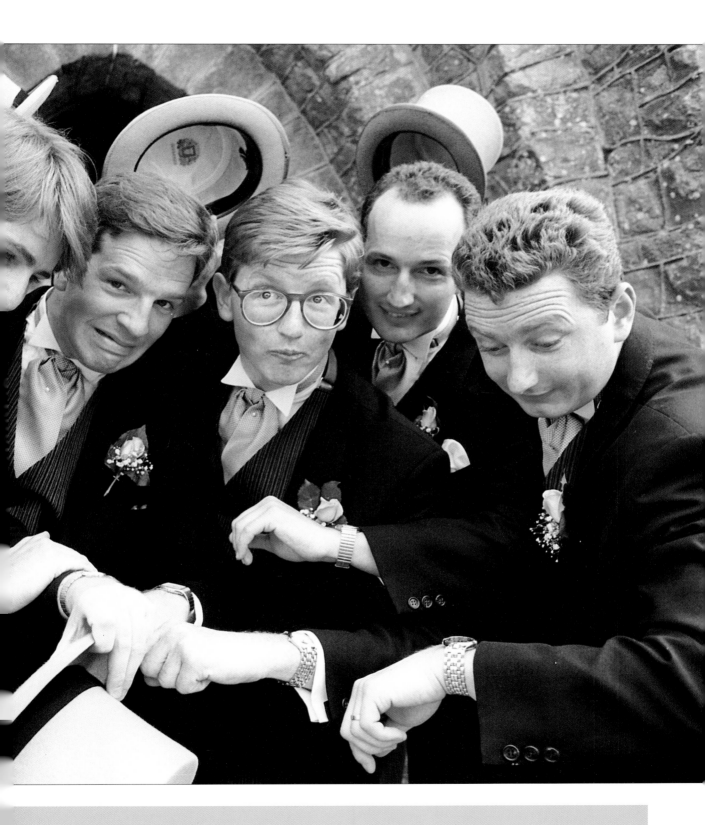

CARE WITH BACKGROUNDS

I t is all too easy when photographing
a wedding to concentrate so intently
on the subjects that you fail to notice
that the background to the shot is not
particularly strong – or, even worse, is
actually distracting. The best way to
avoid this happening is to discipline
yourself to look at all of the frame
before pressing the shutter release.

This charming and informal portrait
of the bride and her very young brides-
maid benefits from a well-conceived
setting. The light for the shot is coming
from one side only, through large win-
dows out of shot on the left of the
frame. The subjects are far enough into
the room, however, for contrast not to
be a problem. If they had been stand-
ing any closer to the window, the sides
of the subjects closer to the light
would have been too bright in compar-
ison with their shadowy sides, making
a single overall exposure for the picture
less satisfactory.

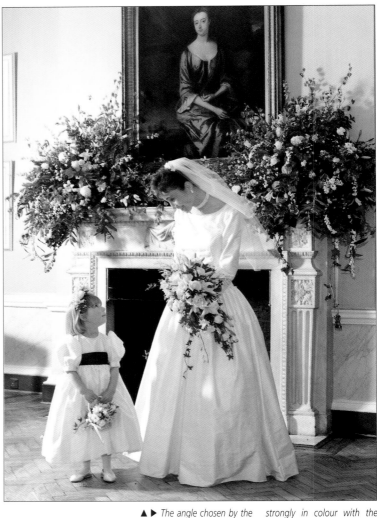

PHOTOGRAPHER:
Philip Durell

CAMERA:
35mm

LENS:
80mm

EXPOSURE:
⅙₀ second at f8

LIGHTING:
Daylight only

▲ ▶ The angle chosen by the
photographer was determined
by the need to show the
bride's head in the relatively
clear area between the two
floral displays above the fire-
place. In the full-frame image
(see above), the flowers act as
a type of frame, contrasting
strongly in colour with the
bride's headdress and visually
distancing her from the back-
ground. In the cropped version
(see right), the composition
has been further strengthened
by omitting the picture above
the fireplace and some of the
room details at the sides.

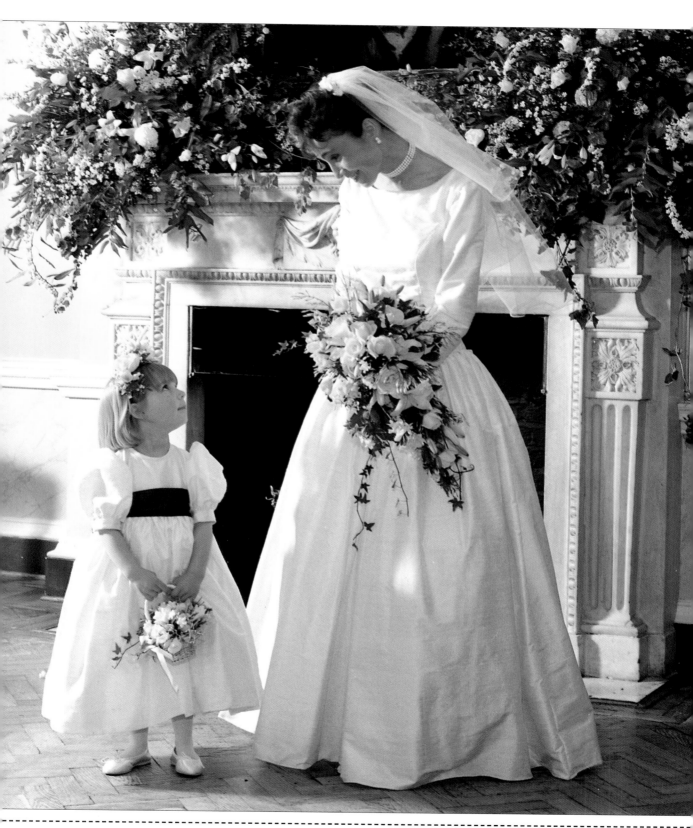

THINKING ABOUT EXPOSURE

The most frequently occurring colour at Western-style weddings is white: the most favoured time of year for weddings ceremonies is when the sun is most likely to be shining. Put these two factors together and you have a potential exposure problem. Strong sunlight reflecting back from white clothing could be so bright that the camera's exposure system will set a shutter speed/aperture combination that underexposes skin tones. You can override the camera's automatics and manually set an exposure to favour the subjects' skin tones (which would mean setting either a wider lens aperture or a slower shutter speed), but then the bride's and bridesmaids' white gowns, or anybody else's light-coloured clothing, may appear overexposed and glaringly bright – a totally unsatisfactory result. The solution to this problem is to pose your subjects where the exposure difference between different parts of the scene is only one or two lens f numbers (also known as f stops).

◀ *Where the light falls directly on the young bridesmaid's dress, all surface information has been bleached out. In the darker part of the frame, however, the folds of the dress are shown as a mixture of light and shade, and you can almost feel the satiny quality of the material.*

◀ *The white clothing of these young supporting players at the wedding ceremony would have caused impossible exposure problems if they had been posed in the bright sunlight you can just see outside the colonnade. Here, in the shadows, the photographer has found the perfect balance of exposure to give good, clean whites and well-rendered skin tones.*

PHOTOGRAPHER:
Philip Durell

CAMERA:
35mm

LENS:
135mm

EXPOSURE:
⅟₆₀ second at f8

LIGHTING:
Daylight only

What are exposure f numbers?

The figures engraved on the lens aperture ring are known as f numbers, or f stops. Every Time you select an f number one stop higher (f8 to f11, for example) you decrease the size of the lens aperture and halve the amount of light entering the camera. Selecting an f number one stop lower (say, f5.6 to f4) increases the size of the lens aperture and doubles the amount of light entering the camera.

Lens aperture ring and typical range of f numbers

YOUTHFUL HIGH SPIRITS

The younger members of the supporting cast of players are going to want to let of steam at some point during the wedding day. The weather at the point of the celebrations when the picture here was taken was a little dull and overcast, and so a static group portrait might have been less than sparkling. In any event, the kids were obviously bursting with energy and so the photographer encouraged them to participate in a high-spirited sprint across the lawn.

PHOTOGRAPHER:
Nigel Harper

CAMERA:
35mm

LENS:
105mm

EXPOSURE:
1/30 second at f8

LIGHTING:
Daylight only

▶ *The panning technique used for this photograph of the bridesmaids and page boy letting off steam away from the adults at the reception has produced a picture full of energy, action, and fun.*

PANNING

To produce a panned picture, you have to move the camera to keep the subject in the frame while the camera's shutter is open and the film is being exposed. The slower the shutter speed and the faster you move the camera to keep up with the action, the more blurred all stationary parts of the scene become.

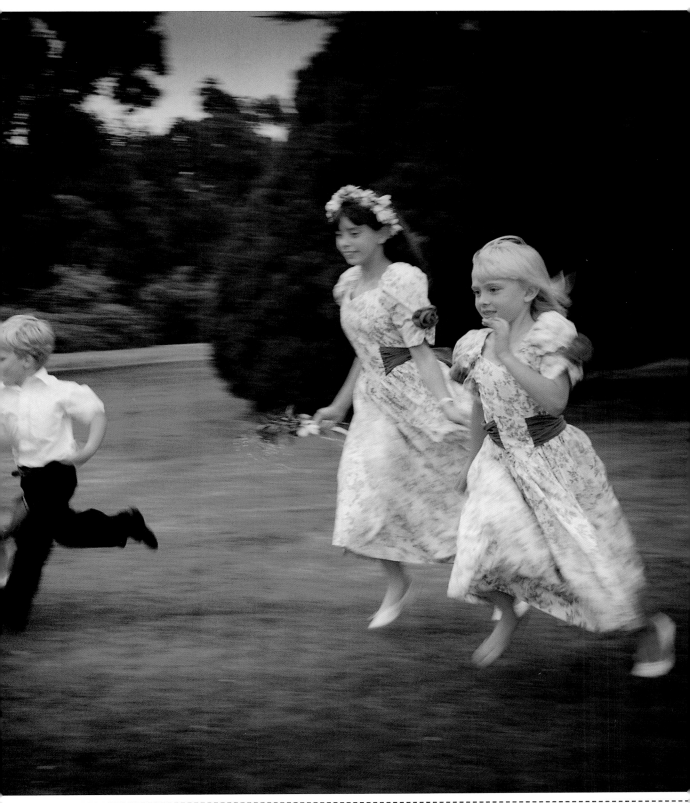

THE
CEREMONY

CAPTURING THE MOMENT

There is always an element of luck involved in being at the right place at the right moment with your camera loaded with film and ready to shoot. But as your experience as a wedding photographer increases, so will you be better able to anticipate where you ought to be, and when.

As the expected time of the bride's arrival draws near, it is a good idea to stay in the vicinity of the groom and his best man or the ushers. It is human nature for them to want to stay outside for as long as possible, timing their entry into the church, registry office, or wherever the ceremony is being held just before the bride's car comes into view. As the tension mounts you should be able to record a few good frames of those anxious last few minutes.

At this time of the proceedings, everybody's attention will be firmly fixed on the bride's arrival, and so you should be able to move about quite freely without drawing attention to yourself, picking off some unposed, candid shots.

PHOTOGRAPHER:
Nigel Harper

CAMERA:
6 x 7cm

LENS:
120mm

EXPOSURE:
½₅₀ second at f8

LIGHTING:
Daylight only

◀ *When this photograph was taken, the bride was already running a little late in arriving at the church. The photographer could sense the tension beginning to build in the ushers, who were still standing outside. Waiting for just the right moment to shoot, he released the shutter as soon as he saw one of the ushers lift his hand to shade his eyes as he strained to catch the first sight of the bride's car. Although this is only a small gesture, it makes a world of difference to the impact of the final photograph.*

ARRIVING AND DEPARTING

Many couples put a lot of thought, and often a considerable amount of money, into how they get to, or depart from, the wedding ceremony. It may help if you think of the whole wedding day, and the activity leading up to it, as a piece of theatre: the participants attend rehearsals, dress up in extravagant costumes, and make their entrances and exits all according to prearranged cues and signals. Everything is designed to leave a happy and memorable impression on the audience.

As part of this theatrical performance, many couples opt for an unusual mode of transport, such as a vintage car or horse-drawn carriage. As part of the shot-list agreed on before the wedding day, the photographer should be briefed to expect something like this so that he or she can be prepared – additional time may be required, for example, or the photographer might want to use a lens not normally required for wedding coverage, or may want to use a special lighting set-up or some non-standard effects filters. The more the photographer knows in advance, the better the resulting photographs are likely to be.

Some photographic studios, ones that specialize in weddings, are able to provide clients with a package that includes the transport to and from the ceremony. If you are interested in this type of deal, you may be able to choose from a range of unusual or vintage cars, motor bikes, horse- or pony-drawn carriages, and so on. If you decide on, say, a vintage car or old-fashioned horse and carriage, you may decide to carry this theme through with a period-style bridal gown and bridesmaids' outfits. The groom and best man could also join in the performance by buying or hiring suits of the appropriate period.

◀ *This couple's choice of transport from the church to the reception was a collector's car dating from the 1950s – huge, with white-wall tyres and masses of chromework. In keeping with the American theme established by the car, the groom is sporting a 10-gallon western-style hat.*

PHOTOGRAPHER:
Desi Fontaine

CAMERA:
6 x 6cm

LENS:
80mm

EXPOSURE:
$\frac{1}{250}$ second at f11

LIGHTING:
Daylight only

▲ ◄ *Because a horse and carriage is such a romantic mode of transport, try to organize as many photo opportunities as possible. In the first image here (see above) this camera angle was chosen because it was the best way to use the church building as a backdrop. In the other (see left) we have a less-cluttered view of the couple on their way to the reception. The use of the out-of-focus branch and foliage in front of the camera lens helps to establish the immediate foreground, and so enhances the picture's sense of depth and distance.*

PHOTOGRAPHER:
Nigel Harper

CAMERA:
35mm

LENS:
80mm

EXPOSURE:
**¹⁄₂₅ second at f16 and
¹⁄₂₅ second at f5.6**

LIGHTING:
Daylight only

▼ *The transport provided for
this wedding was a pair of
Harley Davidson motorbikes.
However, the best man could
not resist getting in on the
shot, which also features the
groom. Before taking this pic-
ture, the photographer's
foresight was rewarded when
she was able to conjure up a
chamois cloth to wipe the
worst of the rain off the
gleaming machines.*

PHOTOGRAPHER:
Desi Fontaine

CAMERA:
6 x 6cm

LENS:
120mm

EXPOSURE:
¹⁄₆₀ second at f4

LIGHTING:
**Daylight supplemented by
diffused flash**

▼ *A vintage Rolls Royce is re-garded by many as being the most appropriate of wedding-day transport. By arrangement, this Rolls was hired for a few extra hours the day before the wedding for a photographic session in the woods.*

PHOTOGRAPHER:
Richard Wilkinson

CAMERA:
6 x 7cm

LENS:
80mm

EXPOSURE:
¹⁄₆₀ second at f16

LIGHTING:
Daylight supplemented by bounced flash

▲ *A flash-synchronization cable connects the camera's shutter to the flash, which is set up facing into a silver-coloured flash umbrella. The light reaching the subject this way is much softer and more flattering than you would get from using flash pointing dir-ectly at the subject.*

Hints and tips

● When working under a heavy canopy of foliage, you need to be careful that a green colour cast is not evident on the bride's white gown. This is caused by the light filtering through the leaves before reflecting back from the subject to the camera.

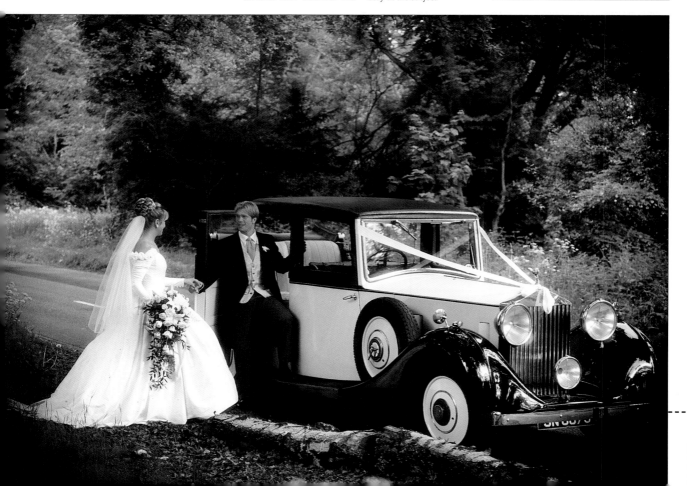

▲ A horse-drawn carriage was the inspiration for this period treatment. As you can see, the bride and bridesmaid are both in Victorian-style gowns, while the groom's top hat and tails, although modern, are little changed since those times. Even the driver, with his protective apron, look just the part. As the perfect finishing touch, some of the images were sepia toned to give them a turn-of-the-century look.

PHOTOGRAPHER:
Nigel Harper

CAMERA:
35mm

LENS:
35mm

EXPOSURE:
⅟₆₀ second at f11

LIGHTING:
Daylight only

SEPIA TONING

Sepia toning black and white prints is not difficult. Special toners can be bought at any large photographic store, or you can mix up your own chemicals consisting of a bleaching agent and toner:

Bleaching agent

Potassium ferricyanide	50g
Potassium bromide	50g

Dissolve in water to make up 500ml of solution and dilute 1:9 before using

Toner

Sodium sulphide	25g

Dissolve with water to make up 500ml of solution

Warning!

You need to take particular care when mixing and using chemicals of any description, but especially acids. Wear rubber gloves when handling all bleaching and toning chemicals and solutions, even if diluted.

READY TO GO

One of the most difficult aspects of the wedding photographer's job is being in at least two places at the same time. One of the "can't be missed" shots is illustrated here – the bride and her father have arrived for the ceremony, the bridesmaids are sorting out the train of the bridal gown before they all enter the church, and everybody is just about ready to go. At the same time, however, the photographer needs to be inside the church itself so that he can take some shots of the bride and her father walking down the aisle, while somehow being in his prearranged position to cover shots of the actual ceremony. Once the service starts, the photographer's movements are very restricted because of the potential distraction too much activity might cause.

▶ *With the bride and her entourage in the street, which can be a visually complex setting, and with many of the guests milling about, you need to find a camera angle and composition that simplifies the scene and so prevents all the other pictorial elements crowding in to the detriment of the final image.*

PHOTOGRAPHER:
Philip Durell

CAMERA:
6 x 7cm

LENS:
80mm

EXPOSURE:
⅛₂₅ second at f16

LIGHTING:
Daylight supplemented by flash

▲ *A circular or elliptical composition, as demonstrated in this illustration, creates a self-contained unit – almost a picture within a picture. The eye of the viewer travels around from figure to figure, and attention is held firmly within this area of the frame – just where the photographer wants it.*

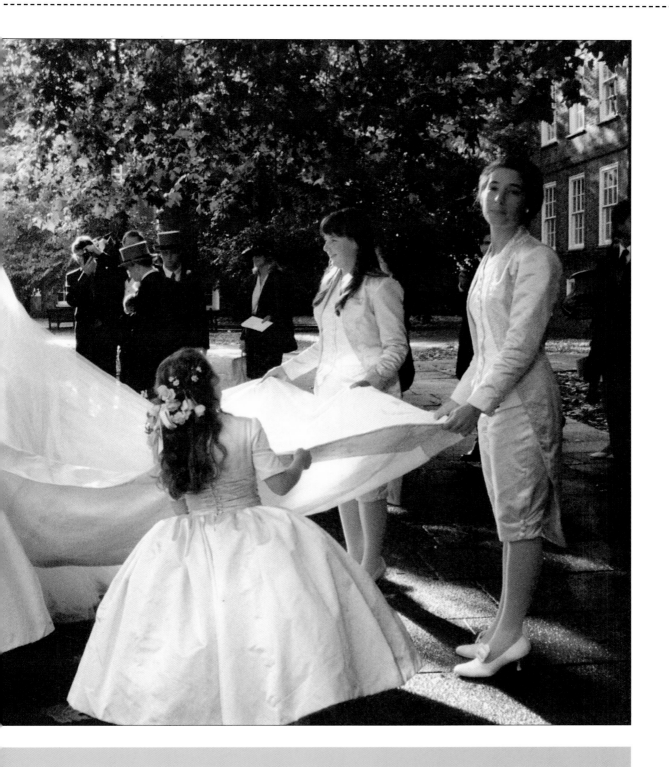

FINAL ADVICE

Photographs of the informal moments of the wedding day are sometimes more important to the couple than the traditional set-piece shots – people say that it helps them to bring back the emotions they were feeling at the time. It is impossible to know what the father opposite was really saying to his daughter as they entered the church, but it appears that he is giving her some final piece of advice – or just joking to get her to relax. What is important, however, is that every time they look at the picture, they will remember exactly how they were feeling.

PHOTOGRAPHER:
Majken Kruse

CAMERA:
35mm

LENS:
150mm

EXPOSURE:
⅛₀ second at f5.6

LIGHTING:
Daylight only

PHOTOGRAPHER:
Richard Dawkins

CAMERA:
35mm

LENS:
105mm

EXPOSURE:
⅟₆₀ second at f8

LIGHTING:
Daylight only

▼ In this church scene, it appears that it is the father of the bride who has been given some final advice. They have just entered the church and as all eyes turn toward them his daughter has whispered for him to button his jacket.

▶ Using a manual camera, with the focus and exposure set before the arrival of the bride and her father, the photographer was able to concentrate on the composition of the photograph – waiting for just the right moment to shoot.

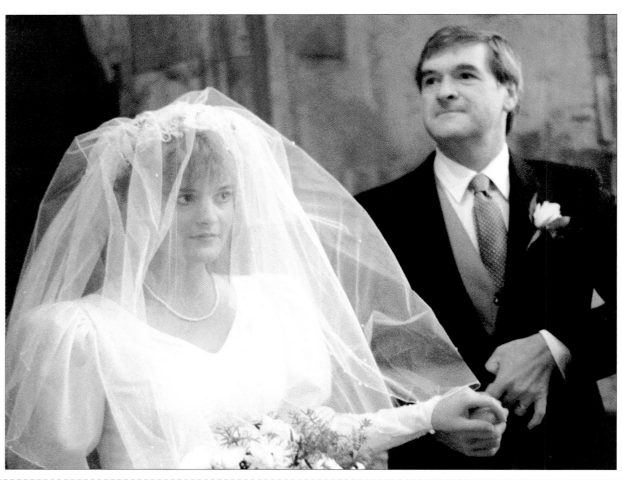

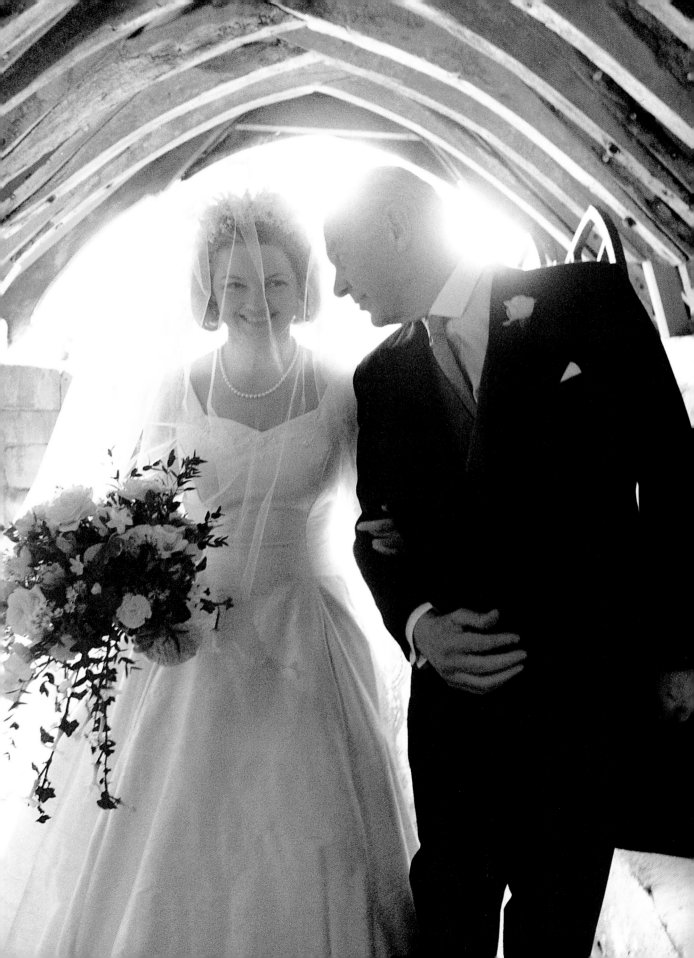

USING THE SETTING

Churches, registry offices, and other venues where wedding are celebrated are often large and sometimes austere places. Even if there is some degree of ornamentation, this can be lost in corners and niches, or high up in the roof spaces where the light does not penetrate. Where you have a church setting like the one shown here, which is not only rich in paintings, carvings, and decorative stonework but is also well lit, make the most of it.

PHOTOGRAPHER:
Philip Durell

CAMERA:
6 x 7cm

LENS:
50mm

EXPOSURE:
⅟₆₀ second at f5.6

LIGHTING:
Window light supplemented by two flash units

▶ *This glorious and highly ornate church makes the perfect setting for photographs of the couple taking their wedding vows. Natural light from windows on both sides of the church produced a good level of illumination, but this was further supplemented by light from two flashguns.*

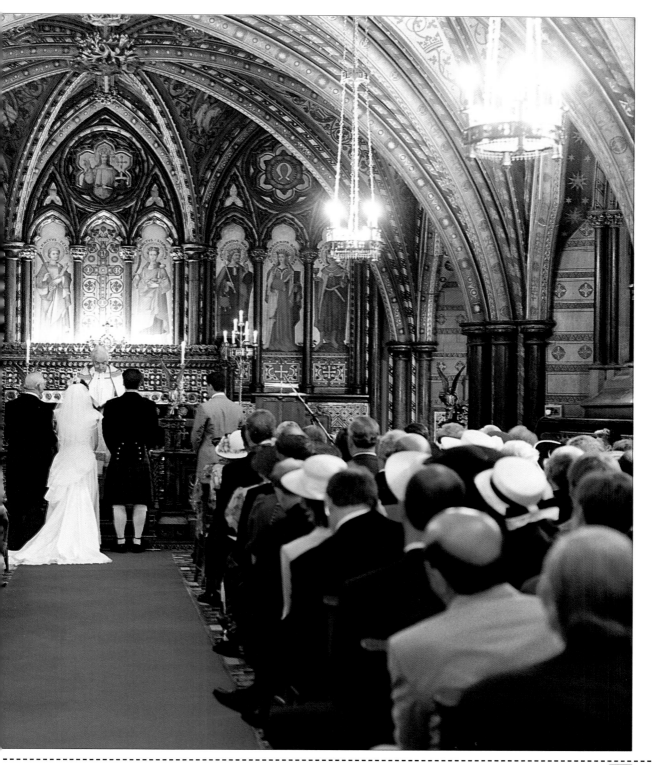

CHOICE OF FRAMING

While the wedding ceremony is being conducted, the photographer has very little opportunity to move around to find the best shooting position. Too much movement, and its associated noise, will simply be an unwanted distraction.

Before the ceremony, then, is the best time to scout out the most revealing vantage points – in terms both of what the lens actually encompasses of the scene and where the available light within the building produces the most aesthetically pleasing results. If possible, visit the church, registry office, or wherever the ceremony is to take place the day before, but at the same time of day as the wedding you will be photographing. This way, you will be able to judge exactly how the light will affect the scene on the actual day and, thus, where you should position yourself to take advantage of it. Then, once you have covered the shots outside the church and the arrival of the bride, you can go straight to your preselected camera position.

The photographic coverage of any event is usually better if there is a variety of framing, ranging from long shots through to more detailed mid-shots and close-ups. When your mobility is restricted, and you don't have the time to stop and change lenses, the best way of achieving this variety of framing is to use a zoom lens.

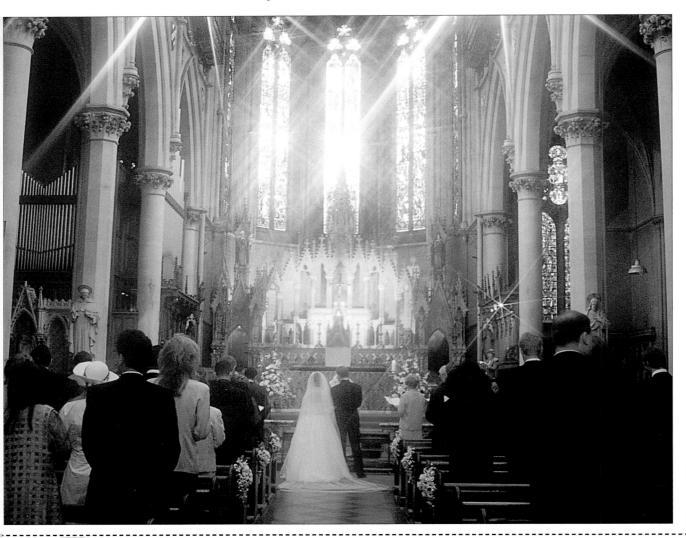

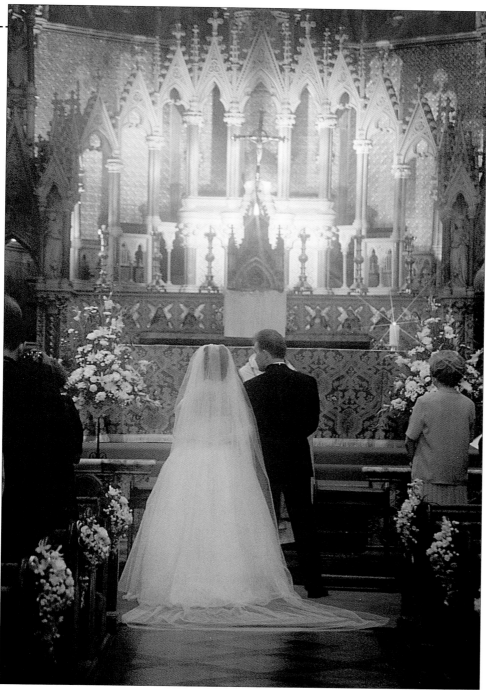

PHOTOGRAPHER:
Gary Italiaander

CAMERA:
35mm

LENS:
70-210mm zoom

EXPOSURE:
⅟₆₀ second at f16 and f5.6

LIGHTING:
Window light and tungsten

EFFECTS:
Starburst filter

▲ Starburst filters have a series of fine lines engraved on their glass surfaces designed to spread point sources of light into starburst patterns. The number and pattern of engraved lines determine the number of points the starbursts will have. A side effect of using this type of filter is that images appear quite soft overall. Starbursts are more prominent at small lens apertures. You can see in the closer shot (see left), that the photographer has opened up the lens aperture to compensate for the loss of some window light as he zoomed the lens in tighter. As a result, the starburst coming from the candle to the right of the couple is not as obvious.

◄▲ The advantage of using a zoom lens to alter the framing of your shots can be seen in these two pictures. Both were taken from the same camera position at the back of the church. The wider view (see left) sets the scene and is full of atmosphere, while the mid-shot (see above) focuses the viewer's attention firmly on the couple taking their vows. For both shots, the lens was fitted with a starburst filter.

GAINING HEIGHT

I f permission to take pictures during the wedding ceremony is given, there is usually an assurance required that the photographer will not disturb the ceremony in any way or distract attention from the solemnity of the occasion. If you decide to shoot from the body of the church or registry office, there is the potential problem that part of the scene may be obscured by members of the congregation in front of you or, alternatively, you may obscure other people's view if you move in front of them too close to centre stage. Additionally, by being at approximately the same level as any ground-floor windows, there is the persistent danger that meter readings may be distorted by light hitting the lens from the windows opposite.

The solution to both these problems is to shoot from a high vantage point. Many churches have an upstairs gallery that should offer an uninterrupted view of the ceremony, since you will be shooting above people's heads (and their hats). Windows, too, are likely to cause less of a meter-reading problem because the light from them will not reach the lens directly.

PHOTOGRAPHER:
Hugh Nicholas

CAMERA:
35mm

LENS:
70mm

EXPOSURE:
⅟₆₀ second at f8

LIGHTING:
Daylight and tungsten

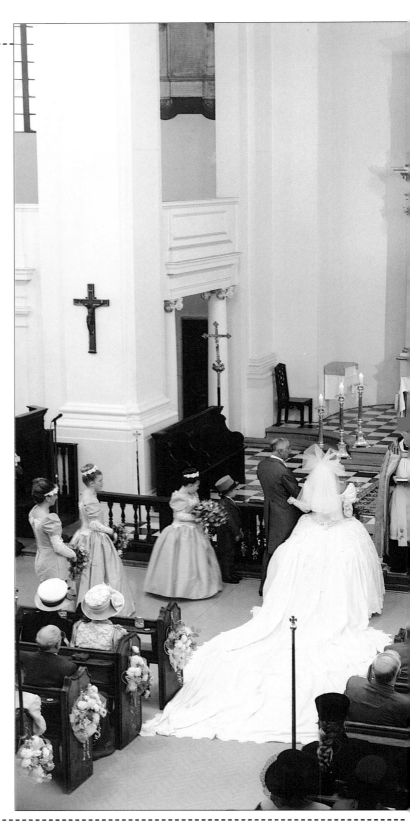

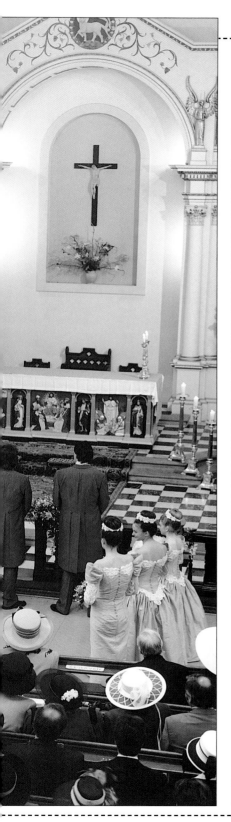

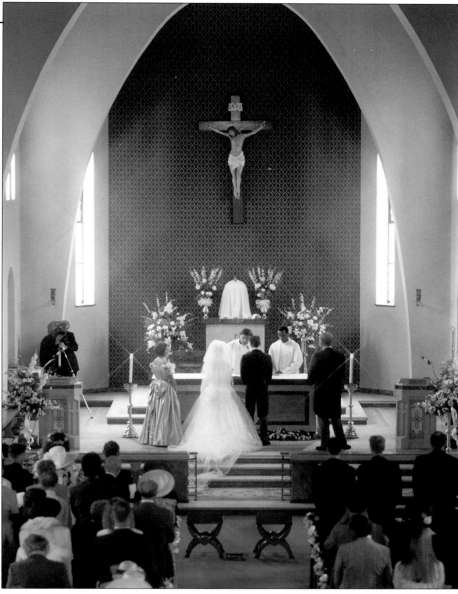

◄ The gallery of this church provided the photographer with the perfect vantage point to cover the wedding ceremony. The photographer could move quite freely along the gallery, taking full advantage of different shooting angles.

▲ The light from the tall windows to the left and right of the wedding couple was bright enough to cause some metering problems in this church. But by shooting from above there was no danger of the meter being over-influenced by direct light. The starburst from the candles either side of the couple, produced by a starburst lens filter, provide additional interest.

PHOTOGRAPHER:
Mandi Robson

CAMERA:
6 x 6cm

LENS:
80mm

EXPOSURE:
⅟₃₀ second at f5.6

LIGHTING:
Daylight only

SIGNING THE REGISTER ----------------------------

One of the classic wedding portfolio photographs is a shot of the couple signing the register after the ceremony is concluded.

Often, the register is placed on a table where there is plenty of free space in front to shoot a normal head-on portrait. The usual arrangement is the bride seated, pen in hand, poised over the register, with the groom standing behind. In the church illustrated in this photograph, however, this approach was clearly impossible because, as you can see, the table supporting the register abuts the church wall. Organizing the positions of the bride and groom so that both their faces were fully visible would have meant placing them in an unnatural looking pose.

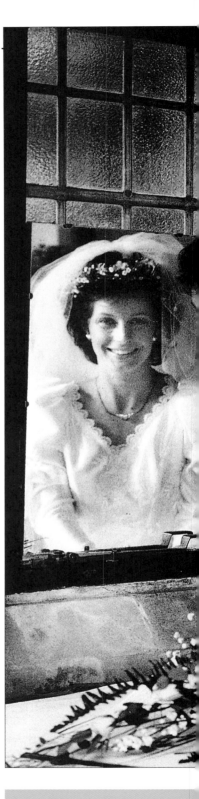

PHOTOGRAPHER:
Nigel Harper

CAMERA:
6 x 6cm

LENS:
75mm

EXPOSURE:
⅛ second at f4

LIGHTING:
Bounced flash supplemented by a little daylight

▶ *Rather than having the bride turn her head to face the camera, which would have looked slightly awkward, the photographer propped a mirror up in the window recess and framed the shot so that the groom's face was visible directly and the bride's indirectly as a reflection in the glass.*

▲ *The frosted glass in the window of the church recess did not allow sufficient light for the photograph. To boost light levels, flash was used. However,* *direct flash would have produced harsh, ugly shadows on the faces of the couple and the wall behind, as well as potential hot spots in the glass of the* *mirror and windows. To create the right type of natural lighting effect, the flash was directed into a flash umbrella to soften and diffuse it.*

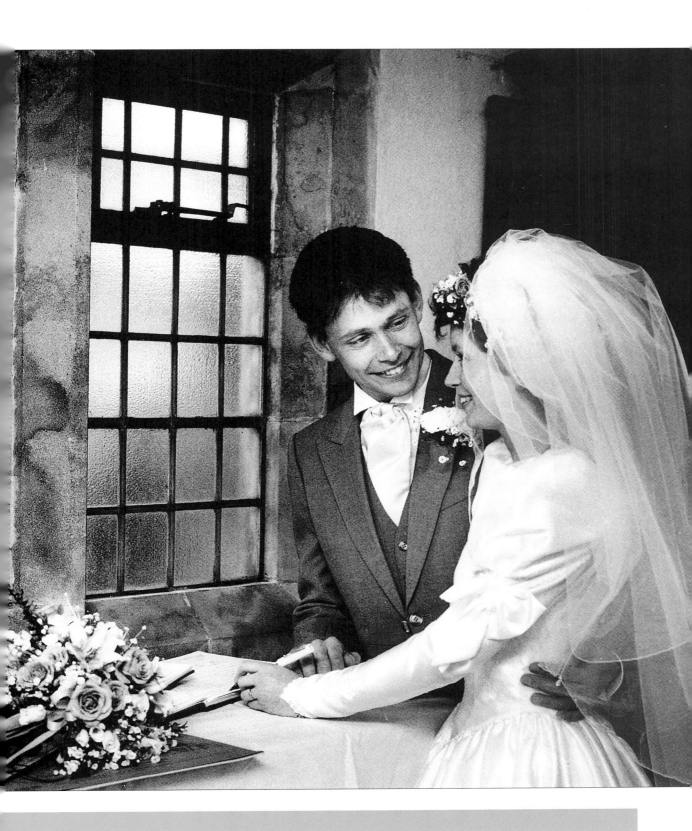

CANDLE-LIT SEND-OFF

Most couples pray for bright sunny weather on their wedding day. Even when the sun fails to materialize, a good photographer will go to a lot of trouble to try and add a little sparkle to the photographs of the day's events, usually by using flash to simulate sunlight. For a completely different approach, at least for one or two of the set-piece shots, why not use candle light instead of daylight as your main source of illumination?

The most obvious difficulty with this experimental approach to wedding photography is that candles produce relatively little light. To overcome this, use a combination of fast film (at least ISO 400), a camera with a B (brief) or T (time) setting (or one that can be set to give an exposure of up to 4 seconds), and a lens with a wide maximum aperture. To avoid any problems to do with camera shake when using a slow exposure, the camera must either be mounted on a tripod or supported on some other firm surface.

Hints and tips

● To make sure that the couple are shown against a completely black, featureless background, you must exclude all extraneous light from the scene. Here, the newlyweds are standing in front of the heavy wooden doors that lead from the church porch to the outside, and the doors are, in turn, covered with heavy velvet drapes normally used as draft excluders when the church is in use during the winter months.

● Even with the camera mounted on a tripod, it is best to fire the shutter using a cable release. Pressing down on the release button with your finger could transmit enough vibrations to the camera to cause slight camera movement, which would be noticeable because of the very long exposure time needed.

● Because this is an experimental approach, take two or three pictures using different lens apertures or shutter speeds, and pick the best result afterwards for enlargement.

PHOTOGRAPHER:
Nigel Harper

CAMERA:
35mm

LENS:
50mm

EXPOSURE:
3 seconds at f5.6

LIGHTING:
Candle light

▶ *The only light used to expose the film for this photograph came from the candles held by the diminutive bridesmaids. The shutter was held open using a cable release for a manually timed exposure of 3 seconds, during which time all of the subjects had to stand as still as they could. As you can see, the little bridesmaid on the left and also the one closest to the camera on the right did move a little and so they appear slightly blurred.*

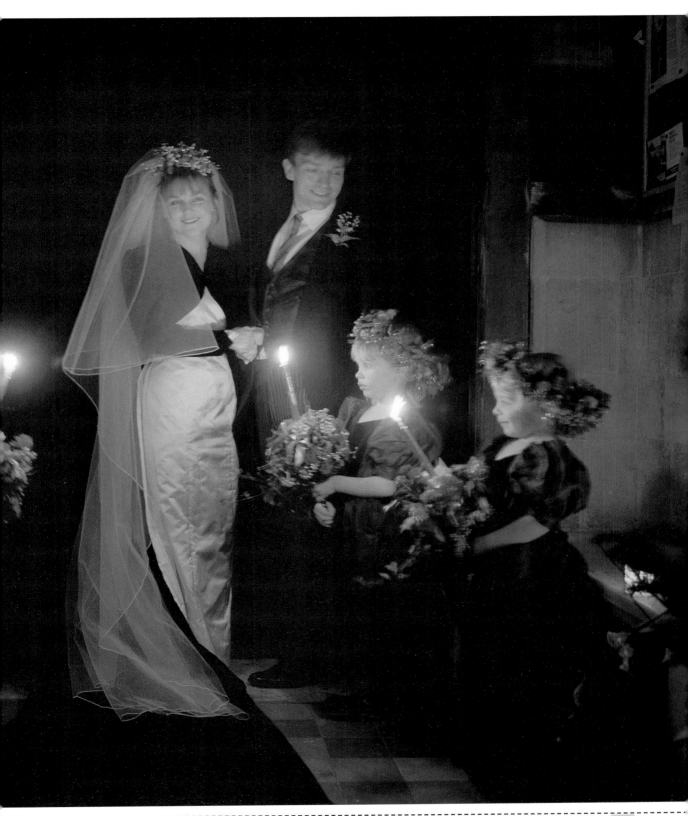

ATTENTION TO DETAIL

On the day of the wedding itself, there is usually very little time to take what could be described as thoughtful or carefully composed photographs. The time pressure on all concerned is great – perhaps the church has to be vacated at once to make way for another wedding ceremony, or everybody may have to set off almost immediately in order to get to the reception on time.

If the couple are willing, and their budget permits, it is an excellent idea to set some photographs up on a day other than the actual wedding day. In this way, you will be able to spend the time required to do justice to the importance of the occasion. Immediately after the wedding, most newlyweds go on honeymoon, and waiting for their return will delay the entire wedding portfolio. It's far better, therefore, to arrange for an additional photography session a day or two before the ceremony – assuming, of course, that they are not concerned about the superstition that the groom should not see the bride's dress before the wedding day itself.

▶ *The success of this picture relies on the care and attention that has gone into the arrangement of the bride's gown, and the precisely selected camera position. The couple's semi-silhouetted forms, and the dark, shadowy recesses of the church porch, act as a striking and dramatic contrast to the satiny whiteness of her gown.*

PHOTOGRAPHER:

Nigel Harper

CAMERA:

6 x 6cm

LENS:

120mm

EXPOSURE:

¹⁄₆₀ second at f16

LIGHTING:

Natural daylight

▲ *A slightly low camera angle (above left) accentuates the statuesque quality of the couple while showing their faces, poised for a kiss, against the uncluttered background of a tiled roof in the distance. If the same shot had been taken from a normal standing position (above right), their faces would have been lost against a confusion of background foliage.*

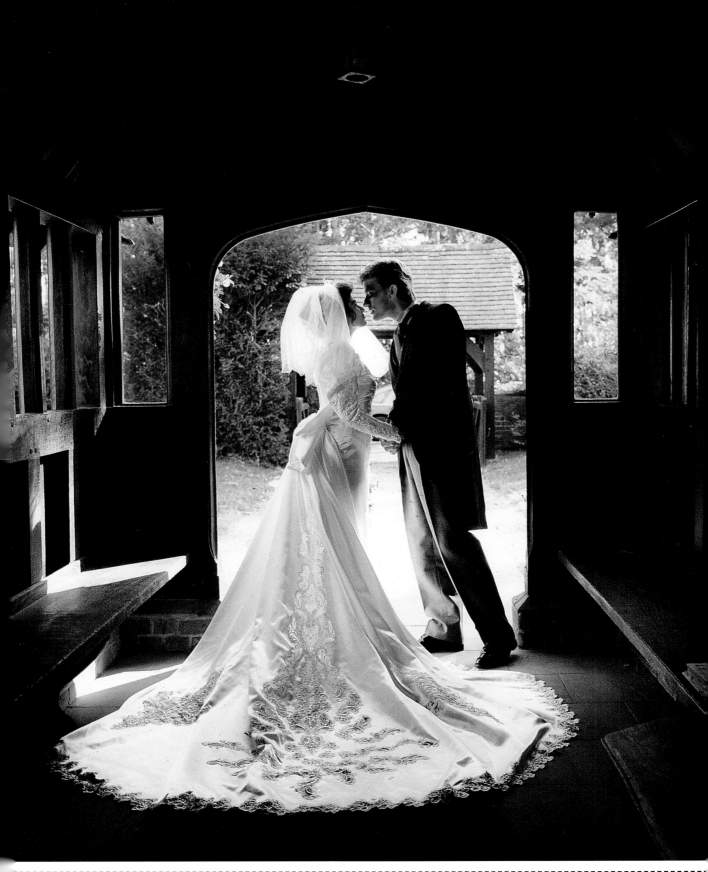

AFTERNOON SUNLIGHT

As the sun moves in an arc through the sky during the course of the day, the different qualities of its illumination can bring about dramatic changes in the appearance of your subjects.

First thing in the morning, the sun is low in the sky, shadows are long, and the colour and quality of its light can be soft and flattering. At noon, with the sun more directly overhead, shadows are short and, although images may be sharp and crisply detailed, contrast can also be harsh and unkind to facial features. As the afternoon progresses, the sun begins to move lower in the sky once more, shadows lengthen again,

and the quality of light takes on more the appearance of morning illumination.

The principal disadvantage when working with a low afternoon sun is the possibility that the sun itself will appear within the frame, flooding the scene with excess light and making the meter reading unreliable for the main subject. To overcome this, choose a camera position that shows your subject away from the sun or, if this is not possible, use some natural cover within the scene to shield the lens from its direct rays. In this example, the photographer has positioned himself so that the top right-hand segment of the arch fulfils this function.

PHOTOGRAPHER:
Nigel Harper

CAMERA:
6 x 7cm

LENS:
80mm

EXPOSURE:
½₅₀ second at f16

LIGHTING:
Daylight only

▲ The low position of the sun in the sky sends a spotlight of illumination through the archway of the church and onto the bridesmaids (above left). If, however, the sun had been slightly higher in the sky (above right), the young girls would have been lost in the shadows and much of the impact of the resulting photograph would have been lost.

▶ The importance of eyeline – where the subjects are looking – cannot be overemphasized in photography. Here, the bride is looking back over her shoulder directly at the camera. This immediately engages you as the viewer and holds your attention. The groom, however, is looking back, directly at the seated bridesmaids, thus drawing them into the image. Their gazes in turn take you back once more to the wedding couple, making this an extremely neat composition.

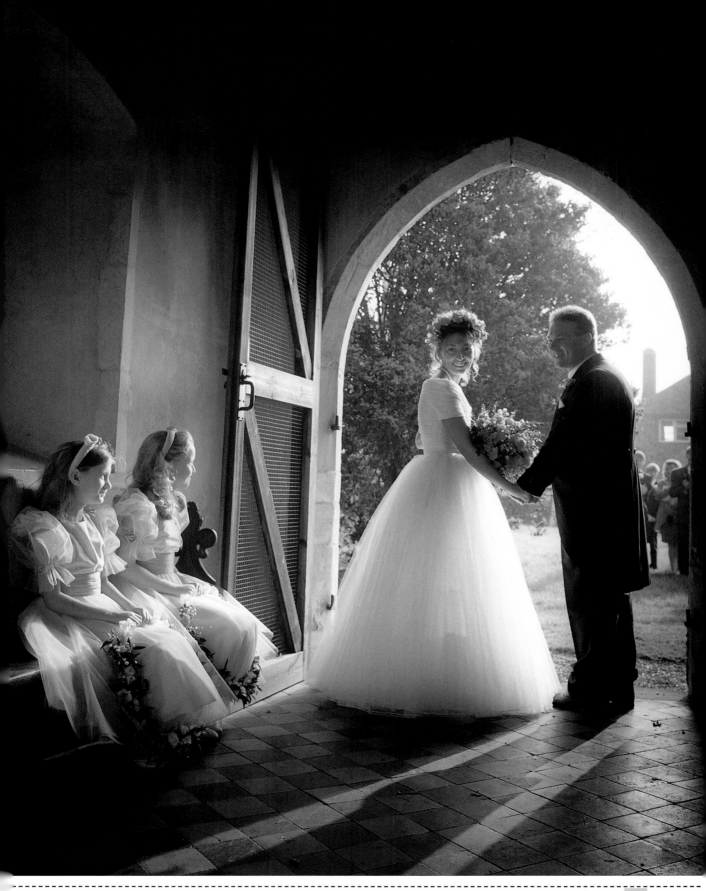

TAKE TWO

If you are the official wedding photographer, then it is your job to ensure the quality of the resulting portfolio of pictures. Sometimes, therefore, you need to take a hand and direct the subjects if, in your judgment, better photographs will result.

Although much of the coverage of a wedding consists of semi-candid images (the guests milling about outside waiting for the bride's arrival or the groom and best man checking their watches nervously) and a series of traditional set-piece shots (the bride arriving at the ceremony, for example, walking down the aisle on her father's arm, and, as here, the couple kissing as they leave the church porch), there is still much scope for creative and imaginative pictures.

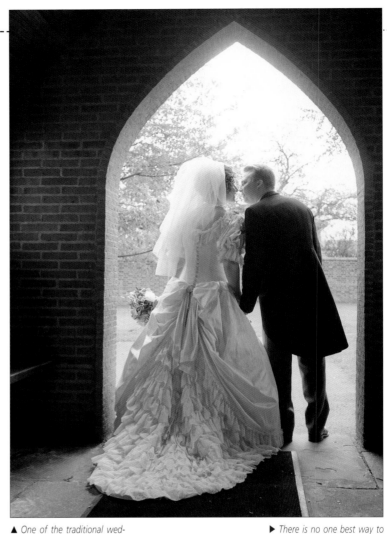

▲ One of the traditional wedding shots is of the bride and groom pausing in the church porch to kiss. Most often, however, this image is taken from the front, with the couple seen against a background of the shadowy interior of the building. A nice variation, therefore, is this image, which has been taken as if it were a candid shot, of the couple viewed from behind.

PHOTOGRAPHER:
Nigel Harper

CAMERA:
35mm

LENS:
50mm

EXPOSURE:
1/125 second at f8

LIGHTING:
Daylight only

▶ There is no one best way to take a picture, and for this version the photographer has moved back a little so that the lens takes in the attractive rough-hewn wooden archway, making a frame within a frame, and the old timbered ceiling and cast-iron light fitting in the church porch. These features alone add extra information, atmosphere, and an enhanced three-dimensional quality. However, the photographer also directed the page boy to enter the frame. The direction of his gaze firmly anchors the couple centre stage.

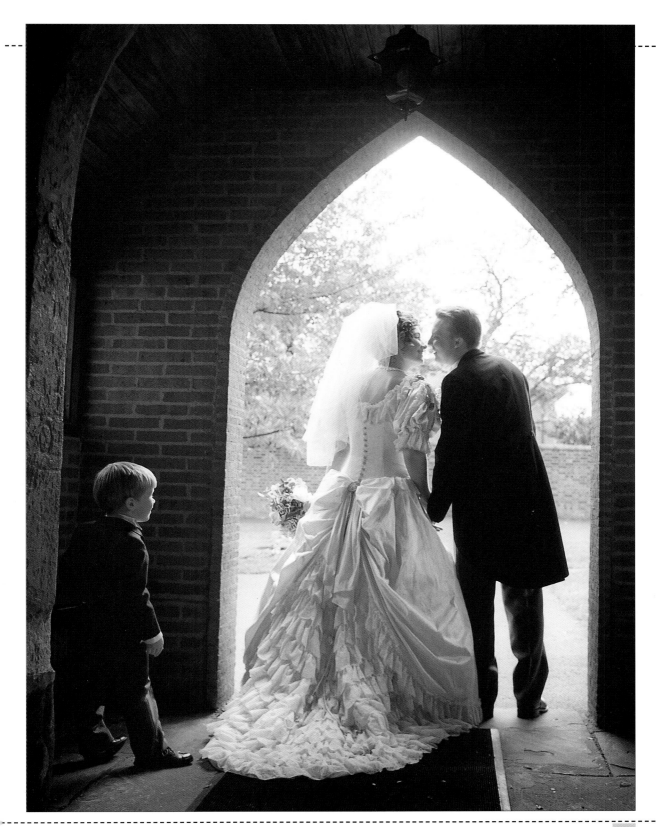

FRAMING FOR IMPACT

Directly after the ceremony, when the bride and groom have emerged from the church, there is often an almost tangible release of tension. For the leading players, and the supporting cast of characters, the weeks of planning and worrying are at last over; for the invited family and friends, the most restrained part of the proceedings are behind them and, like a long-held breath, they can now relax, loosen overtight clothing a little, and look forward to the party to come.

It is at this point that you, as photographer, will really appreciate any preplanning you have carried out. The time and place of the ceremony have been known well in advance – so, weather permitting, you should have a pretty clear idea of where the light will be best around the church building and grounds for the first of the many set-piece shots that will be required of you throughout the rest of the day.

PHOTOGRAPHER:
Trevor Godfree

CAMERA:
35mm

LENS:
210mm

EXPOSURE:
¹⁄₆₀ second at f8

LIGHTING:
Daylight only

▶ *The framing of this close-up is perfect of its type. The faces of the couple completely fill the frame (excluding any possibility of a distracting background), the lighting is bright and revealing without being harsh or unflattering, the kiss on the cheek is tender, and the bride looks radiant as she gazes directly into the camera lens.*

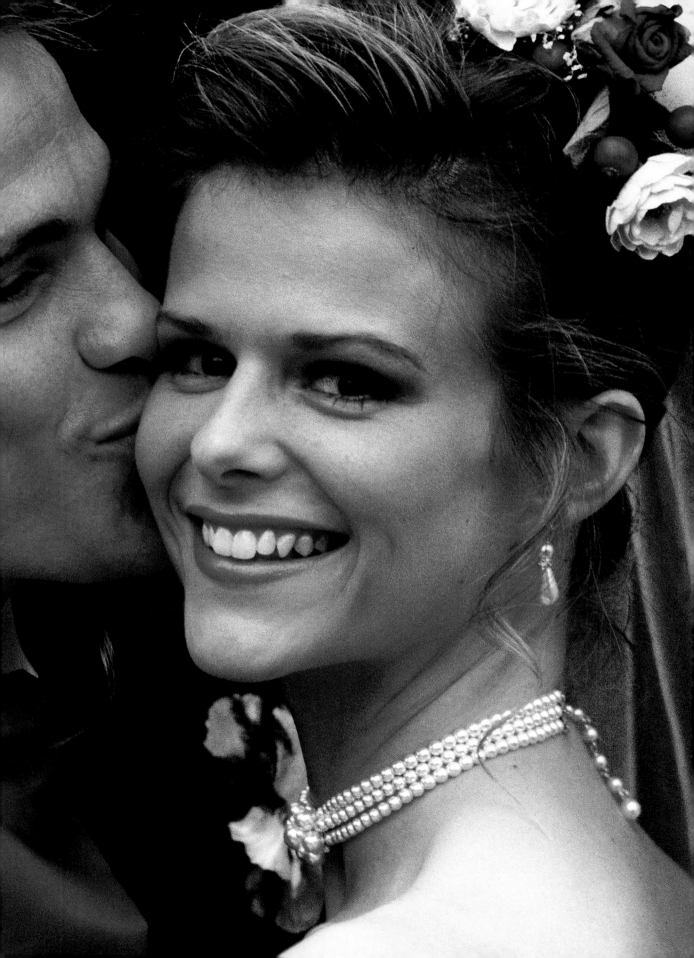

Bear in mind that the newlyweds still have a difficult role to play. They are the centre of a great many people's attention and there are many demands on them to greet family and friends, to circulate, to be part of this group or that. You will have to be firm, yet diplomatic, in order to get the couple quickly into the various spots you should have pre-selected for the different shots.

▶ *Every wedding album will benefit from a thoughtful range of differently framed photographs. In this shot of the couple, an earlier visit to the church grounds by the photographer determined that this background of shrubby foliage would be ideally lit at about the projected time for the end of the ceremony. It is this type of planning that can make the difference between one set of pictures that simply "does the job" and another set that makes the day look like it was a magical event.*

PHOTOGRAPHER:
Trevor Godfree

CAMERA:
35mm

LENS:
105mm

EXPOSURE:
$\frac{1}{125}$ second at f11

LIGHTING:
Daylight only

▲ *A part of the preplanning exercise the wedding photographer should carry out before the wedding day involves visiting the location where the ceremony is to take place. This need take only a few minutes of your time, but it will allow you to see where the strengths and weaknesses of the venue lie and where the sun will be on the "big day" so that you can plan your set-piece photographs – those inside the building as well those outside in the grounds.*

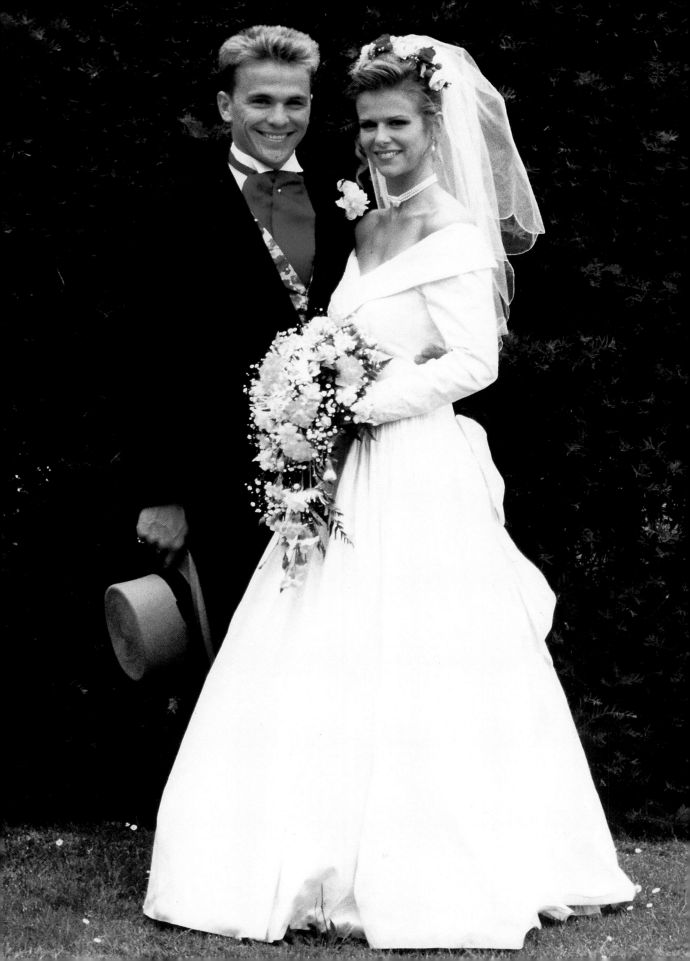

COLOUR OR BLACK AND WHITE?

The debate concerning the relative merits of colour versus black and white has been going on since colour film first became widely available about 30 years ago. A minority of photographers work happily in both mediums, but most photographers prefer to specialize in either one or the other. As the two excellent pictures presented here illustrate, however, both black and white and colour are eminently suitable for recording a wedding portfolio – it basically comes down to a question of personal preference.

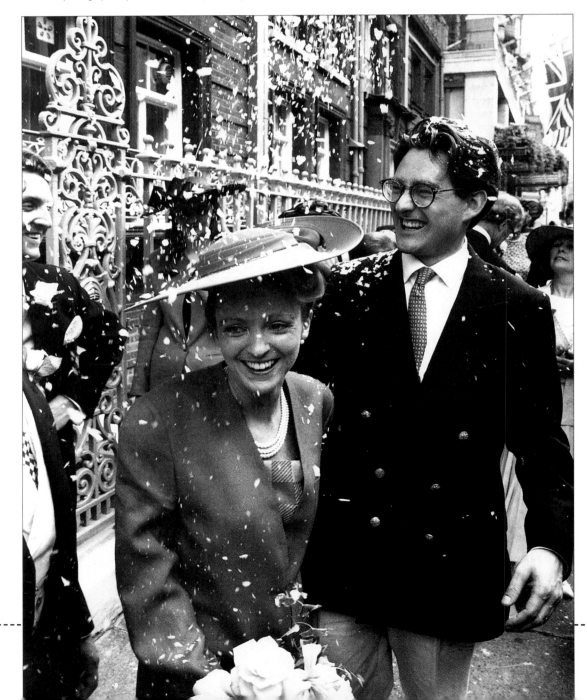

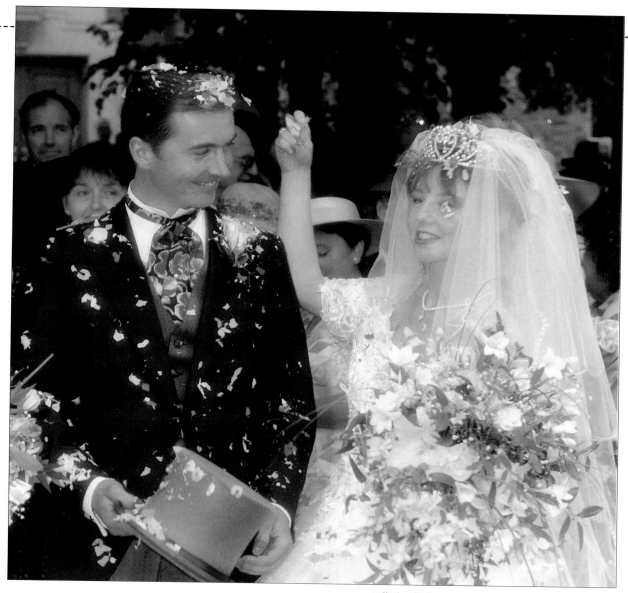

▲ *Sharing this happy moment, the bride catches a handful of confetti to add to the growing pile on her husband's head.*

◀ *Leaving the registry office, these newlyweds look radiantly happy as the confetti rains down on them.*

PHOTOGRAPHER:
Richard Dawkins

CAMERA:
35mm

LENS:
35mm

EXPOSURE:
1/500 second at f5.6

LIGHTING:
Daylight only

PHOTOGRAPHER:
Mandi Robson

CAMERA:
6 x 6cm

LENS:
120mm

EXPOSURE:
1/125 second at f8

LIGHTING:
Daylight supplemented by flash

WIDE-ANGLE VIEWS

Although the majority of pictures making up a typical wedding portfolio will be taken by lenses with focal lengths ranging from standard (50mm on a 35mm camera) through to moderate telephoto (about 135 or 150mm on a 35mm camera), there are times when the wider angles of view of shorter focal lengths are necessary.

The principal advantage of using a telephoto is that you can fill the frame with the subjects without having to move in too close. Stemming from this, it is therefore possible to take more candid, informal images because subjects are less likely to be aware of your presence. However, when you want to show the setting of an event, such as a wedding, or you need to encompass a large group of people, your best choice of lens is a wide-angle.

▶ *In order to show the church, thronging guests, the bridal couple themselves and the flying confetti, the tartan-clad piper, and the ceremonial Rolls Royce, the photographer used a wide-angle lens. If he had been shooting from the same camera position using a 135mm telephoto on a 35mm camera, the photographer could have taken a close-up portrait of the bride and groom alone.*

PHOTOGRAPHER:
Hugh Nicholas

CAMERA:
35mm

LENS:
28mm

EXPOSURE:
¹⁄₂₅₀ second at f8

LIGHTING:
Daylight only

Wide-angles and camera formats

When you classify lenses as wide-angle, standard, or telephoto, you have to remember that the specific focal lengths you assign to these categories depend on the format of the camera. The two most popular camera formats are 35mm and medium format – either 6 x 6cm or 6 x 7cm. The image area of a 35mm negative is considerably smaller than that of a medium-format camera, and wide-angle lenses start at about 45mm Wide-angle focal lengths for medium format cameras start at about 65mm. For comparative purposes, a standard lens on a 35mm camera is about 50mm, while a standard lens on a medium format camera is about 75mm.

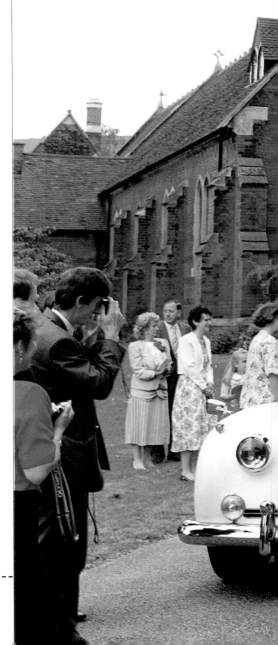

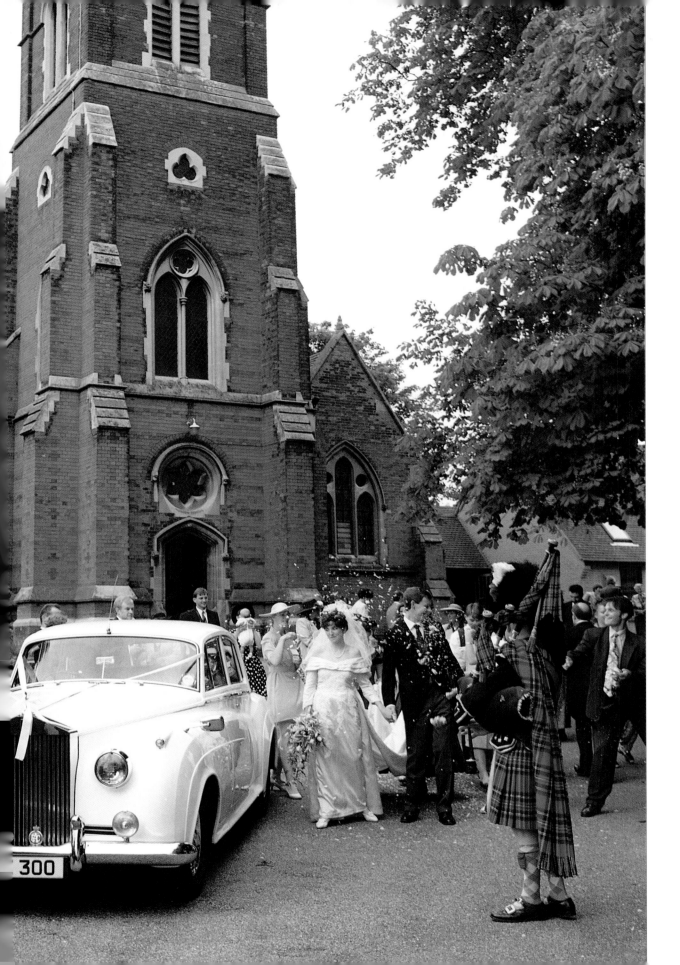

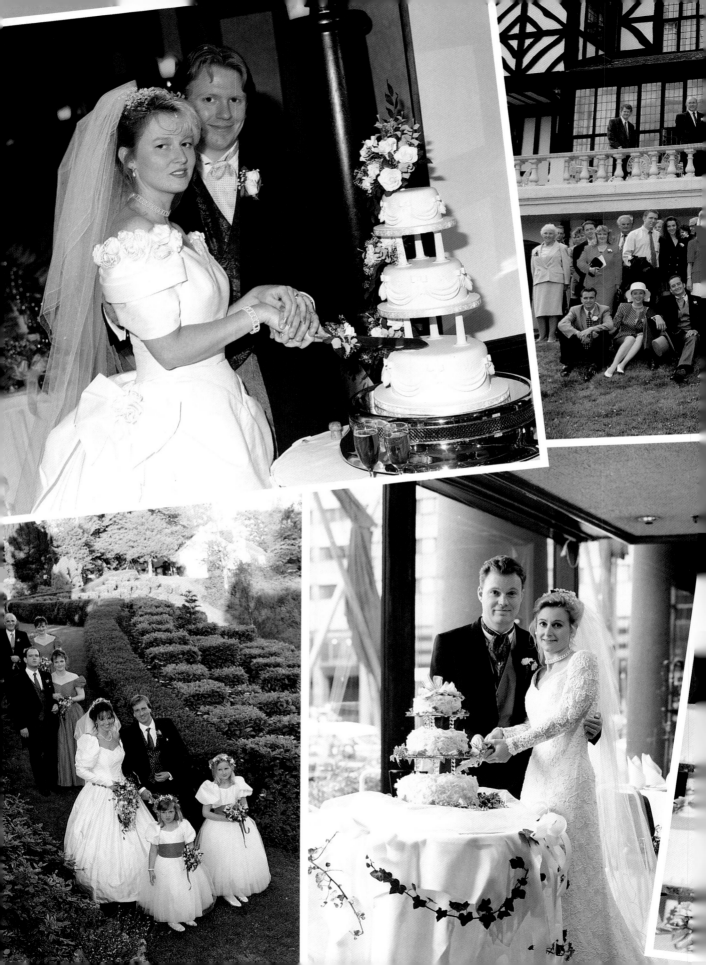

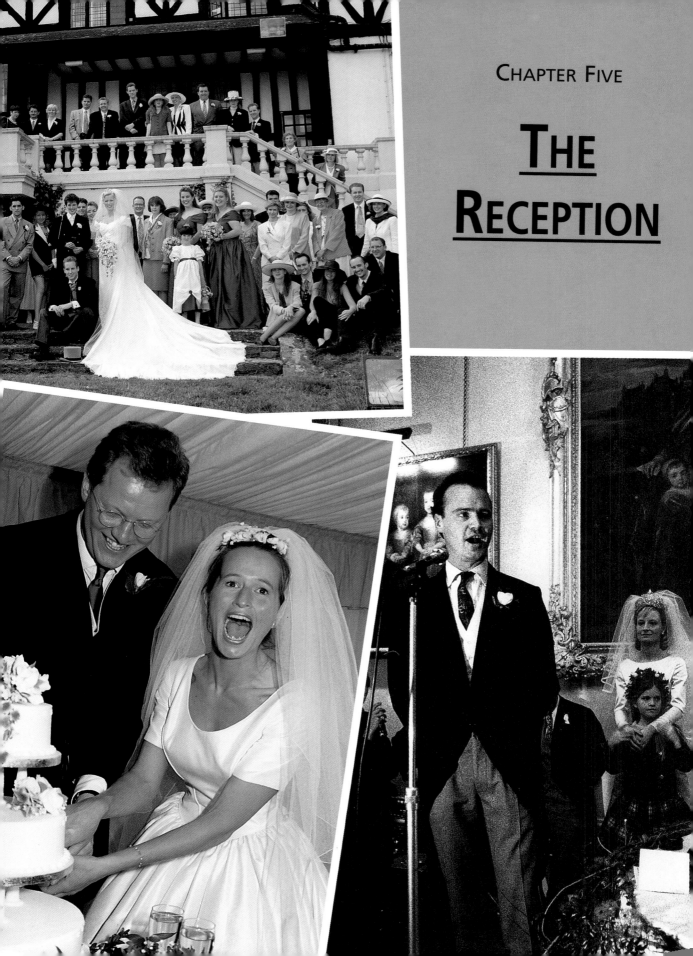

CHAPTER FIVE

THE RECEPTION

CREATIVE SHUTTER SPEED

The majority of wedding photographs are taken at shutter speeds that allow the camera to be safely hand held without the danger of camera shake or subject movement intruding and "spoiling" the image – approximately in the range of 1/125 second up to the fastest shutter speed offered on the camera. But by experimenting with other shutter speeds you can create some extremely unusual and eye-catching effects. Obviously, techniques such as the one employed here, can be used only occasionally in the context of producing a portfolio of wedding photographs.

PHOTOGRAPHER:
Nigel Harper

CAMERA:
6 x 6cm

LENS:
120mm

EXPOSURE:
3 seconds at f16

LIGHTING:
Flash and tungsten

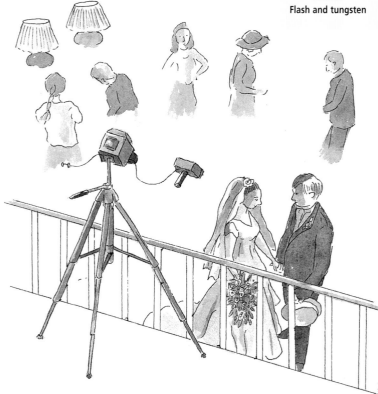

Hints and tips

To produce a photograph of the type shown here, follow these steps:

● Set the camera up on a tripod where you have an unobscured view of the subjects.

● Select a shutter speed of about 3 full seconds (or manually time a 3-second exposure if necessary).

● Use a cable release to trip the shutter and, as soon as the exposure starts, fire a flash directed just at the subjects.

● Brief the subjects beforehand so that they know they must stand completely still throughout the entire exposure.

● While the shutter remains open for the full 3 seconds, the people swirling about and dancing will record on the film as impressionistic streaks and blurs.

▶ The length of the exposure needed to create an effect such as this depends on how quickly the people are moving past and around the stationary couple in the centre. The quicker they are moving, the briefer the exposure needed. This is obviously an experimental technique, however, so try a series of exposure ranging from, say, 2 seconds up to 5 or even 6 seconds, and then select the best one after processing and printing. You will need a camera with a shutter speed that can be set for multiple seconds (or one that can be held open for a manually timed exposure); a tripod (or some other firm camera support); a cable release to trip the shutter; and a flash. Some of the figures in the background are reasonably sharp due to the fact that they were sitting down and barely moving throughout the exposure.

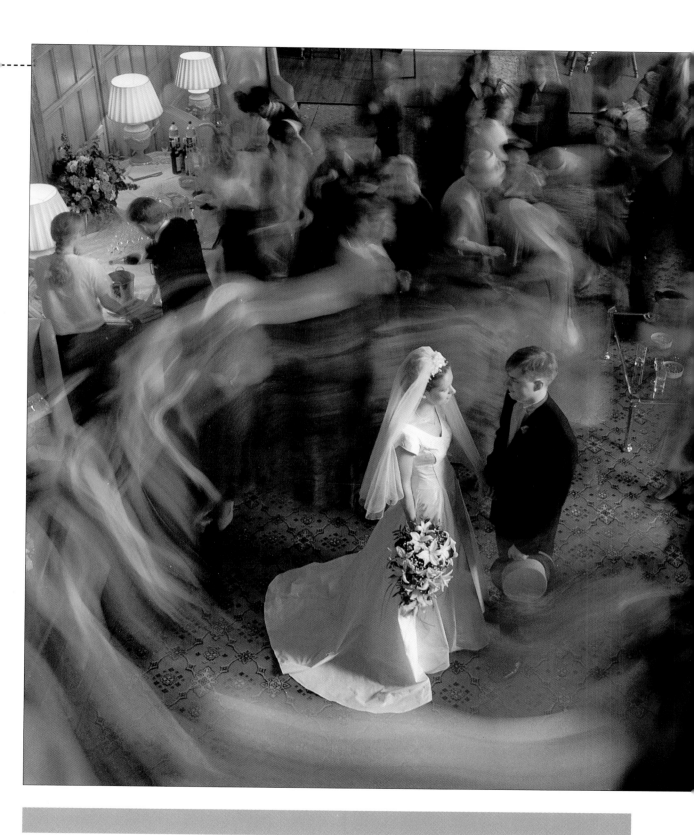

"CAN'T BE MISSED" SHOTS

If you were to ask people to make a short list of the highlights of a wedding reception a photographer had to cover – shots that really can't be missed – coming somewhere near the top of the list would be the speeches from the head table and cutting the cake.

The speeches ceremony is, by definition, one of the least action-packed phases of the entire affair, but from the newlyweds' point of view, it must form part of their picture portfolio because all of the most central characters are present at the same table – parents and other members of the immediate families, best man, close friends, and so on. The challenge from the photographer's point of view is to somehow record the speeches in a lively and entertaining fashion. Traditionally, the speeches are used partly to thank those who have helped in the planning and preparation of the wedding, and also those of the supporting cast who actually participated in it. However, part of the tradition also involves a certain amount of humour, usually by relating publicly

some anecdote or event that the subject of the speech would rather have remained private. These are the moments you need to listen out for, since it is precisely then that the facial expressions of those listening, and of the person being publicly embarrassed, make the best photographs.

The cake-cutting part of the reception, as recorded by the photographer, is almost always set up specifically for the camera. At some point during the party, the bride and groom will be extracted from the throng and asked to pose by the cake, with both their hands on the knife handle, while the photographer takes a few photographs. Because it is a set-piece shot, the photographer should coach the subjects through it, asking them to adjust their positions to improve the composition, to look at the camera, or at each other. Talking to the couple throughout is a good way of getting them to relax and to react, and thus stop them going "wooden", and this maximizes your chances of producing an entertaining photograph.

PHOTOGRAPHER:
Richard Dawkins
CAMERA:
35mm
LENS:
105mm
EXPOSURE:
1/125 second at f8
LIGHTING:
Portable flash

▶ *The composition of this wedding reception speech is thoughtful and considered. A moderate telephoto lens was used to fill the frame from the body of the reception hall and the photographer has checked the viewfinder frame to ensure that all visible subjects are contributing to the atmosphere of the shot. The expression of the groom delivering the speech is natural and the attention being given to what he has to say, and its obviously amusing content, is evident in the faces of the people listening.*

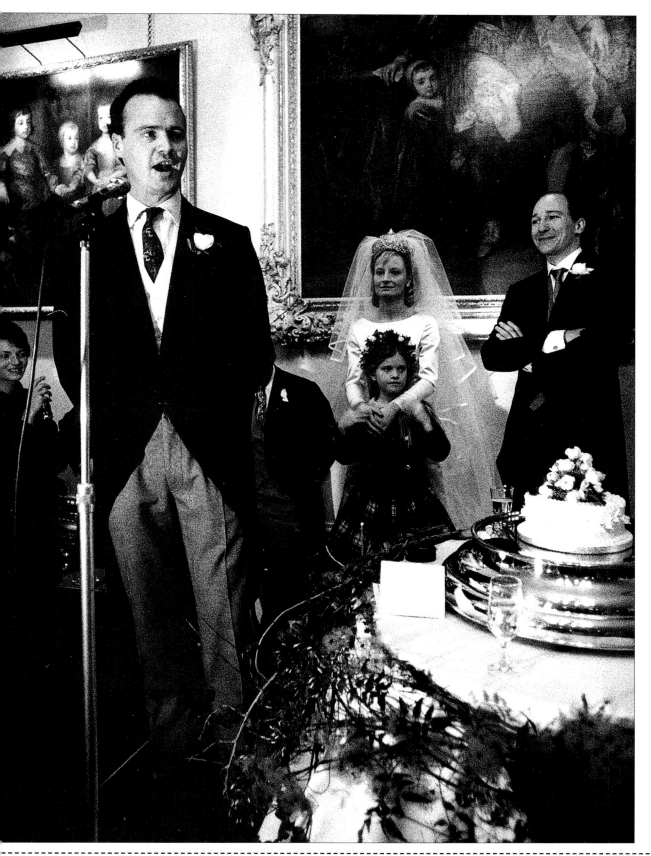

▶ The photographer's timing for this image of the head table is near perfection. The groom has obviously just revealed in his speech something amusing about the woman dressed in red on the extreme left of the frame, and every face is laughing and turning in her direction, while she looks suitably embarrassed. From the angle the picture was taken you can imagine where the photographer was standing, and it is evident that as you look down the table there is a subtle change in overall colour, with the image becoming increasingly "warm" looking. This is due to what is referred to as flash fall-off (see below).

FLASH FALL-OFF

The light output from a flash gives consistent colour results for subjects positioned between a minimum and maximum distance from the flash. Anything positioned too close will be overexposed and subjects beyond the maximum range will become progressively underexposed. This is known as flash fall-off. In this diagram you can see that the angle of the flash has recorded the subjects as far as the groom well, with whites looking white and skin tones looking natural. Beyond the groom, however, the power of the flash has diminished and tungsten room lighting can be seen to be having more of an effect. Tungsten lighting is deficient in the blue part of the colour spectrum and so anything recorded by it takes on an orange colour cast.

PHOTOGRAPHER:
Nigel Harper

CAMERA:
35mm

LENS:
28mm

EXPOSURE:
¹⁄₆₀ second at f5.6

LIGHTING:
Portable flash

◀ *The photographer's coaching was vital to the success of this picture. While the shot was being set up and arranged, the photographer constantly talked to the subjects, finally eliciting this joyful expression from the bride just as the shutter release was pressed.*

PHOTOGRAPHER:
Philip Durell

CAMERA:
35mm

LENS:
75mm

EXPOSURE:
½₅₀ second at f8

LIGHTING:
Portable flash

▶ *The wedding cake is often elaborate and has to be a feature. This picture has all the elements of a good shot – the newlyweds with their hands on the handle of the knife and the wine glasses in the foreground symbolizing their union.*

PHOTOGRAPHER:
Hugh Nicholas

CAMERA:
6 x 7cm

LENS:
80mm

EXPOSURE:
½₂₅ second at f5.6

LIGHTING:
Portable flash

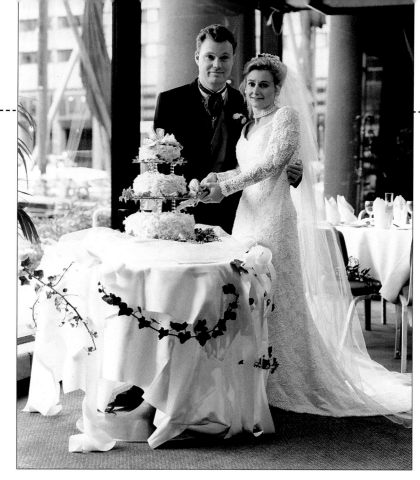

◀▼ *Whether the image is sharp and crisply detailed or more interpretative in its treatment, with some of the detail sacrificed to create more of a soft and romantic type of image, is largely a matter of personal taste. Here, the photographer has covered himself by taking two version of the same scene, incorporating a slight change of pose. In one he used no special effects filter on the lens, while in the second he used a diffusion filter – which is also known as a soft-focus filter.*

PHOTOGRAPHER:
Hugh Nicholas

CAMERA:
6 x 7cm

LENS:
105mm

EXPOSURE:
1/125 second at f8

LIGHTING:
Daylight supplemented by flash

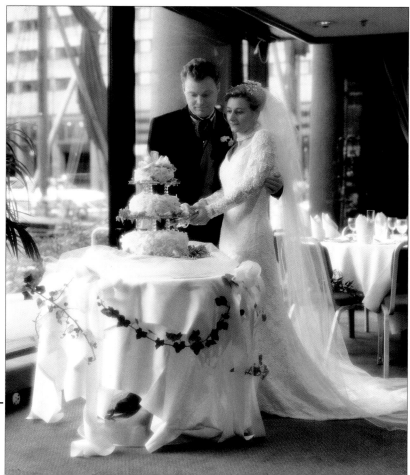

PICTURE FORMATS

When using a 35mm or medium-format camera, other than 6 x 6cm, you have the choice of framing your subjects with the camera held normally, to produce a horizontal-format picture (also known as "landscape" format) or, with it turned on its side, to produce a vertical-format picture (sometimes referred to as "portrait" format). As you would assume from the 6 x 6cm camera's name, it produces a square negative, and so it make no difference which way around you hold it.

Although it is generally more comfortable to hold the camera as if taking a horizontally framed picture, you should use the different types of framing available to you to help strengthen subject composition. Horizontally framed pictures, for example, tend to emphasize the flow of visual elements across the frame, while vertically framed shots help to strengthen the relationship between foreground and background picture elements. A square-format image tends to be neutral in this regard, but if you leave space at the top and bottom, or to the left and right of the subjects, you can crop the image at the printing stage to produce a horizontal or vertical image, depending on which suits the subject.

▶ In this picture, the photographer has used horizontal framing to good advantage in order to emphasize the visual flow of the subjects across the frame in an informal group portrait that was taken at a quiet moment during the wedding reception. Holding the camera the other way around would also have given undue prominence to the foreground area of grass.

PHOTOGRAPHER:
Mandi Robson

CAMERA:
6 x 6cm

LENS:
105mm

EXPOSURE:
1/125 second at f8

LIGHTING:
Daylight supplemented by flash

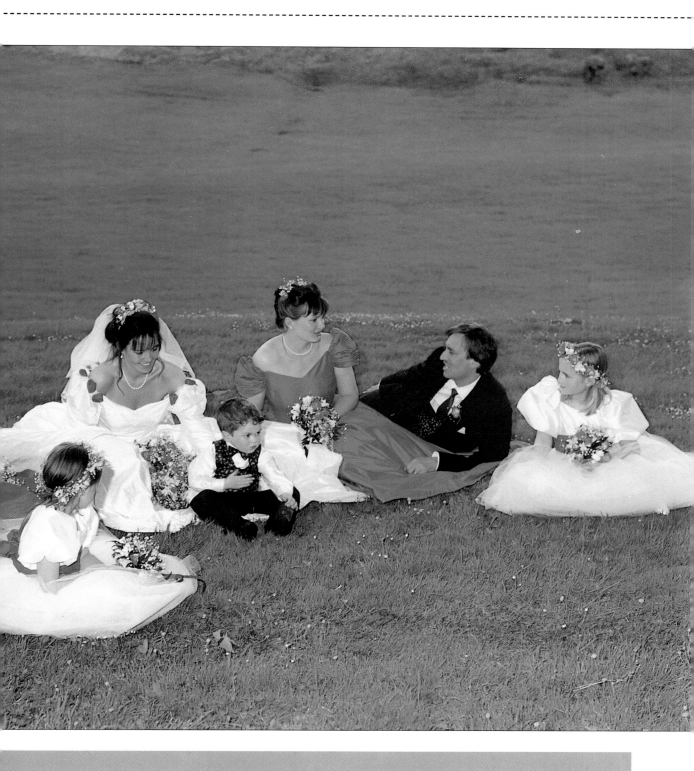

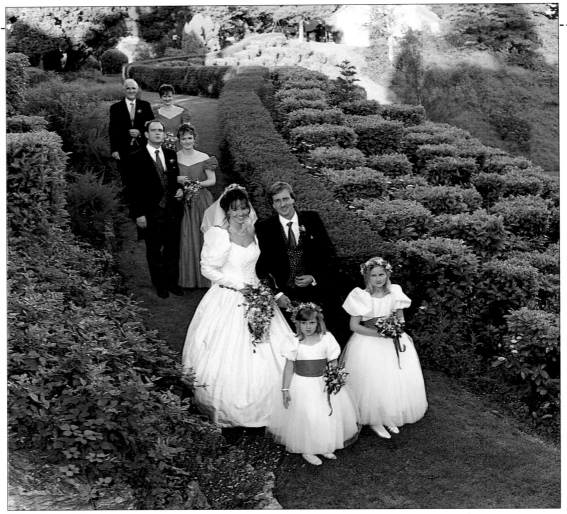

▲ Of all the picture formats available, the type of square image produced by a 6 x 6cm medium-format camera tends to be most neutral in the influence it has on subject matter. In this more formal portrait of the wedding party, the movement from front to back through the frame is very strong in any case, and thus works well as a square image. Note, however, that the photographer has left room at the sides of the subjects to allow for some cropping later on if necessary (see opposite).

PHOTOGRAPHER:
Mandi Robson
CAMERA:
35mm
LENS:
50mm
EXPOSURE:
1/125 second at f8
LIGHTING:
Daylight supplemented by flash

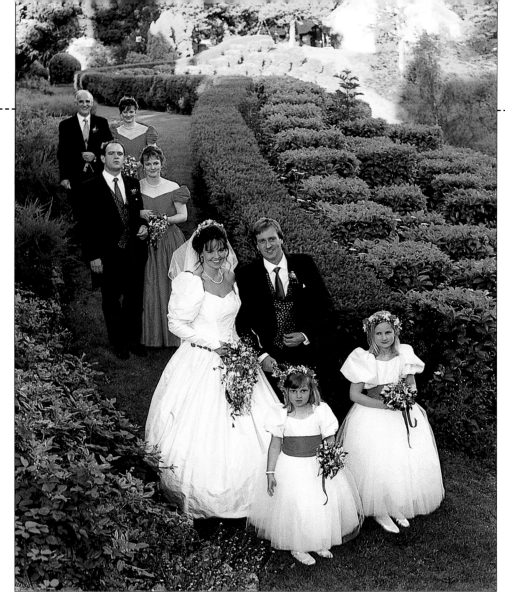

◄ By cropping some of the image either side of the procession, the photographer has turned a square-format image into a vertical one. The relationship between foreground and background subject elements was already strong, but this movement into the frame has been even further enhanced by this darkroom treatment.

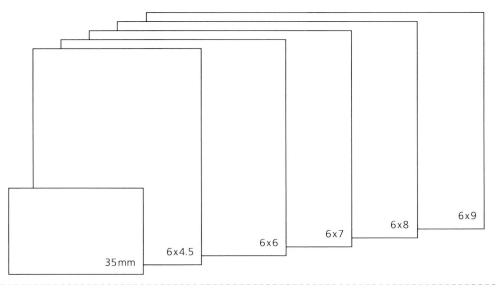

35mm

6x4.5

6x6

6x7

6x8

6x9

◄ All but the 6 x 6cm format produce a rectangular image, giving you the option of recording a vertical or a horizontal image, depending on which way around you hold the camera. All of the various 6cm-format cameras are known as medium format.

LARGE-GROUP PORTRAITS

At some stage of nearly every wedding reception the official photographer will be confronted with the sometimes daunting prospect of organizing and shooting a group photograph of the newlyweds, their immediate families, and all of their guests. This could involve arranging dozens of people at an average-sized wedding, all the way up to a hundred plus people at large affairs.

The most difficult setting you may find yourself in is when you (and the camera) are on flat ground at the same level as the members of the group. In this situation you have no option other than to rank people according to their height, much as in a school photograph, with the taller members of the group toward the rear and the shorter ones at the front. Associated with this solution are the disadvantages that you break up family groupings, and you also tend to find that most of the men are at the rear because they are taller and most of the women are at the front because they are shorter. But it may be the only way to organize the shot so that all their faces are visible. Even so, you will have an added margin of flexibility if you can gain just a little extra height – by standing on your camera case, for example, if it is sufficiently robust. Some photographers carry a lightweight aluminium stepladder in the back of the car for just such a situation.

PHOTOGRAPHER:
Nigel Harper

CAMERA:
6 x 7cm

LENS:
50mm

EXPOSURE:
⅟₆₀ second at f8

LIGHTING:
Daylight only

▶ A sloping lawn set-in with steps leading to another flight of steps and a long balcony provided a good variety of levels on which to pose the members of this wedding party. The black and white Tudor-style façade of the reception venue is another attractive feature of the picture.

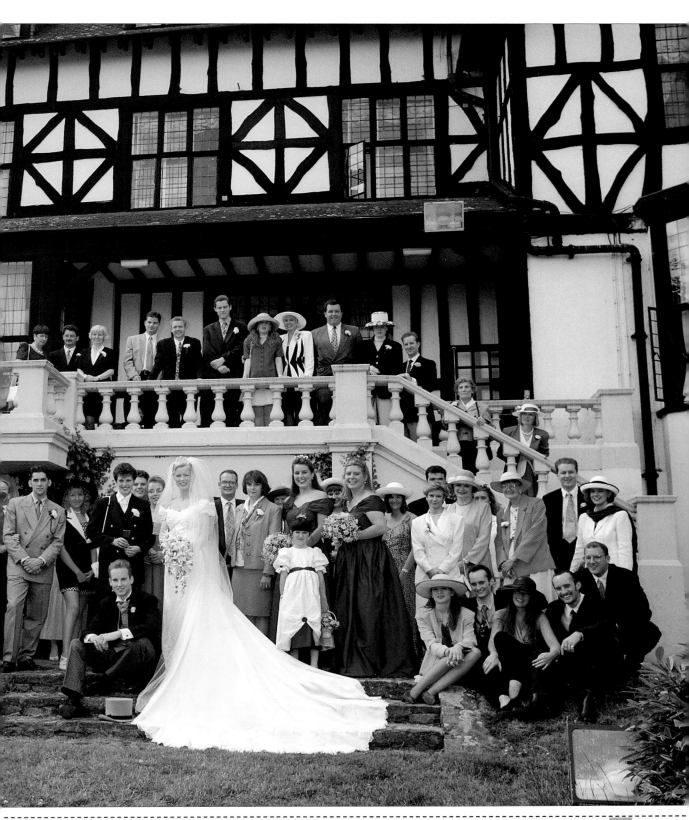

Large-group portraits become a lot easier to organize if the camera and the subjects are on distinctly different levels. If the reception venue has a series of steps – perhaps leading up from a lawn and then carrying on up to the front lobby area – then you can start being more creative in how you compose the shot. You may now, for example, be able to keep family groups together by ranking members of individual groups according to height and then positioning groups as a whole on different levels, while you stay down below and shoot up at them.

If, however, the venue does not offer you a series of steps to work with (or the light is not suitable), or the building itself is not particularly attractive on the outside and you don't want it visible in the picture, you may still be able to shoot from a different level – from a balcony or an upper floor window. This way, you will be above the group shooting down at their upturned faces.

No matter which solution is best in the circumstances you are confronting, it is a wise course of action to make three, four, or five exposures. While it is true that the faces of those at the back of the group will probably not be seen clearly enough for their facial expressions to matter much, those in the first few ranks of the group should be clear enough for a stifled yawn, half-blinking eyes, or a pulled face to spoil the shot – especially if it is one of the leading players or a member of the supporting cast.

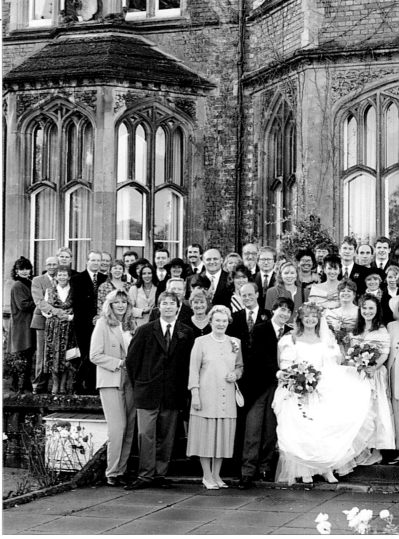

PHOTOGRAPHER:
Nigel Harper

CAMERA:
35mm

LENS:
35mm

EXPOSURE:
¹⁄₁₂₅ second at f8

LIGHTING:
Daylight only

▲ *Space was tight either side of this group because of a car park and a public entrance to the building, so the photographer had to keep everybody close together. Changes of level were only slight as well, so people had to be ranked according to height. By using a moderate wide-angle lens off-centre to the group, a large expanse of uninteresting foreground was avoided.*

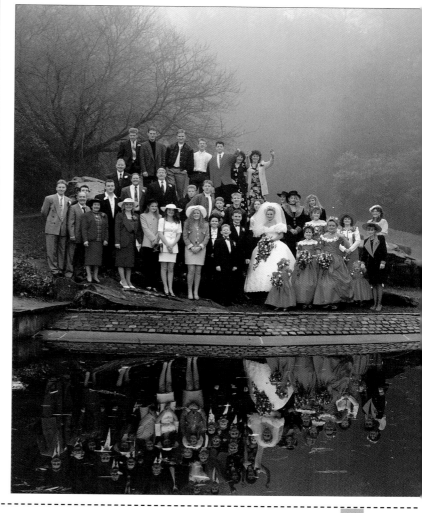

PHOTOGRAPHER:
Mandi Robson

CAMERA:
35mm

LENS:
85mm

EXPOSURE:
¹⁄₆₀ second at f11

LIGHTING:
Daylight only

▶ *As the mist thinned, the photographer quickly assembled the guests by the side of an ornamental pond, where she could take advantage of the reflections thrown back by the water. A variety of different levels was achieved by arranging people on the large boulders of a rockery. Luckily, most of the guests were wearing bright, strongly coloured clothing, which, when combined with the background mist, gives this photograph an almost theatrical quality.*

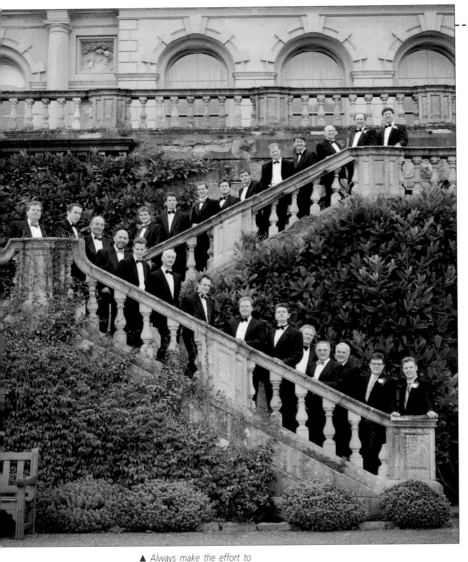

Which lens?

If the general conditions are cramped and you can't distance yourself much from the group, then you will have little option other than to use a wide-angle lens. On the popular 35mm camera format, a useful focal length is a 35mm wide-angle. A 28mm wide-angle is also suitable if it is a good-quality lens and free from distortion at the edges. Anything wider than 28mm is likely to show distortion as well as make the figures so small in the frame individual faces may hardly be discernible. Unless you are extremely close to the group, a wide-angle lens will tend to encompass a lot of the foreground between the camera and the subjects. If necessary, this can be cropped off during printing.

If you have plenty of free space to move back away from the group, then you may find that a moderate telephoto lens is a better bet – a lens of about 70-85mm for the 35mm camera format. These moderate telephotos are sometimes called portrait lenses because of the flattering effect they have on facial features, but their more restricted angle of view means they have to be used from further back for large groups.

▲ *Always make the effort to introduce a little humour into your photography if possible – weddings shouldn't be desperately serious affairs after all. Here the photographer has seen the light-hearted potential offered by this flight of steps, and has arranged one dinner-suited guest on each step. The effect is a little like seeing a parade of penguins, which, by the expressions on some of the faces, is a thought that had also occurred to those involved in the shot.*

PHOTOGRAPHER:
Nigel Harper

CAMERA:
6 x 7cm

LENS:
75mm

EXPOSURE:
⅟₆₀ second at f16

LIGHTING:
Daylight only

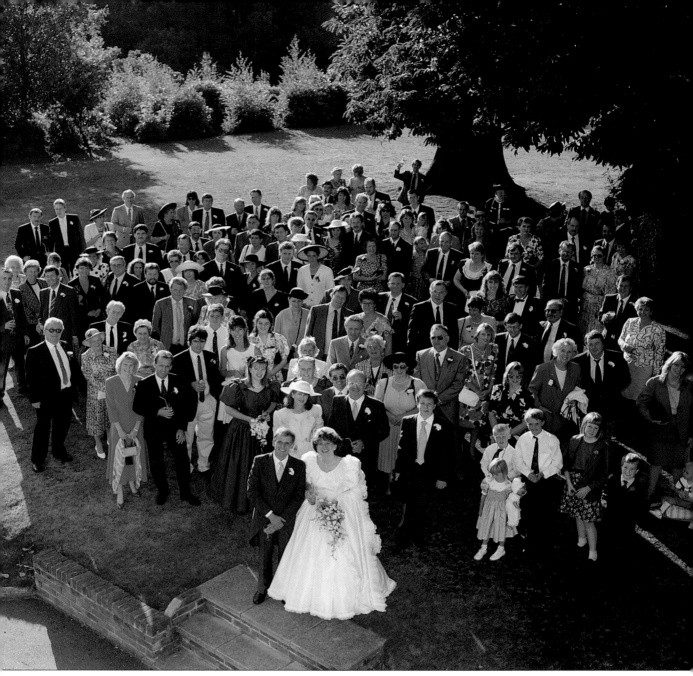

▲ The most appropriate way to organize the large-group portrait at this wedding reception was to allow people to come together in a loose group on the sun-lit lawn and then to take the picture from an upstairs window. Everybody seems happily relaxed and every face is clearly visible. However, do take care – if the window you shoot from is too high up, then people will have to bend their necks at an uncomfortable-looking angle in order to look at the camera.

PHOTOGRAPHER:
Trevor Godfree

CAMERA:
6 x 6cm

LENS:
85mm

EXPOSURE:
⅟₅₀₀ second at f11

LIGHTING:
Daylight only

THE FIRST DANCE

One of the rituals commonly observed at the wedding reception is the bride and groom taking to the floor for the first dance. If you have discussed the form the celebrations will take with the bride and groom before the ceremony, you will know in good time about detail such as this, and so you can be ready in position beforehand. You need to keep your wits about you at the reception and be sensitive to how the activities are progressing. Bear in mind that this is the newlyweds' occasion and you are there to, largely, record it as it happens. By asking the couple to go back and do it again because you were not ready, you are likely to miss out on capturing the spontaneity of the event. You may get the picture, but the expressions on the onlookers' faces will probably reveal the cheat.

PHOTOGRAPHER:
Nigel Harper
CAMERA:
35mm
LENS:
24mm
EXPOSURE:
⅟₂₅ second at f5.6
LIGHTING:
Daylight only

▲ The many people working behind the scenes are a vital component of a successful wedding celebration. Here, the photographer has turned his camera on the string quartet playing just out of sight of the main reception area. His foreground framing to include a topper and ladies' bonnets is a clever visual link to the celebrations in the next room.

PHOTOGRAPHER:
Nigel Harper
CAMERA:
35mm
LENS:
24mm
EXPOSURE:
⅟₂₅ second at f8
LIGHTING:
Daylight only

▶ Strong directional sunlight flooding into the reception venue throws hard-edged shadows onto the dance floor in front of the newlyweds. Lighting such as this creates a high-contrast image, which is extremely suitable for the black and white medium. By using a fast film (ISO1600), the photographer had extra flexibility with his exposure settings, since he was able to choose a fast shutter speed to freeze subject movement and a small aperture for additional depth of field.

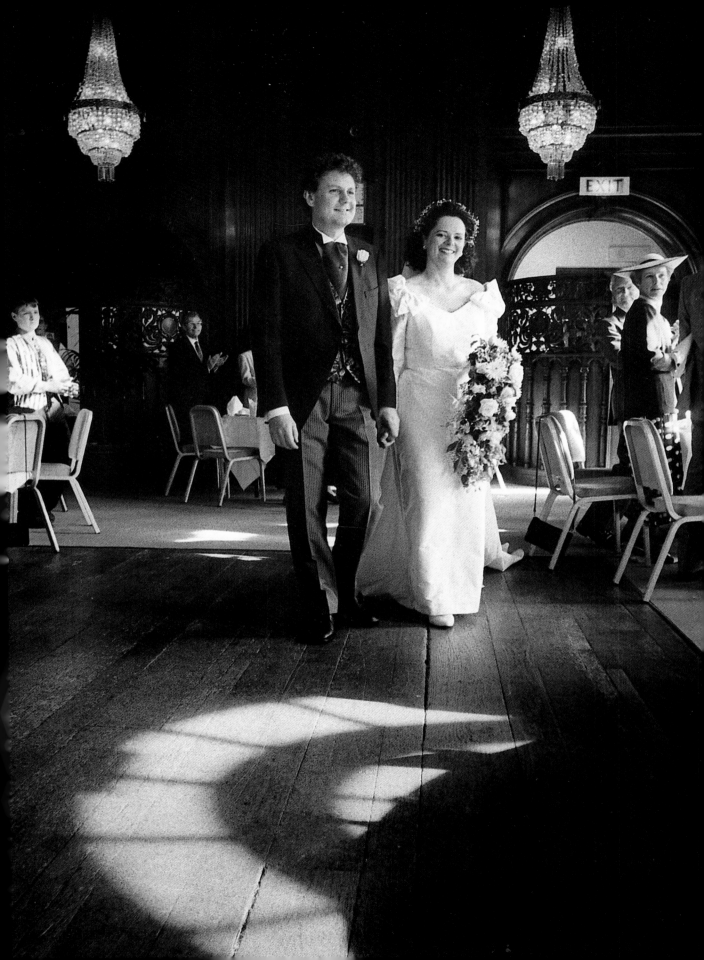

ELEMENTS OF
PORTRAITURE

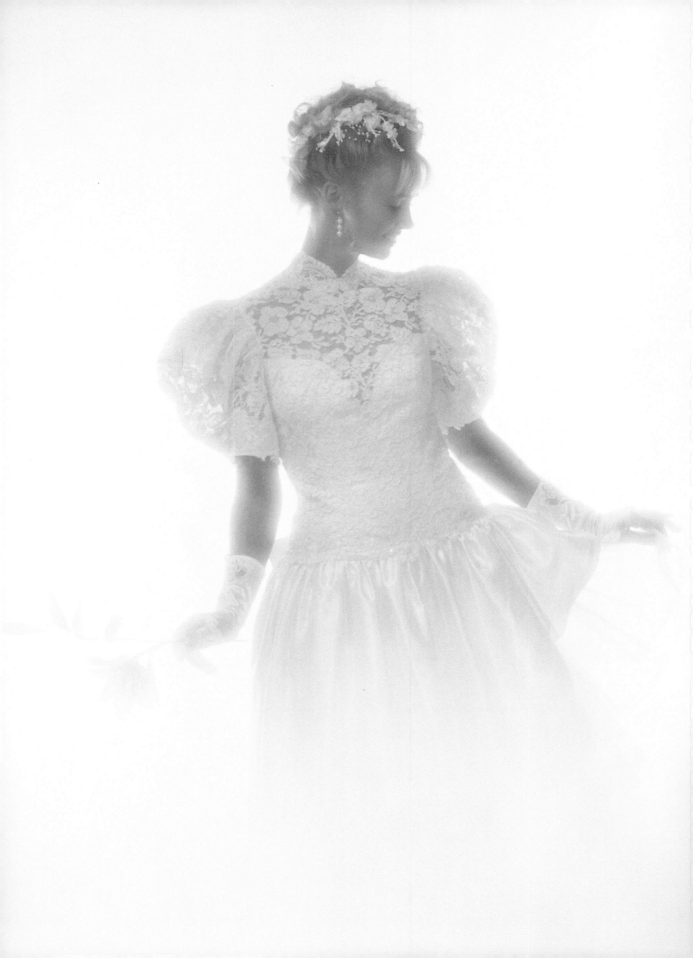

LIGHTING ATMOSPHERE

Studio portraiture is, by definition, more limited than location work in the type of backgrounds and settings that can be used. Thus, the atmosphere of a studio portrait is, largely, a function of the style of lighting adopted.

A "normal" subject is made up of a mixture of light and dark tones or colours, and an average exposure reading from a camera's built in metering system will endeavour to accommodate them all. However, by selectively metering, or using your camera's exposure-override facility, if available, you can alter the picture's lighting balance to conjure up the particular atmosphere you wish to create. Two broad terms used to describe very contrasting lighting styles are high-key and low-key.

A high-key photograph is composed predominantly of light tones or colours, while a low-key photograph concentrates on dark tones or colours. We all associate particular colours with certain moods and atmospheres. Yellows and reds, for example denote heat and passion, white is for purity, and blues and greens are considered cool, reserved colours. Likewise with tones: dark tones denote enclosed feelings, and can create images that are moody and perhaps even menacing. Light tones can produce images with an open, airy atmosphere; they seem candid, bright, and cheerful.

But not all the responsibility for the mood of a photograph rests on the lighting – the subject, too, must play his or her part. A vital part of the photographer's job conducting a portrait session is to pose the subjects in an appropriate fashion and to encourage them to use their facial expressions and their body language – the tilt of their head, the set of their shoulders, the tensing of muscles – to communicate with the camera and, through the camera, to the viewer of the photograph.

High key

To take a high-key portrait with an averaging exposure meter, first take the reading as you would normally and then set the camera controls to give about an extra stop's exposure – either open the aperture by one f stop (from f8 to f5.6, for example) or use the next slower shutter speed ($\frac{1}{125}$ second instead of $\frac{1}{250}$ second, for example). If you can take a selective exposure reading, perhaps by using a spot meter, fill the meter's sensor area with a darker-than-average colour or tone. This way, the meter will recommend, or set automatically, the aperture and shutter speed you require to produce a predominantly light-toned image.

PHOTOGRAPHER:
Jos Sprangers

CAMERA:
6 x 6cm

LENS:
80mm

EXPOSURE:
¹⁄₆₀ second at f11

LIGHTING:
Studio flash x 4, 2 with softboxes

◀ *Awash with light, this high-key portrait of a bride sends all the right signals of candour, openness, and purity.*

◀ *To produce a high-key lighting effect, you want to flood the subject with light. In this set-up, two studio flash units, both fitted with softboxes, were positioned either side of the camera position to provide a wash of frontal illumination. In addition, a flash unit low down behind the subject provided rimlighting, while a fourth flash was directed at the background paper.*

PHOTOGRAPHER:
Gary Italiaander

CAMERA:
6 x 6cm

LENS:
120mm

EXPOSURE:
⅟₆₀ second at f8

LIGHTING:
Studio flash and barn-doors, plus reflector

Low key

To take a low-key portrait with an averaging exposure meter, first take the reading as you would normally and then set the camera controls to give about one stop less exposure – either close the aperture by about one f stop (from f5.6 to f8, for example) or use the next fastest shutter speed ($\frac{1}{250}$ second instead of $\frac{1}{125}$ second, for example). If you can take a selective exposure reading, perhaps by using a spot meter, fill the meter's sensor area with a lighter-than-average colour or tone. This way, the meter will respond by recommending, or setting automatically, the aperture and shutter speed you require to produce a predominantly dark-toned image.

▶ Directional lighting, confined to fall mainly on the sides of the faces of the subjects, dark clothes, and an underlit set combine to produce a pensive, moody double portrait.

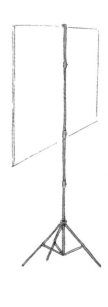

▲ The lighting set-up for this low-key double portrait is extremely simple – a single studio flash unit fitted with a set of barndoors. Barndoors have individually adjustable flaps so that the spread of light from the flash can be carefully fine-tuned. The flash was placed on the left of the camera position so that its light fell on the sides of the subjects' faces furthest from the camera. A small reflector, mounted on a stand at eye level, was placed to the right of the camera to give a little extra detail in the shadow areas.

USING THE FRAME

Using the term "photographic composition" can be problematic, since it brings to mind a set of rules that should be followed in order to achieve a satisfactory result. In fact, there are no photographic rules that cannot be broken. However, by being aware of how the arrangement of visual elements within the frame communicates different things, you will be in a better position to manipulate the audience's response to your work.

At its most basic, composition is simply the position of the subject, and any other elements making up the image, in a visually pleasing fashion within the area bounded by the viewfinder frame. A centrally placed subject tends to imply a lack of movement within the frame and it is the most static of arrangements. Positioning your subject toward one side of the frame, or more toward the top or bottom, immediately introduces a sense of movement and perhaps tension as well. And the use of diagonal lines, as opposed to vertical or horizontal ones, is another way of introducing tension and apparent movement.

Colour can be another compositional device. "Warm" colours – reds, yellows, oranges – tend to advance in the frame toward the viewer, while "cool" colours – blues, greens – tend to recede. In some circumstances, therefore, the impact on the overall composition of different subject elements can be altered through the use of colour. Colour, too, can affect our perception of the amount of space subject elements (objects or people) occupy within the frame, with some colours making them seem larger or smaller. This also applies to the tones of black and white, with dark tones seeming to occupy more space than light tones, for example.

▲ *When the subject is shown in profile like this (above left), include more free space in front of the face than behind it. This avoids producing an image that looks uncomfortably cramped. This is especially important here* *because the face is so tightly cropped at the top. To gain some impression of how the shot would have looked if his face had been more centrally framed, see the comparative illustration (above right).*

PHOTOGRAPHER:
Anthony Oliver

CAMERA:
6 x 6cm

LENS:
180mm

EXPOSURE:
¹⁄₁₂₅ second at f11

LIGHTING:
Daylight and studio flash

▲ *Tightly cropped at the top and side of the frame, this portrait shows a face full of character. Only one of the subject's eyes can be seen, and it is looking directly at the lens and, through it, at you.*

◀ The use of tone and shape in this double portrait gives the subject a solid, physical presence in the frame.

PHOTOGRAPHER:
Jos Sprangers

CAMERA:
6 x 4.5cm

LENS:
80mm

EXPOSURE:
⅟₃₀ second at f22

LIGHTING:
**Studio flash x 3,
1 with softbox**

◀ Triangular shapes always tend to produce a very stable, solid-looking composition. This factor has been reinforced in this portrait by the dark clothing worn by the subjects and the deliberate underlighting toward the bottom of the frame, which add to the pictorial "weight" of the subjects.

▲ A centrally framed subject usually produces a very static composition. Here, however, the photographer has directed the subject to adopt a pose that counteracts that "rule".

▶ The strongly diagonal lines formed by the subject's pose and posture, as well as his eye-line, which takes you out of the frame, produce a portrait full of movement and tension.

PHOTOGRAPHER:
Jos Sprangers

CAMERA:
6 x 6cm

LENS:
80mm

EXPOSURE:
⅟₃₀ second at f22

LIGHTING:
**Studio flash x 3,
1 with softbox**

PHOTOGRAPHER:
Jos Sprangers

CAMERA:
6 x 6cm

LENS:
100mm

EXPOSURE:
1/125 second at f8

LIGHTING:
**Studio flash x 2,
1 with softbox**

▶ *This picture breaks some of the "rules" of portrait composition – the subject's face is largely obscured and the subject's eyes are not engaging those of the viewer. But rules are meant to be broken, and it is an endearing and entertaining portrait nevertheless.*

▲ *One of the more useful rules of composition is known as the intersection of thirds. If you imagine that the frame produced by the viewfinder is divided both horizontally and vertically into thirds, then any subject element positioned on one of those lines is given additional emphasis. Particular emphasis is given to anything positioned on an intersection of lines, such as the child's eye in this portrait.*

Emphasizing Texture

The appearance of texture in photographs is the visual impression of what the surface being photographed would feel like if you could somehow reach into the frame and actually touch it. The importance of texture lies, therefore, in its ability to lift the image away from the flat two-dimensional paper on which it is printed and to give it a sense of realism.

Texture is most apparent when the light reaching the subject is directional, coming from the side and raking across the surface. Frontal lighting tends to have a texture-suppressing effect – something to bear in mind when you are trying to minimize the appearance of texture in, say, the clothing or skin of your subject.

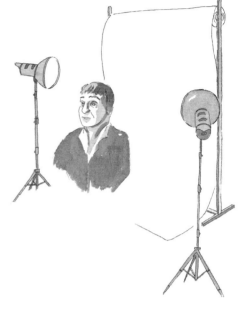

▲ The lighting for this studio portrait is hard and uncompromising. The face has been lit with a single studio flash unit to the left of the camera position and three-quarters on to the subject. The addition of a snoot to the front of the light narrows and concentrates the flash's output, ensuring that there is no unwanted spill-over of illumination into other parts of the face. Behind the subject, out of sight of the camera, two flash units have been directed at the plain background paper to kill any shadows thrown behind the subject and to ensure that he is seen against a toneless area of white.

PHOTOGRAPHER:
Anthony Oliver

CAMERA:
6 x 6cm

LENS:
120mm

EXPOSURE:
⅕₀ second at f16

LIGHTING:
Studio flash x 3

▲ To better see how directional lighting enhances surface texture, a small area of the subject's face has been reproduced here as an isolated and enlarged detail (far left). In the diagrammatic representation (left) you can readily see that directional lighting tends to strike the raised parts of the surface, creating a series of minute areas of highlighting. At the same time, each raised area casts a tiny shadow into its adjacent dip or hollow.

It is the contrast between these highlights and shadows that produces the visual impression of texture in the photographic image. If the lighting for this portrait had been more frontally arranged, then both the "peaks" and the "valleys" would have been equally illuminated, and the lit surface would have appeared relatively flat, and certainly less interesting.

PHOTOGRAPHER:
Mark Gerson

CAMERA:
6 x 6cm

LENS:
135mm

EXPOSURE:
¹⁄₃₀ second at f8

LIGHTING:
**Daylight and tungsten
photoflood**

EFFECTS:
**Negative printed through
texture screen**

▶ *Sometimes, the camera image is merely the first step in the picture process. In this shot of the Irish novelist and playwright Edna O'Brien, texture has been added to a "straight" portrait by printing it through a specially prepared screen. Texture screens can be bought ready made in a range of patterns, but it is relatively simply to make a screen to suit your specific requirements.*

MAKING AND USING A TEXTURE SCREEN

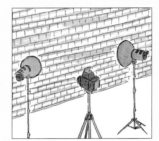

Find the appropriate surface pattern or area of texture to photograph that will become your texture screen. Move in close to fill the viewfinder frame with it, and then produce a series of negatives that are about two to three stops underexposed.

Process the negative, but underdevelop it by about 25-35 per cent. Vary the camera exposure and development time of the screen image as necessary until you have a negative of the right density.

Once this very thin negative is fully processed and dried, place it in the negative carrier of the enlarge, emulsion to emulsion with the negative of the portrait you have taken and expose them both together onto the same piece of printing paper.

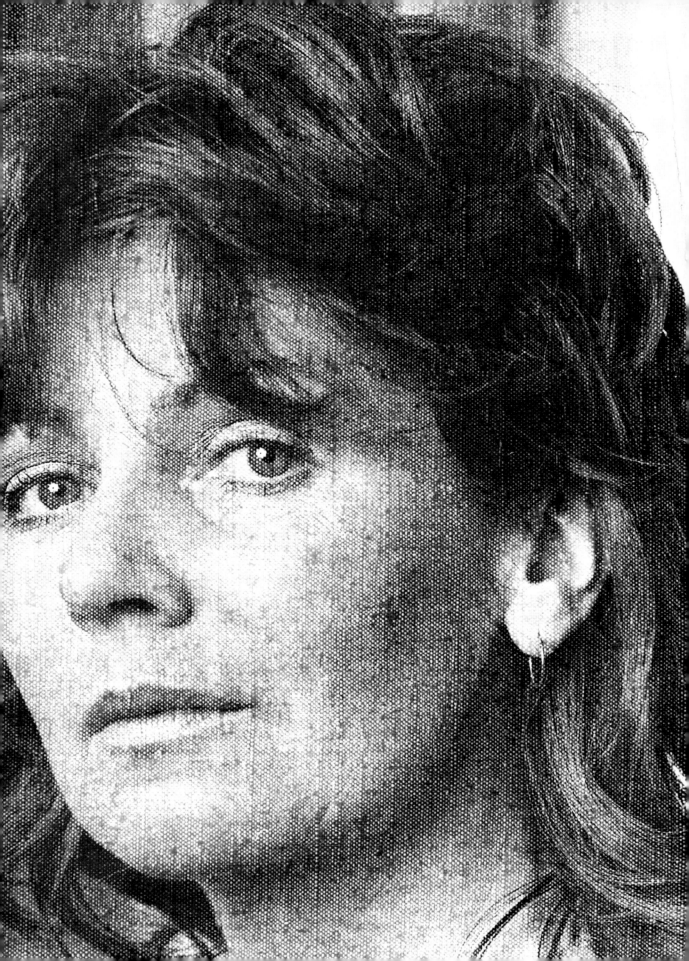

ACCENTUATING FORM

Whereas the appearance of texture in photographs depends on the often sharp contrast between lit and unlit subject planes, or surfaces, form is better described by the graduation of light and shadow as they merge and blend together to produce a sense of roundness and solidity. It is the visual impression of a subject's form that helps to give the photographic image its three-dimensional quality.

If form is an important element in the portrait you have in mind to shoot, then you need to pay particular attention to how you set the lights. Using studio or hand-held flash may sometimes be a disadvantage here. The burst of light from flash is virtually instantaneous and, thus, it can be difficult to judge precisely how the light and shade is falling on your subject until you see the processed results. Unless you are very experienced with flash, you may find continuous-output tungsten lighting and/or daylight easier sources to work with.

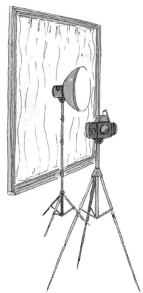

PHOTOGRAPHER:
Nigel Harper

CAMERA:
6 x 7cm

LENS:
180mm

EXPOSURE:
$\frac{1}{125}$ second at f5.6

LIGHTING:
Diffused daylight, photoflood, and reflector

EFFECTS:
Chemical toning

▲ The principal light source for this photograph was window light, diffused by net curtaining slightly to the left and behind the camera position. A photoflood next to the camera provided more frontal lighting, and a reflector, low down to the right of the camera, returned enough light to ensure the baby's downturned face was not lost in shadow.

▶ The soft roundness and solidity of this joint portrait of a mother and her young baby are the result of diffused daylight supplemented by light from a photoflood. Although neither is making eye contact with the other, the relaxed way in which the baby's head rests against her mother's cheek makes evident the bond of affection between them.

▶ In this portrait, the use of form to imply the dimension of depth can be seen to best advantage in the subject's hat face, and hands, as well as in the tangible roundness of the tulips resting on the table in front of her.

PHOTOGRAPHER:
Nigel Harper

CAMERA:
6 x 7cm

LENS:
100mm

EXPOSURE:
¹⁄₃₀ second at f4

LIGHTING:
Spotlight, photoflood, and reflector

EFFECTS:
Chemical toning

▼ Lighting here is principally from the left of the camera. A tungsten spotlight, used well back from the subject, creates the highlight on her cheek, while a photoflood, fitted with a scrim to soften its effects, was placed about half that distance away. To the right of the camera, a reflector on a lighting stand returns some light to that side of the subject's face.

*U*TILIZING SHAPE

O f all the picture components, shape is probably the most fundamental. It does not, for example, rely on the surface characteristics of the subject, as does texture, or imply its solidity, as does form.

Shape is one of the pictorial devices used by photographers to create divisions and compartments within the frame, to add interest to the composition, and to guide the viewer's eye around the picture's content. Shape can be defined within the subject itself – by bone structure, for example, or by the fall of a person's hair or by clothing – or it can be external to the subject, yet still remain a key element of the overall composition.

PHOTOGRAPHER:
Nicholas Sinclair

CAMERA:
6 x 6cm

LENS:
150mm with 8mm extension tube

EXPOSURE:
1/60 second at f5.6

LIGHTING:
Studio flash with softbox and reflectors

◄ The use of shape here is subtle but telling. The lighting emphasizes the bone structure of the woman's face, which stands out against a featureless background. The photographer has also used the picture edges, cropping in to the top of her head to emphasize the shape of the frame in which she appears. Finally, the eye is drawn to the V-shape of her neckline, which takes your attention downward, where it is brought to a halt by the bottom of the picture frame.

Hints and tips

● To reduce a subject to pure shape, without texture or form, arrange the lighting to produce a silhouette. The stronger the contrast between highlight and shadow areas, the stronger the potential silhouette will be.

● The strongly rectangular or square shape of the picture frame can become a part of the photograph's composition.

▲ Here the photographer has used the picture edges to restrict and confine his young subjects, producing an almost claustrophobic effect. Shapes within the composition, formed by the straight and curved sections of the wrought-iron gate, act as individual spaces in which the subjects have been carefully aligned.

PHOTOGRAPHER:
Nigel Harper

CAMERA:
35mm

LENS:
50mm

EXPOSURE:
½₅₀ second at f4

LIGHTING:
Daylight only

SPECIAL OCCASIONS

Most commercial portrait photographers depend heavily on being commissioned to take "special occasions" pictures. When children are young, for example, they change physically very dramatically from year to year, and parents may have an annual portrait taken on or near their birthdays. Graduations, confirmations, bar mitzvahs, and anniversaries are all important events, but the occasion that brings in most revenue is without doubt wedding photography. Indeed, some commercial studios specialize in little else, and a good set of studio portraits before the wedding day will almost certainly lead on to a commission to cover the ceremony and perhaps the reception, too.

◀ After settling the bride and groom in position and arranging the woman's gown, the principal lights were set up to the right of the camera and higher up on the left. Using a snoot ensures that the beam of light falls only in a restricted area. Further back, another flash, with a softbox attached, was used to throw a dappled shadow on the rear wall. You can cut out and tape any pattern to the front of a softbox for this type of shadow effect.

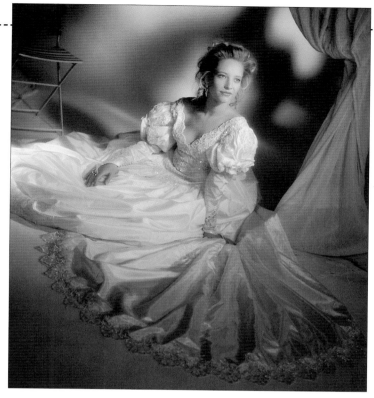

◀ ▶ *The most elaborate piece of wedding finery is undoubtedly the bridal gown. Much care, attention, and money are lavished on these creations and they need to be carefully arranged and precisely lit to show them and, of course, those wearing them, to the best possible advantage.*

PHOTOGRAPHER:
Jos Sprangers

CAMERA:
6 x 6cm

LENSES:
50mm and 80mm

EXPOSURE:
1/30 second at f16

LIGHTING:
**Studio flash x 3,
1 with snoot and
1 with softbox**

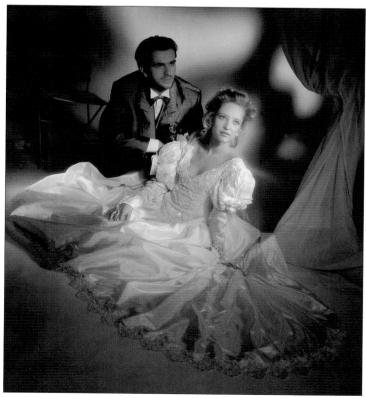

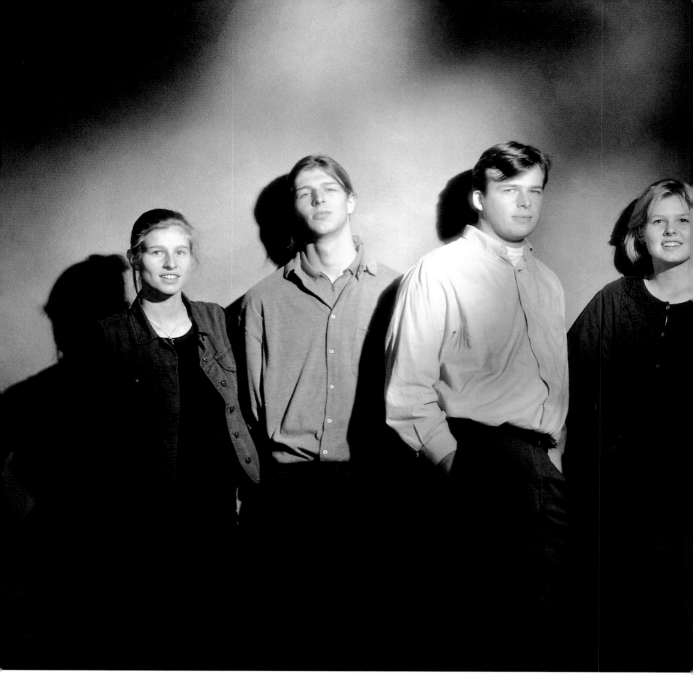

▲ High school graduation was the occasion that prompted this group portrait. These teenagers had a firm idea about how they wanted to be photographed, and so the photographer arranged a simple lighting scheme to match the mood created by their informal poses.

◀ Just a single studio flash was used to light this group. It was positioned to the right of the camera, set at an angle that sent light raking across the subjects, which accounts for the steadily lengthening shadows as you move down the line-up of figures.

▲ This celebratory double portrait marks this couple's 40th wedding anniversary. The lighting was kept as frontal as possible to minimize the appearance of creases and wrinkles on the skin.

▲ The principal light used for this portrait was a studio flash with a snoot attached to throw a tightly controlled beam of light. The light was set to the left of the camera, while a reflector to the right ensured that contrast on the subjects' faces was kept to a minimum. Behind the subjects, another flash was used to light the background paper.

PHOTOGRAPHER:
Math Maas

CAMERA:
6 x 7cm

LENS:
100mm

EXPOSURE:
¹⁄₆₀ second at f16

LIGHTING:
Studio flash x2, 1 with snoot, and reflector

WORKING TO A BRIEF

The potential of photography to communicate with a target audience is a potent force, so much so that photographers can sometimes be given a tightly detailed brief by clients specifying precisely the type of image they want produced. Actors, politicians, artists, business leaders, authors, musicians, models, and others in many different walks of life make use of photography to ensure that they are instantly recognized by particular groups of people.

PHOTOGRAPHER:
Mark Gerson

CAMERA:
6 x 6cm

LENS:
135mm

EXPOSURE:
⅟₃₀ second at f8

LIGHTING:
Tungsten floodlight and 2 tungsten spotlights

▲ The main light for this portrait was a 500w tungsten floodlight positioned to light principally the far side of the subject's face. Another light, a tightly focused spotlight, was used to create the highlight on his hair, while a third light was positioned behind the subject to create the graduated tone on the background paper.

◄ This formal portrait of the Trinidadian novelist Vidiadhar Surajprasad Naipaul was commissioned by the National Book League in the UK. The organization wanted a dramatically lit portrait of the author to use as a publicity poster.

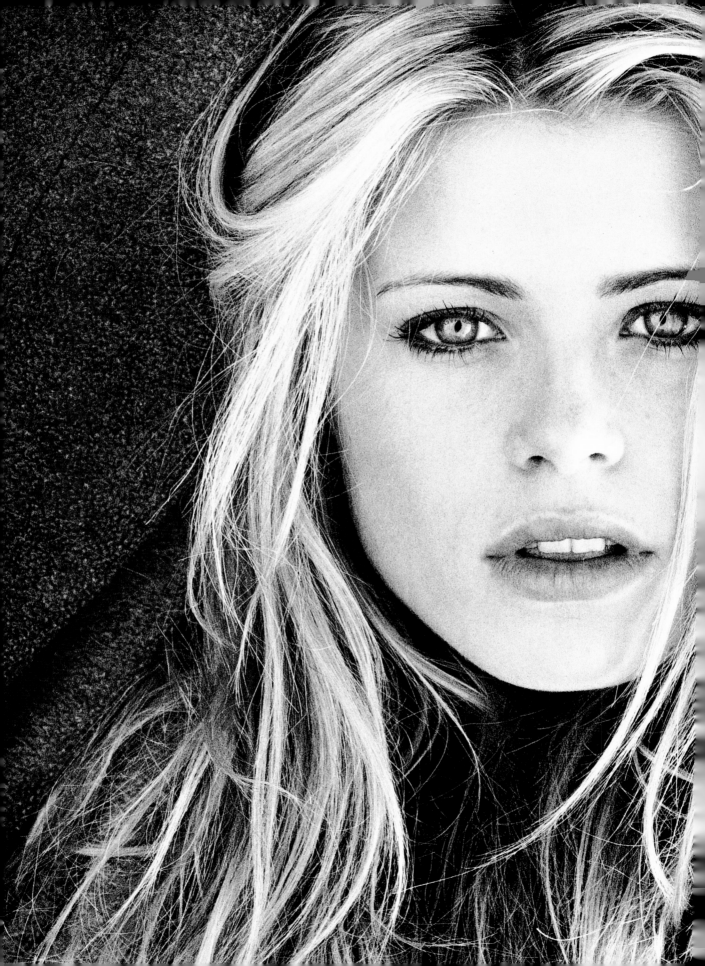

◀ Models have a constant need for new and imaginative portraits to keep their portfolios fresh and up to date. Agencies frequently commission new material of the models on their books for submission to picture editors, advertising agencies, and casting agents.

PHOTOGRAPHER:
Richard Braine

CAMERA:
6 x 6cm

LENS:
180mm

EXPOSURE:
⅟₈₀₀ second at f5.6

LIGHTING:
Studio flash

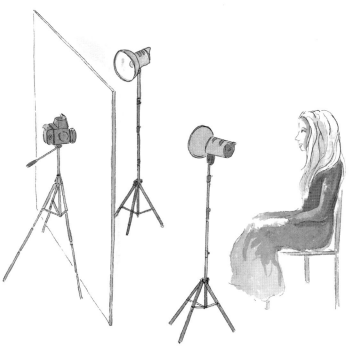

▲ To produce the even, virtually shadowless lighting used for the subject of this portrait photograph, studio flash was bounced off a large white paper screen. Within the area of the screen, a hole was cut to accommodate the camera lens.

PHOTOGRAPHER:
Robert Hallmann

CAMERA:
6 x 7cm

LENS:
105mm

EXPOSURE:
⅟₆₀ second at f16

LIGHTING:
Studio flash x 2

▶ A fun commissioned photograph of artist Jim Mawtus looking upward to meet the gaze of his self-portrait.

▶ A high-contrast, dramatically lit portrait such as this could be ideally used as a poster or record sleeve. The large area of dense black could be used to carry a lot of editorial information, reversed out as white type. A light reading was taken from the subject's face and the tungsten studio lights balanced so that one exposure would suit the subject's face, hands, and saxophone while leaving the rest of the set, and his dark-coloured clothing, massively underexposed.

PHOTOGRAPHER:
Anthony Oliver

CAMERA:
8 x 10in

LENS:
180mm

EXPOSURE:
½₅₀ second at f16

LIGHTING:
Tungsten spotlights x 3

PHOTOGRAPHER:
Trevor Leighton

CAMERA:
6 x 7cm

LENS:
50mm

EXPOSURE:
½₅₀ second at f4

LIGHTING:
Studio flash x 2

▲ The flamboyant and effervescent personality of the fashion and portrait photographer Norman Parkinson shows through magically in this studio portrait. His hands, which punctuated the air whenever he spoke, act as frames, not only confining his face within the picture area but also contrasting in tone with the brightly lit background. A low camera angle helps to enhance the subject's stature.

◀ Direct flash used low down creates a theatrical lighting scheme, not unlike that of the footlights at the front of a stage. Behind the subject, out of sight of the camera, another flash has been used to light the backdrop. This differentiates it tonally from the top of the subject's head.

◄ ► *A similar approach has been adopted by the photographer of these two personalities – the actor John Hurt (left) and novelist and poet Kingsley Amis (right). For both portraits, the lighting is indirect – a single studio flash fitted with an umbrella reflector.*

PHOTOGRAPHER:
Trevor Leighton

CAMERA:
6 x 7cm

LENS:
120mm

EXPOSURE:
1⁄25 second at f11

LIGHTING:
Studio flash and umbrella reflector

THE FOUR AGES

BABIES AND TODDLERS

One of the main problems when photographing babies and young toddlers is that they are not able to support themselves – at least, not reliably so. This means that they often have to be shown either with an adult cradling or otherwise supporting them, or with some other object on the set that they can hold on to. In fact, this can often be turned to your advantage, since it is then possible to emphasize their diminutive size.

Your approach to photographing babies and toddlers has to be very different to the way you would tackle a portrait of an older child or adult. First of all, since your young subject will not realize who you are or what you are doing, you cannot expect any active co-operation. Instead, you will have to be patient and rely on your reflexes not to waste any photo opportunities that occur. Also bear in mind that the movements of babies are not predictable, so you need to use a lens focal length and camera position that allow a little space around the subject in case of any sudden, unexpected movements. The height of the camera and lights is also critically important. If lights are set too high the subject will be basically toplit, which could result in unattractive shadows being cast down over the face. In most situations, the height of the camera should be at about the level of your subject's eyes. If you shoot from a camera position suitable for an adult, you will be looking down on the child, making him or her seem even smaller.

PHOTOGRAPHER:
Jos Sprangers
CAMERA:
6 x 6cm
LENS:
85mm
EXPOSURE:
⅟₂₅ second at f8
LIGHTING:
Tungsten spotlight

◄ *The lighting in this portrait, a tungsten spotlight, is an integral part of the image. Its beam has been made more visible in the darkened studio by the addition of just a little well-dispersed smoke in the air.*

Hints and tips

● A young child will be happier and more relaxed if the surroundings are warm and comfortable and his or her mother is close at hand. Soothing background music is a good idea, too.

● Keep photographic sessions short so as not to tire your young subjects – about 15 to 20 minutes is probably the upper limit.

● With luck, after the first two or three firing of the flash, a baby will soon learn to ignore these sudden explosions of light. If the baby will not settle, however, it may be better to use daylight or continuous tungsten.

◀▶ *In both of these photographs, a parent has been included in the set-up to support the tiny subjects. Both of the babies have obviously drawn comfort from their presence and they look very relaxed. By introducing an adult, you can readily see just how small they are.*

PHOTOGRAPHER:
Jos Sprangers

CAMERA:
6 x 4.5cm

LENS:
105mm

EXPOSURE:
½₅₀ second at f5.6

LIGHTING:
Studio flash with softbox

◀ *To make a white vignette, print the image through a piece of stiff opaque cardboard with a hole cut in it corresponding to the part of the image you want to be seen. Where the cardboard blocks the light from reaching the printing paper, no tone will appear.*

NOVELTY PORTRAITS

Since most children enjoy being the centre of attention, it is usually not too difficult to encourage them to dress up for the camera for a series of novelty portraits. And things will go far smoother if you turn the photographic session into a game.

With the session illustrated here, the child was initially a little hesitant about posing in front of the stand supporting the angel's wings and halo. To encourage the right atmosphere, the photographer's assistant was the first up in front of the lights. By taking a few frames of his assistant, the photographer was able to show the girl that she was there to have fun, and that the studio flashes were nothing to be frightened of. Even so, there was an adult present the child knew throughout the entire session.

◀ ▶ *It is astonishing how many mood changes a child undergoes during the course of a 30-minute photo session.*

PHOTOGRAPHER:
Anthony Oliver

CAMERA:
6 x 6cm

LENS:
120mm

EXPOSURE:
¹⁄₆₀ second at f11

LIGHTING:
Studio flash with softboxes x 2

◀ *Two studio flash units, both fitted with softbox diffusers, were positioned either side of the camera. Because of the diminutive size of the subject, both lights were set low down to ensure that the little girl's face was properly lit.*

FLEXIBLE WORKING

Older children are a mixed blessing in the studio. They can be refreshing to photograph because they tend to be uninhibited – once the initial shyness has been overcome – and are usually very willing to co-operate. This is especially true if you introduce some fun and play elements into the photo session.

On the down side, children's concentration span is extremely limited and their moods can swing wildly from laughter to tears in a matter of seconds. You will almost certainly lose their attention if you spend too much time fiddling with lights or reflectors and adjusting backgrounds between shots, and then you will probably have to spend most of the session coaxing them back onto the set and settling them down once more.

You can minimize a lot of problems if you create a base for your young subjects for the session. Once they accept it as "their territory" you have a focus around which you can set your lights. In the example here, and on the following pages, a chair has been used in just this way. Once you know where physically the child will be, set about arranging your lights. Only at the last minute call your subject onto the set for a light reading and any last-second adjustments.

Aim for a broad lighting scheme, relying more on photofloods or flash units with flash umbrellas and large reflector boards, rather than spotlights. You don't want a situation where a sudden turn of the head or an unplanned fidget in the chair destroys a too-precise lighting scheme.

◄ ▲ *For the first of these pictures (left), the little boy's mother was helping by talking to him and telling him stories to try and make him laugh. To record a variety of facial expressions, for this next shot (above) the photographer called out the boy's name and quickly snapped him as he looked around in response.*

PHOTOGRAPHER:
Gary Italiaander

CAMERA:
6 x 4.5cm

LENS:
100-200mm

EXPOSURE:
⅟₆₀ second at f8

LIGHTING:
Studio flash x 2, one with umbrella, and large reflector boards

EFFECTS:
Diffusion filter used for black and white photographs during printing

▲ Most medium-format cameras are ideal for studio work when you want to take a mixture of colour and black and white – all you need do is remove the film back, even in mid-roll, and snap on another preloaded with the other type of film. The first shot of this pair (above) is in black and white. However, as the photographer paused to change films the boy started to take an interest in what he was doing, which resulted in the second colour shot (above right) of him staring intently at the camera.

◄ To create an easy and flexible lighting scheme that didn't rely on the subject adopting a precise pose, the main light was set up to the left of the camera. This flash unit was fitted with a flash umbrella to produce a broad spread of illumination. In an arc on the other side of the subject, large white reflectors were set up to confine and reflect the light within the area around the chair. Between the boards, a second flash unit without reflector was used to create localized highlighting.

▲ ▶ The flexibility of using a zoom lens is demonstrated by these two photographs. Both were taken from about the same camera position as the previous ones in this set, but here the boy can be seen in the equivalent of a full-length portrait. The toys and books can also be seen here being put to good use.

Hints and tips

● Provide a few toys, games, and books for children to use while in the studio. This will prevent them from becoming bored as they wait for their turn in front of the camera and lights.

● All children should be accompanied by a responsible adult while in the studio.

● You will elicit more co-operation from children if you make their studio session into a fun time for them.

● Using a zoom lens will allow you to vary subject framing, from close-ups to full-length shots, from about the same camera position and without having to alter the position of lights. Zooms also allow you to capture fleeting facial expressions that you would almost certainly miss if you had to change lenses.

BACKLIGHTING

One of the most commonly used studio lighting schemes is based around a three-light set-up: a main light, a fill-in light, and a toplight. The main light, as its name implies, provides the principal illumination for the subject, or subjects. This light is often positioned somewhere to one side or the other of the subject to provide directional lighting.

The fill-in light will usually either be of less power than the main light or be positioned further back from the subject so that its light has less effect. Often, this light is positioned on the other side of the subject from the main light in order to lighten – or fill-in – the shadow areas on that side. Sometimes you will find that the fill-in light is substituted by a large reflector, which serves the same function by reflecting light from the main light back onto the subject's shadow side.

The toplight is used most often above the subject's eyeline, illuminating, say, the persons head and shoulders. One of the functions of this light is to help to differentiate the subject from the background.

When the top light is taken further around the subject, so that its light strikes the subject from the rear, this is known as backlighting. This type of lighting scheme is most often employed to produce what is known as rimlighting – a halo-like effect surrounding the subject's head and shoulders. As well as being an attractive lighting effect in its own right, backlighting more strongly separates the subject from the background than does toplighting.

◀ *In this portrait, the main light to the right of the camera and the fill-in light to the left were supplemented by a light positioned behind the subject's back. From here, its light floods through the paper umbrella she is holding and produces an attractive rim of illumination around her wispy hair, shoulders, and arm.*

PHOTOGRAPHER:
Gary Italiaander
CAMERA:
6 x 6cm
LENS:
120mm
EXPOSURE:
⅙₀ second at f5.6
LIGHTING:
Studio flash x 3

FORMAL PORTRAITS

Babies and toddlers can't be directed into specific poses and so the photographer needs to adopt more of a candid approach, picking off shots as and when the opportunities arise. With older children, however, there is the option of taking more formal portraits.

As with portraits of adults, which follow later in this chapter, the photographer has to make great efforts to record something of the subject's character and personality. A friendly and chatty approach often works well, helping the child or children to relax and express themselves in front of the camera. But beware of being patroniz-ing or condescending – children are intuitive, often more so than adults, and they may become unresponsive if they feel you are being insincere.

Whether or not to shoot a formal portrait in the studio or in the subject's home depends very much on the personality of the child concerned. Some children might love the adventure aspect of visiting the studio and so respond well to the situation. Others, however, might go "wooden" in the same situation and would be better photographed at home where they are surrounded by all the familiar things that make them feel safe.

PHOTOGRAPHER:
Gary Italiaander

CAMERA:
6 x 6cm

LENS:
90mm

EXPOSURE:
1/125 second at f8

LIGHTING:
Studio flash x 2

Hints and tips

● Allow a little time before the photography session actually starts so that the children can become used to both you and your equipment.

● To encourage a spirit of co-operation between you and your subjects, let them look through the viewfinder of the camera while you pose in front of the lens.

● If the children are interested and ask questions about what you are doing and why, take the time to give as full an explanation as you think they will understand.

● If children seem nervous and unrelaxed, make the first few exposure without any film in the camera. When they have become used to the clunking of the shutter and the flash of the lights they may relax more and make better subjects.

● Keep the photographic session short. A child's attention span is less than that of most adults.

▶ A well-composed studio portrait of a young sitter turned sideways to the camera but with her head turned to produce a three-quarter view. The formality of the pose is nicely set-off by her simple string of pearls and the addition of just a little lipstick to bring out the colour in her lips.

◀ Scrubbed clean and neatly pressed, this young sitter is obviously extremely proud of his Foreign Legion uniform. The background to the subject is domestic, but the lens aperture was large enough to produce such a limited depth of field that any detail was reduced to a blur. The lighting is flash, diffused and low-key, but the tungsten table lamp that can be seen shows up as a warm and pleasant orange cast on the film, which was balanced for flash and daylight.

PHOTOGRAPHER:
Nigel Harper
CAMERA:
35mm
LENS:
90mm
EXPOSURE:
⅟₁₂₅ second at f8
LIGHTING:
Studio flash heavily diffused

▶ Much of the appeal of this charming portrait is due to the young subject's pose, which is reminiscent of the type you would expect to be adopted by an older person. The lighting is soft and gentle and her upturned glance toward the camera helps to emphasize the shape and size of her eyes. A lens diffusion filter with a clear centre spot has created a slightly soft-focus effect around the periphery of the frame.

PHOTOGRAPHER:
Nigel Harper
CAMERA:
35mm
LENS:
70mm
EXPOSURE:
⅟₁₂₅ second at f4
LIGHTING:
Accessory flash heavily diffused

INFORMAL PORTRAITS

I t is the very variability of children's moods that makes them such interesting and challenging subjects for the portrait photographer. If your intention is to take informal portraits, then you should try to intrude as little as you possibly can on your subjects. And their own homes may be a better venue than a studio, where they are less likely to feel relaxed. For the first few minutes after your arrival, they will be naturally curious about you and your equipment, but it won't be long before they become engrossed once more in their own activities – giving you the chance to start work.

Which lens?

For informal portraiture, which is like candid photography in many respects, it is better if you can distance yourself as far as possible from your subjects. In this way, your presence won't unduly influence their activities. For the popular 35mm camera format, one of the best lenses to use is a 135mm telephoto. With this lens you should be able to fill the frame with a head-and-shoulders shot from a distance of about 3 metres (10 feet). A telephoto lens with a wide maximum aperture is best (say, about f2.8) because you will be able to shoot in quite poor light without flash while maintaining a shutter speed brief enough to freeze most normal subject (and camera) movement. As lenses become longer, they also become heavier, making some sort of camera support essential to prevent camera shake. But for flexibility of framing, an excellent choice of lens is a 70-210mm zoom, although with most zooms you will have to sacrifice a little lens speed.

PHOTOGRAPHER:
Nigel Harper

CAMERA:
35mm

LENS:
80-210mm zoom

EXPOSURE:
1/60 second at f11

LIGHTING:
Daylight only

▶ *Taken with a telephoto zoom lens, this informal and very relaxed portrait takes advantage of the difference in exposure between the boy's face and his shadowy surroundings to suppress the background. The picture was taken indoors by window light.*

Caught totally unawares by the camera, this young boy had taken himself off to his private thinking place just outside the back door of his house and the picture was taken from indoors through an open window.

▲ *To produce a warm-looking type of light, the photographer used an orange-coloured filter over the camera lens. The general colour cast produced as a result is reminiscent of the light from an open fire. The main illumination was an accessory flash unit, direct and undiffused, but slightly to the left of the camera position to make the light more directional.*

PHOTOGRAPHER:
Nigel Harper

CAMERA:
35mm

LENS:
135mm

EXPOSURE:
1/125 second at f5.6

LIGHTING:
Daylight only

PHOTOGRAPHER:
Majken Kruse

CAMERA:
35mm

LENS:
90mm

EXPOSURE:
1/60 second at f8

LIGHTING:
Accessory flash

FAMILY PORTRAIT

This portrait, of the photographer's daughter, is technically the type of result you could expect to achieve in an averagely equipped home studio. The subject has been lit entirely by artificial light – a single studio flash unit fitted with a softbox, which spreads and softens the illumination, and a reflector on the far side of the subject to relieve the shadows slightly.

The key to the impact of this portrait lies in its simplicity and it eloquently makes the point that it is not the equipment used that determines the success of any particular photograph; rather, it is the perception and talent of the photographer.

Even when looked at in detail, the image is virtually free of any signs of graininess. The skin of the subject is smooth and flawless, and every ringlet of hair is clearly defined. Modern emulsions, especially the slower types such as the one used here, which is ISO 100, will tolerate a high degree of enlargement before grain becomes a concern.

PHOTOGRAPHER:
Linda Sole

CAMERA:
6 x 6cm

LENS:
150mm

EXPOSURE:
1/125 second at f5.6

LIGHTING:
Studio flash with softbox and reflector

EFFECTS:
Diffusion filter

▲ The studio flash and softbox provided the principal illumination here, with the reflector board used to lighten the shadow a little and prevent the lighting becoming too contrasty. To mask off the rest of the studio, black background paper was used. This was positioned well behind the subject to prevent any stray light from the flash spilling over onto it and producing an unwanted grey tone.

▶ In order to soften the image slightly a diffusion, or soft-focus, filter was used over the camera's lens. Then, during printing, the image was further softened by printing it through another diffusion screen.

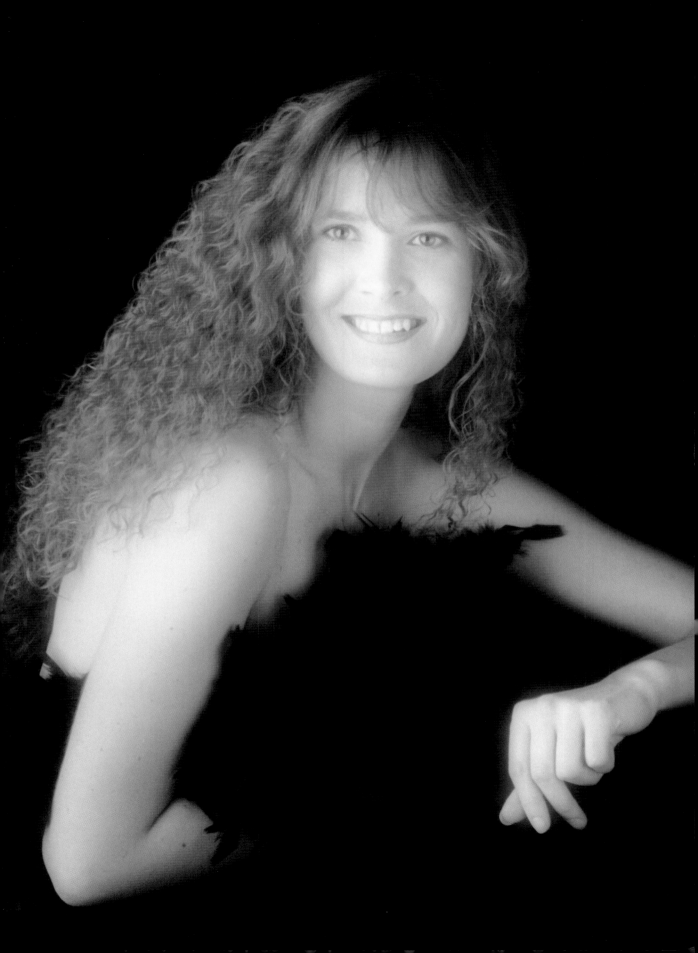

ON LOCATION

Not all photographers favour the studio approach to portraiture, or even necessarily have their own studio in which to work. However, most will at least have access to studio facilities, which can be hired by the hour or day, whenever the necessity arises.

Not having a studio base is by no means a disadvantage. Indeed, many potential clients prefer the photographer to visit them at home to discuss the approach to be adopted for a portrait session and then to take the pictures there on location. People can find the studio to be a strange and rather forbidding place, and simply can't sufficiently relax and allow their "real selves" to come through in front of the camera.

When visiting a client's home with a view to using it for photography session, pick a time of day that corresponds to the time the actual session will take place. In this way, you will be able to look at each room, note where the windows or balconies are located in relation to walls and so on you may want to use as backdrops, and see exactly how much natural light you will have to work with.

It is not only the quantity of light that is a consideration; you also need to asses its quality. Daylight flooding in through large picture windows, for example, may be far too overpowering for the type of images you want to produce. In this type of situation, make sure you take along with you on the day some sort of diffusing material, such as sheets of tracing paper, that can be temporarily stuck onto the glass to manipulate lighting quality.

PHOTOGRAPHER:
Majken Kruse

CAMERA:
6 x 6cm

LENS:
105mm

EXPOSURE:
⅟₆₀ second at f8

LIGHTING:
Diffused daylight

▶ *The light for this home portrait came from a large picture window immediately to the subject's left. Even with the blinds drawn, as they are in the picture here, the light was still far to bright, and so lengths of fine gauze, similar to the material used for some net curtains, were taped to the glass to act as a diffuser.*

◀ Because the light levels in the room in which this photograph was taken were extremely poor, they had to be supplemented by two accessory flash units with layers of tracing paper taped over their lighting heads. Both flashes were slightly elevated to ensure that any shadows cast by the subject onto the wall behind would be masked by her own body, and so would not be visible in the final photograph.

PHOTOGRAPHER:
Majken Kruse

CAMERA:
6 x 4.5cm

LENS:
90mm

EXPOSURE:
¹⁄₂₅ second at f8

LIGHTING:
**Diffused flash x2
and daylight**

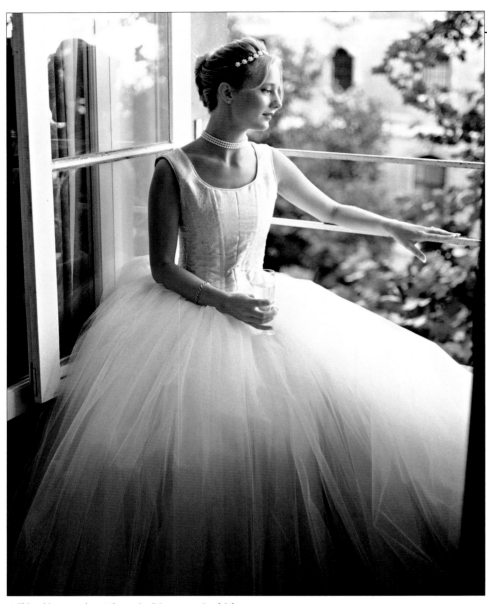

▶ Bright light from a mid-morning summer's sun was the only illumination needed for this evocative portrait. Being in her own home, the subject was completely at ease and the photographer adopted more of a candid approach to the session. During the morning, the photographer used the camera to pick off shots as the client basically went about her normal routine, and directed and fine-tuned her poses only when absolutely necessary.

PHOTOGRAPHER:
Majken Kruse
CAMERA:
6 x 4.5cm
LENS:
80mm
EXPOSURE:
⅛₂₅ second at f4
LIGHTING:
Daylight only

▲ This subject was due at the church for her wedding later that morning, and so the photographer had only limited time to take pictures. All the rooms of the apartment were either full of people or cluttered with pre-wedding paraphernalia, and so the best place for the portrait was a small balcony off the living room. Careful framing shows the bride free of the chaos that really existed in the room at the time, seemingly with all the time in the world to relax and drink a glass of champagne. By selecting a large aperture, the background has been thrown sufficiently out of focus not to intrude.

PHOTOGRAPHER:
Majken Kruse
CAMERA:
35mm
LENS:
50mm
EXPOSURE:
½₅₀ second at f16
LIGHTING:
Daylight only

VARIATIONS ON A THEME ----------------------------------

All manner of people commission portrait photographs for all types of reason. Some people have their portraits taken at set intervals every few years, for example, so that they have a record of the physical changes that occur with the passage of time; others may want a portrait taken to give to a friend or loved one who is going away for an extended period; yet others may want a record of an important occasion or event in their lives, such as graduation from school or college, a wedding, or anniversary.

◀ ▶ *The subject of these two photographs, a captain in the Guards, was photographed in a traditionally formal military pose, seated in a high-backed chair. The two uniforms he is seen in – one his ordinary service uniform, the other a magnificent full ceremonial uniform with plumed bearskin helmet and dress sword – were obvious themes to incorporate into the photographic session. The inclusion of the Guardsman's pet dog produces an informal and slightly humorous note in what is otherwise a very formal composition.*

PHOTOGRAPHER:
Julian Deghy

CAMERA:
6 x 7cm

LENS:
180mm

EXPOSURE:
¹⁄₆₀ second at f11

LIGHTING:
Studio flash x 2, plus flash umbrellas

◄ A directly head-on view would have been unsatisfactory here because of the shape made by the subject's legs. The most elegant solution was to angle the chair slightly and have the subject turn his face directly toward the camera. The main flash was set up to the left of the camera, while the secondary, or fill-in, flash was at the same distance to the right of the camera, powered down to produce a less intense light.

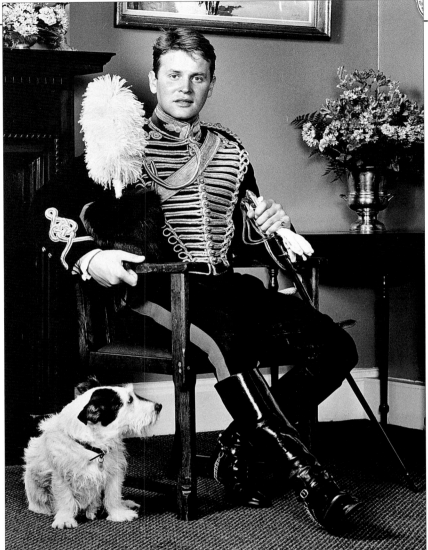

◄ The original of this portrait variation was taken on black and white film stock and the print was then treated with a commercially available selenium toner. The use of this toning agent deepens the blacks and strengthens image contrast. As well, selenium toner can be used to archivally stabilize prints.

PHOTOGRAPHER:
Julian Deghy

CAMERA:
6 x 7cm

LENS:
180mm

EXPOSURE:
¹⁄₆₀ second at f22

LIGHTING:
Studio flash x 2, plus flash umbrellas

▶ For this image from the portrait session, the black and white print was treated with thiocarbamide toner. The finished print looks very similar to the type of effect achieved with old-fashioned sepia toning, but the modern chemicals are easier to use and don't have the unpleasant odour associated with sepia toners.

From a strictly photographic point of view, subjects who opt to have their portraits taken in other than normal street clothes make, potentially, far more interesting pictures. And the more colourful or unusual the style of dress, the more eye-catching appeal it is likely to have. However, some caution is called for, since colour in portraiture can sometimes work against you by becoming the dominant feature of the photograph and pushing the subject into the background.

Formally commissioned portraits are, for the subject concerned at least, special events, since they happen only very occasionally. To maximize your chances of producing a photograph, or set of photographs, that clients will be happy with, suggest that they bring one or two changes of clothing with them to the studio, or at least a selection of different accessories. If you are shooting the pictures in the client's own home, then you will have the entire wardrobe from which to make a choice.

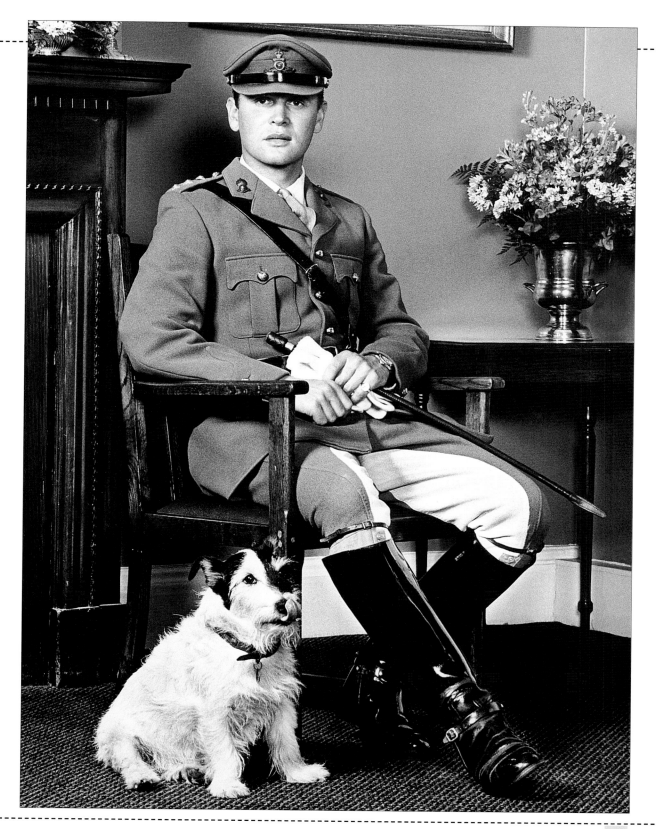

SHADOWLESS LIGHTING

irectional lighting (that is, light falling on your subject from predominantly one direction only) – with, perhaps, a reflector positioned on the opposite side to help lighten the shadows a little and thus hold contrast down overall – is one of the standard techniques employed to bring out such subject qualities of shape and form, as well as surface characteristics, such as texture. However, if you set up two lights positioned equidistant from the subject, one on either side of the camera, making sure that the power settings on both lights are identical, then the shadows cast by one light will be filled (and therefore largely neutralized) by the light from the other. The result is, as you can see here, a virtually shadow-free photograph.

PHOTOGRAPHER:
Simon Alexander
CAMERA:
6 x 6cm
LENS:
80mm
EXPOSURE:
⅟₃₀ second at f11
LIGHTING:
Studio flash x 2 with translucent flash umbrellas and reflector

◀ The subject was positioned 1½ metres (about 5ft) from the camera, and matched flash units fitted with translucent "shoot-through" flash umbrellas to diffuse and soften the light, were set up either side of the camera. A reflector just in front of the subject's lap picked up enough light to kill any shadows on her neck and the underside of her chin. The black background paper was 3 metres (about 10ft) behind the subject – far enough back not to pick up any overspill of light from the set.

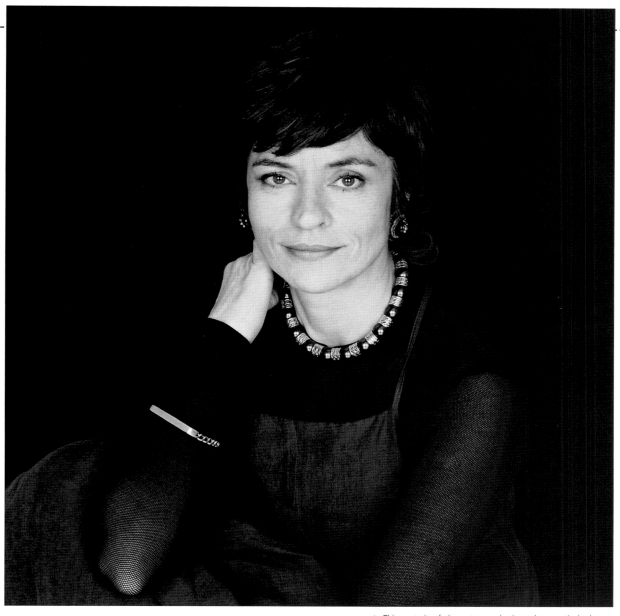

▲ This portrait of the actress Diana Quick was composed and lit to work on two levels. First, as a large print, the starkness of the lighting, with the subject's face glowing out of a featureless black background, has great impact. Note, too, that all the information is in the horizontal or vertical plane – there has been no attempt to imply the dimension of depth.

Second, when greatly reduced in size, the picture still has great presence on the page – a necessary attribute since this shot is used small in the casting directory Spotlight.

RELAXING THE SUBJECT

Unless you are working with a model or a celebrity, people usually look forward to being in front of the camera for a studio portrait session with some degree of apprehension. Not only are the surroundings strange and unfamiliar, but most people are more aware of their perceived physical shortcomings than their attributes, and thus feel vulnerable under the glare of the studio lights.

An important part of the photographer's task, therefore, is to put the subjects at ease, and one of the best ways of doing this is to engage them in conversation. If you know something about the people, either professionally or personally, before meeting them, conversation will be easier to generate. If not, then try to find out from your subjects something about their interests, hobbies, what they do at work, how they like to relax, and so on. If subjects have strongly held opinions about how they should best be photographed, and these don't correspond with what you want to achieve during the session, listen to their points of view, take some frames, and then start suggest slight changes that, bit by bit, bring them more around to your way of thinking.

Hints and tips

● As photographer, play the role of host in the studio. If the session is going to take some time, have some refreshments available.

● Some people relax more if they have some sort of prop to concentrate on. People not used to being in front of the camera often don't know what to do with their hands and so they may respond well if you give them something to hold.

▲ A single studio flash, fitted with a softbox, positioned immediately to the right and behind the camera position provided the only illumination for this portrait. Reflector boards on the opposite side of the subject were used to lighten shadows, and the subject was seated well in front of the background paper to ensure that he appears as a well-lit figure in a totally dark and featureless space.

PHOTOGRAPHER:
Robert Hallmann

CAMERA:
6 x 7cm

LENS:
80mm

EXPOSURE:
1/60 second at f8

LIGHTING:
Studio flash with softbox and reflectors

▶ A cup of tea offered to the subject during a pause in shooting helped to put the man at ease, and the resulting photograph of him, with cup still in hand, was the most successful shot of the session.

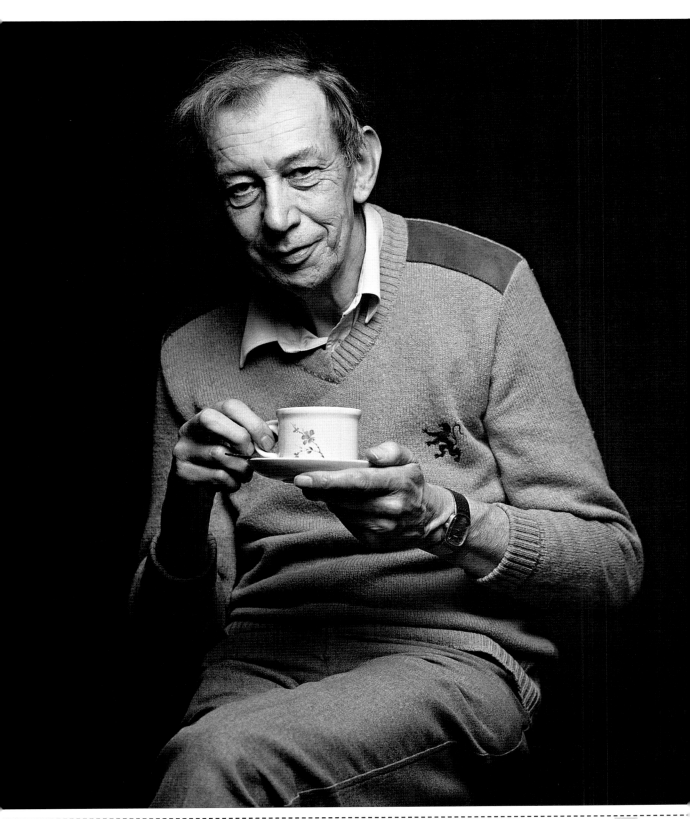

USING THE SETTING

Portraits often communicate better if subjects are photographed in settings that are relevant to their personal or professional lives. Not only does this give the viewer of the photograph some additional information about and insight into the person featured, you will probably find that your subject is more relaxed, too, and this greatly contributes to the success (or otherwise) of a session.

When working in the subject's home or office, however, you inevitably lose some of the control over lighting you would have had in the studio. If possible, visit the location for the session before the day of the shoot to see what natural light, if any, will be available, to see what space you will have to work in, and to determine the need for extension leads, background papers, filters, and so on.

▶ *The glowering features of the publisher Lord Weidenfeld in his office. Consciously or otherwise, he has adopted a pose not dissimilar to the bust under which he is seated.*

PHOTOGRAPHER:
Steve Pyke

CAMERA:
6 x 7cm

LENS:
65mm

EXPOSURE:
$\frac{1}{25}$ second at f11

LIGHTING:
Daylight, studio flash x 3, and reflector

◀ *To supplement the background level of daylight, one flash unit was set just to the left of the camera position, but well above the subject's eyeline so that any cast shadows would be short. Other flash units were positioned to the left and right to light the floor-to-ceiling bookshelves, while a reflector low down in front of the subject bounced additional light upward, toward his face.*

LAST PORTRAIT

The actress Dame Gwen Ffrangcon-Davies was 90 years old and almost blind when this photograph of her was taken. It was one of a series of pictures taken by the photographer, Nicholas Sinclair, of actors and actresses for an exhibition he was preparing for in 1992. At first, Dame Gwen refused Nicholas's request for a sitting. However, when she later heard that Alec Guinness, Paul Scofield, Wendy Hiller and Cyril Cusack had already sat for their portraits, she changed her mind saying: "I've decided that I want to be amongst my friends."

"Had I photographed her looking directly into the lens," writes Nicholas Sinclair, "the picture would have been very unflattering, given the fact that she was almost blind and had very thick glass in her spectacles. I therefore used a three-quarter view, turning my subject away from the light source but keeping enough contact with her eyes to express both her spirit and her inherent sense of tranquillity. I added the shawl because she complained of feeling cold during the sitting and, in fact, the shawl adds a strong circular feel to the composition."

PHOTOGRAPHER:
Nicholas Sinclair

CAMERA:
6 x 6cm

LENS:
150mm

EXPOSURE:
⅙₀ second at f5.6

LIGHTING:
Studio flash with softbox and reflector

EFFECTS:
Platinum print (see following page)

◀ One studio flash unit fitted with a softbox was positioned to the right of the camera and one large white reflector board on the opposite side, angled to reflect light back into the subject's face.

▲ Sadly, this is the last portrait ever taken of Dame Gwen Ffrangcon-Davies. She died just a few months after the picture was taken.

STRENGTH AND FRAGILITY

This portrait was taken in 1990 when the artist John Piper was 87 years old. In the photographer's words: "There was no motive for taking the photograph beyond the fact that he has an extraordinary face and has always been one of my favourite British landscape painters. He was a very modest and gentle man, frail after an illness, but his gaze into the lens is haunting. With such intensity in a face, my instinct is to move in close and let the subject's face dominate the frame."

PHOTOGRAPHER:
Nicholas Sinclair

CAMERA:
6 x 6cm

LENS:
150mm with 16mm extension tube

EXPOSURE:
$\frac{1}{125}$ second at f4

LIGHTING:
Daylight and studio flash with softbox

EFFECTS:
Platinum print

◄ *The simplicity of the composition and the absence of anything artificial or contrived in the picture make this a particularly powerful image of a face that expresses both a strength of purpose and the fragility of old age.*

The platinum print process

This photograph of John Piper, and the one on the preceding page of Dame Gwen Ffrangcon-Davies, are platinum prints made by Roy Gardner. This process was favoured at the end of the 19th century and combined platinum and iron salts to make a light-sensitive solution that was coated on a sheet of fine-quality paper. The platinum process used in these prints has been adapted to take advantage of contemporary materials. They were made by contact printing enlarged negatives onto watercolour paper that had been hand coated with an emulsion consisting of platinum and palladium metals. After drying, the paper was exposed under the negative to a strong ultraviolet light source. Development is in a bath of potassium oxalate after which the print is immersed in baths of hydrochloric acid before being washed. Each print can take as long as three days to complete and requires considerable skill, experience, and patience.

CHAPTER EIGHT

COUPLES AND GROUPS

STREET ENCOUNTERS

While it is true that nearly all portrait photographers earn their living by taking commissioned photographs of people who have contacted them specifically, there are some for whom portraiture holds such a fascination that at least part of their work is more speculative in nature. The subjects of these pictures may be the result of casual encounters, people the photographer has simply met in the street and asked to pose or has taken unawares, using more of a candid approach to the photography.

When we look at some portraits it is possible to see far more than just that person's physical appearance. Rather, the photographer has managed to get under the skin of the subject and provide us with at least some insight into that person's character. Good-quality portraits of this type do have a market, although it is not an easy one to break into. Some galleries, for example, specialize in mounting photographic exhibitions, while some more general art galleries hold periodic photographic exhibitions, where individual prints can be bought by collectors. The publishing world, too, is another outlet for work of this type – for use in books and magazines.

PHOTOGRAPHER:
Anthony Oliver

CAMERA:
6 x 6cm

LENS:
80mm

EXPOSURE:
1/60 second at f8

LIGHTING:
Daylight and flash

▶ *With his arm protectively around his partner's shoulders, a range of emotions can be read into the faces of this couple as they stare, with a goodly measure of distrust, into the camera's lens.*

◀ Two faces, lined and in-grained with dirt, with a history we can only begin to guess at. Although poor and homeless, their faces are still strong and their spirits appear unbroken.

PHOTOGRAPHER:
Steven Pyke

CAMERA:
6 x 6cm

LENS:
100mm

EXPOSURE:
⅟₆₀ second at f11

LIGHTING:
Portable flash

▼ The light from accessory flash is most often used bounced off a ceiling or wall to produce an indirect, more flat-tering type of effect. Outdoors, however, where reflecting sur-faces are more difficult to find, flash can be used direct to give a gritty type of realism. A flash bracket such as the one illus-trated here, lifts the flash unit well away from the camera lens and so virtually eliminates the problem of "red eye".

▲ Ramrod straight and formally posed, these two soldiers of the Salvation Army were photographed against a featureless backdrop to emphasize the restricted tonal range of which the image is composed.

PHOTOGRAPHER:
Steven Pyke

CAMERA:
6 x 6cm

LENS:
120mm

EXPOSURE:
⅓₀ second at f16

LIGHTING:
Studio flash x 2

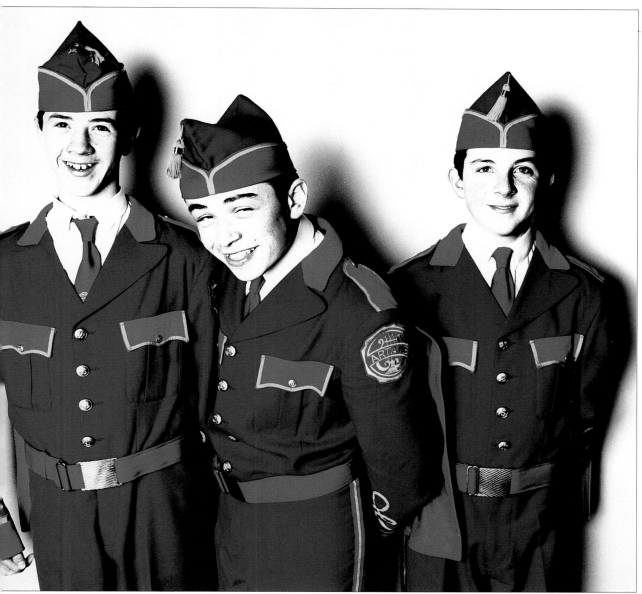

▲ *A mixture of pride and adolescent awkwardness can be seen in this group portrait of three boys following in the long tradition of Irish marching bands. The colour of their uniforms was already intense, but it has been strengthened further by processing the colour transparency film in chemicals designed for colour negatives.*

PHOTOGRAPHER:
Steven Pyke

CAMERA:
6 x 6cm

LENS:
80mm

EXPOSURE:
¹⁄₆₀ second at f11

LIGHTING:
Studio flash x 2

COLOUR OR BLACK AND WHITE? ----------------------------

Unless you specialize in either the black and white medium or the colour medium, and clients commission you on that basis, then the choice of which type of film stock to use for a particular portrait session is something photographers and clients should discuss at the outset.

On some occasions, the argument for using one medium instead of the other is overwhelming. If, for example, the clients are a couple looking for a set of studio wedding shots, then the colour of the bridal gown and the bridal bouquet may be sufficiently important to make colour the obvious choice. Similarly, in a portrait of somebody with startlingly blue eyes or deep chestnut-red hair, these features will become less significant if shown in black and white. On the other hand, colour can be distracting in portraiture, with small areas of essentially irrelevant colour in the clothes, props, or set taking attention away from the face, form, or figure of the subject.

Keep your options open

As a commercial photographer, the most prudent and flexible approach to the subject of black and white or colour is to keep your options open. By shooting in colour transparency film, you then have the choice of producing:

● A slide for projection
● A colour print
● A black and white print
● A black and white transparency

Some of these conversion process do require copying the original image, however, so you must expect some loss of picture quality. Bear in mind that any after-treatments will inevitably add to the costs to the client.

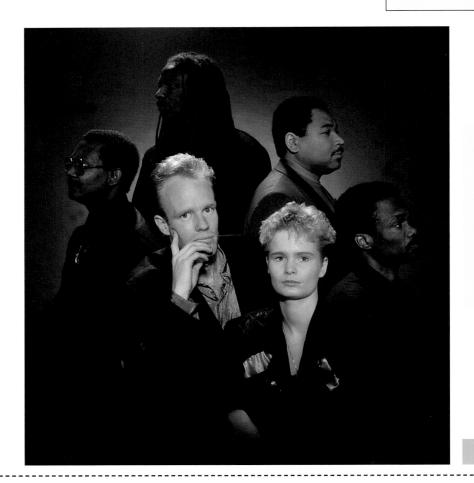

PHOTOGRAPHER:
Jos Sprangers

CAMERA:
6 x 4.5cm

LENS:
70mm

EXPOSURE:
⅛ second at f16

LIGHTING:
Studio flash x 4

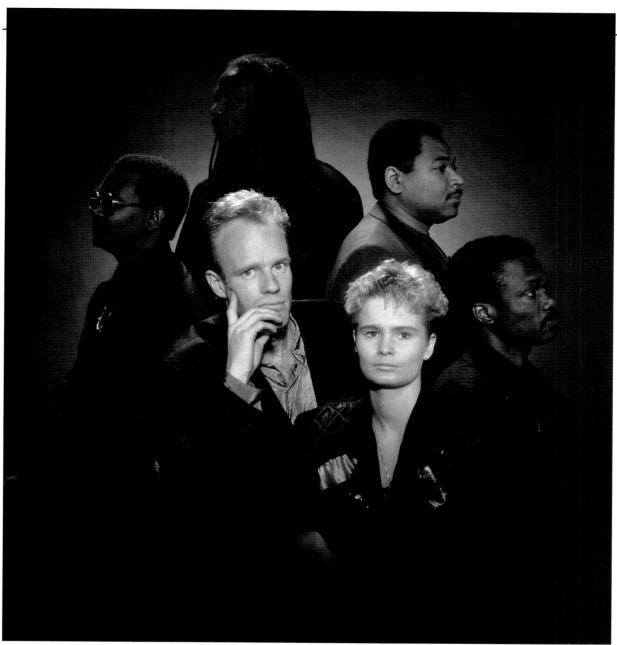

◀ ▲ Starting with a colour neg-
ative original, the photographer
produced both colour and
black and white prints. The
colour version shows a well-
composed, well-lit group
portrait, with all subject detail
crisp and clearly defined. The
black and white version is
slightly softer in comparison –
black and white printing paper
is not designed for the different
layers of emulsion of a colour
negative – but the areas of gold
detailing on the woman's dress,
the blue shirt of the foreground
man, and the red T-shirt of the
background figure are not
nearly as prominent and are,
therefore, less distracting.

DAYLIGHT EFFECTS

The principal advantage of using artificial studio lighting – either tungsten or flash – is that it offers the portrait photographer consistent, and therefore predictable, results. There is, however, a quality to natural daylight that makes it the preferred light source for many photographers.

The fact is that daylight is anything but consistent or predictable. Early morning daylight, when the sun is low in the sky, tends to be soft and warm-coloured. As the morning progresses and the sun moves higher in the sky, its light often becomes harder, shadows become better defined, and its colour

more blue in content. Then, as the sun moves back down toward the horizon once more in the afternoon, its lighting quality changes yet again – shadows lengthen and its colour content shifts more toward the yellow and red end of the spectrum.

It is not only the time of day, however, that affects the quality of daylight. Other factors, such as the weather or the changing seasons, also have a tremendous impact.

However, it is these many different moods and qualities of daylight that are so favoured by dedicated daylight portrait photographers.

▶ *Daylight is capable of producing all manner of lighting effects, from soft and even to contrasty and uncompromising. The light levels on the subjects' faces in this portrait were so high that an aperture/shutter speed combination could be set that rendered the shadowy background completely black.*

PHOTOGRAPHER:
Majken Kruse

CAMERA:
35mm

LENS:
90mm

EXPOSURE:
½₅₀ second at f11

LIGHTING:
Daylight only

◀ *Indirect daylight from an open, bright sky entered the studio through windows that had been masked down with black-out material to produce a this spotlight effect.*

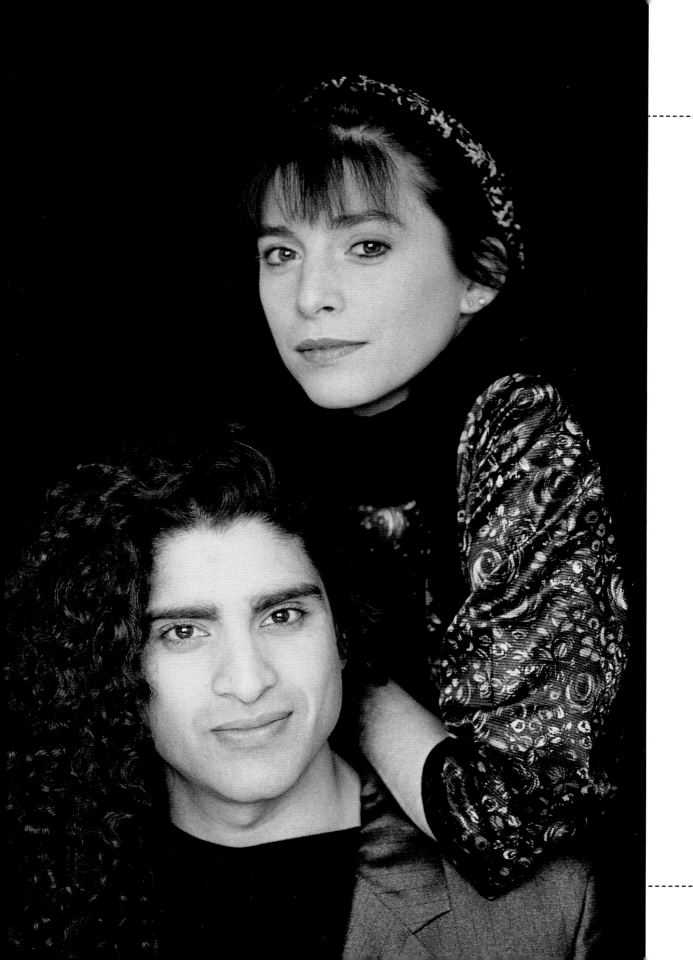

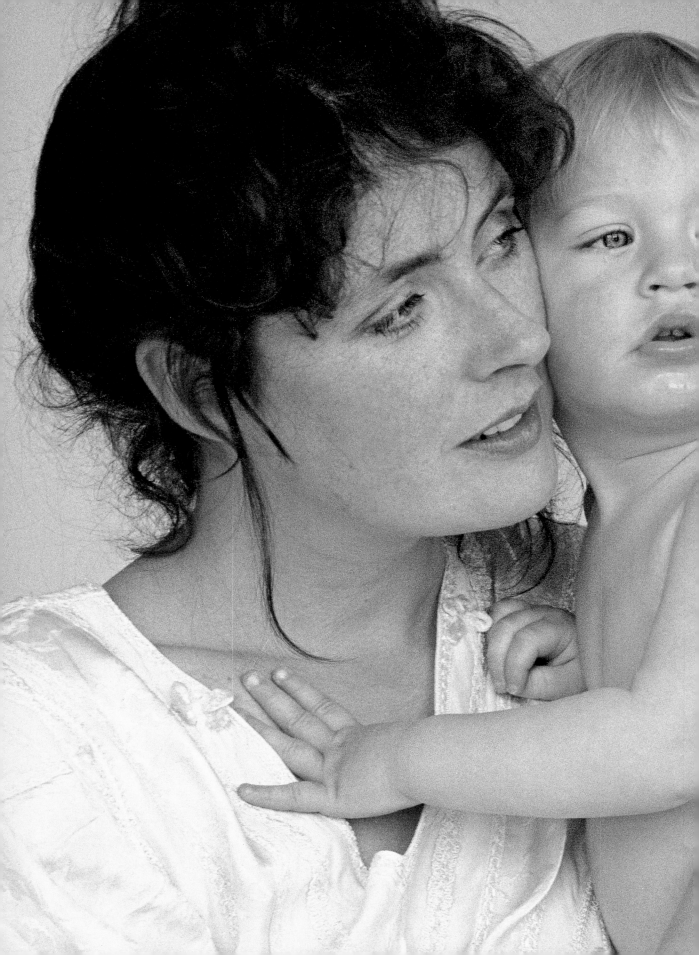

◀ When an infant is involved, it is sometimes better to conduct a portrait session in the client's own home. The travelling involved, as well as the strange surroundings of a studio, can be very unsettling.

PHOTOGRAPHER:
Majken Kruse

CAMERA:
35mm

LENS:
28-70mm zoom

EXPOSURE:
1/125 second at f11

LIGHTING:
Daylight only

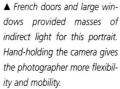

▲ French doors and large windows provided masses of indirect light for this portrait. Hand-holding the camera gives the photographer more flexibility and mobility.

▶ *A bright, overcast sky provid-ed the main lighting for this double portrait, taken just out-side the photographer's studio. The only other light used was supplied by a silver-coloured reflector, angled to bounce a little extra light into the faces of the children.*

PHOTOGRAPHER:
Nigel Harper

CAMERA:
35mm

LENS:
135mm

EXPOSURE:
⅟₆₀ second at f5.6

LIGHTING:
Daylight and reflector

▲ *Small portable reflectors are useful outdoors to fill shadows and even out contrast.*

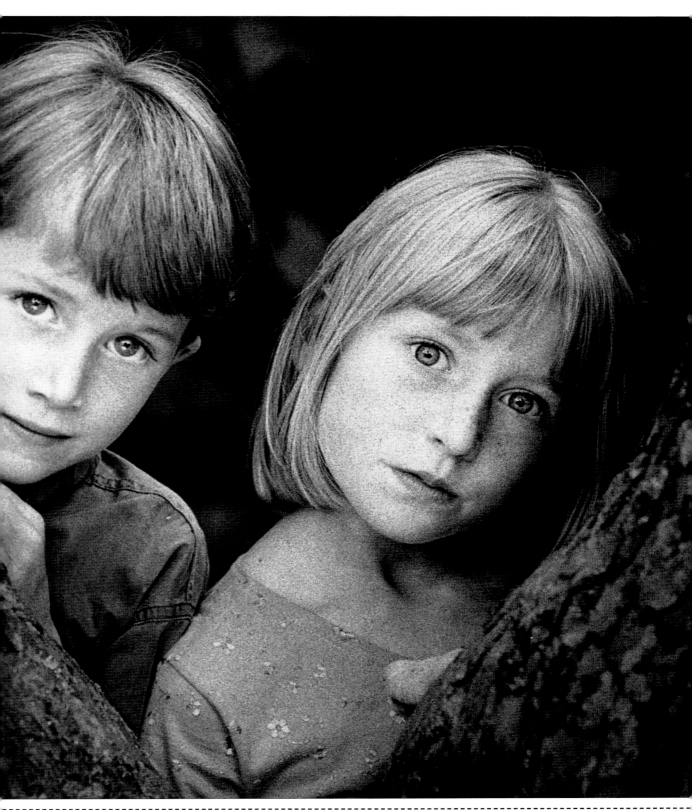

LIGHTING VARIATIONS

As the number of subject elements increases so the potential technical and aesthetic problems tend to multiply, especially if you want to achieve very precise results. All the considerations to do with relaxing the subjects and getting them in the right frame of mind to project their personality in front of the camera still exist, but when you are photographing couples and groups you need to bring everybody to the right pitch at exactly the same time.

The principal lighting problem with couples and groups is ensuring that shadows from one person are not cast over visually important parts of another person in the group. This is of particular concern when you are using directional lighting, either to the left or right of the subjects, as the main illumination, and less of a problem if you employ predominantly frontal lighting and pose all your subject in approximately the same plane.

Another lighting technique often used is toplighting. When the light is positioned above the level of the subjects, shadows will be cast downward where they usually don't represent a problem. However, you need to watch out for unattractive shadows from the nose being thrown down over the mouth and chin and, if necessary,

counter these with some additional frontal light. In all cases, shadows are less hard-edged and, therefore, less pronounced if the light is reflected or diffused before it reaches the subjects.

Because of the need to monitor the effects of lighting so closely, continuous light sources, such as tungsten light and, of course, natural daylight, are often easier to work with than flash. Flash produces such a short-lived burst of light it is impossible to preview results. Professional studio flash units are often equipped with built-in modelling lights that indicate where the highlights and shadows will fall, and these do help considerably.

◀ To light this group satisfactorily, each face needed its own light source. The lights were positioned the same distance from each person and each light was set to give the same output. Balancing the lights in this way is important so that any shadows cast by one light are filled in and, therefore, counteracted by the output from another. Out of sight of the camera behind the group, another light was used to illuminate the background paper.

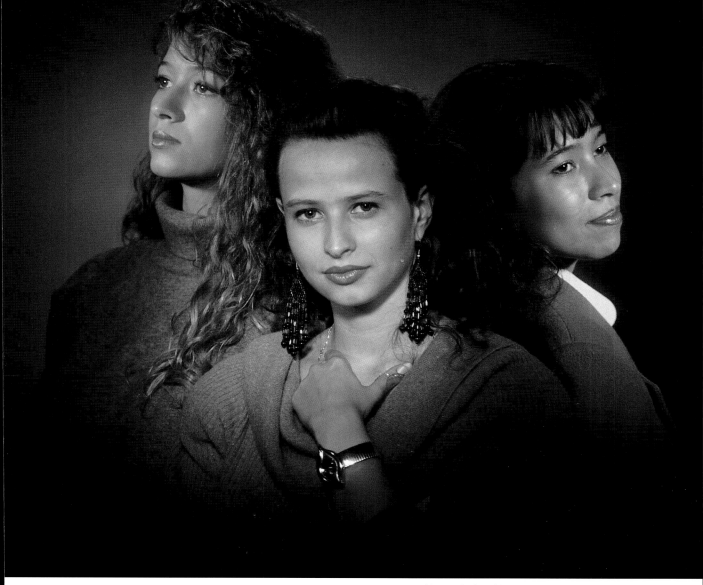

In this portrait, the subjects are back to back and their faces are not all in the same plane, so lights need to be carefully set. Note the catchlights in each of the subject's eyes – although they are only tiny points of brightness, they bring the women's faces alive. In the darkroom, the edges of the printing paper were vignetted to create a darker tone.

PHOTOGRAPHER:
Jos Sprangers

CAMERA:
6 x 4.5cm

LENS:
80mm

EXPOSURE:
⅟₆₀ second at f8

LIGHTING:
Studio flash x 4

▲ A studio flash fitted with a large softbox to the left of the camera provided the main illumination for this portrait. A secondary flash, positioned much further back, and also fitted with a softbox, provided fill-in lighting to the right of the camera, while a third light, low down behind the girls, produced a halo of light on the wall behind them.

PHOTOGRAPHER:
Gary Italiaander

CAMERA:
6 x 7cm

LENS:
80mm

EXPOSURE:
⅟₆₀ second at f8

LIGHTING:
Studio flash x 3, 2 with softboxes

▶ Head to head, both dressed in basic black, and with their dark hair framing their faces, these two sisters make an attractive double portrait. Unless the photographer stays alert to potential problems, parts of the anatomy, such as the hand, may look very awkward in the final photograph.

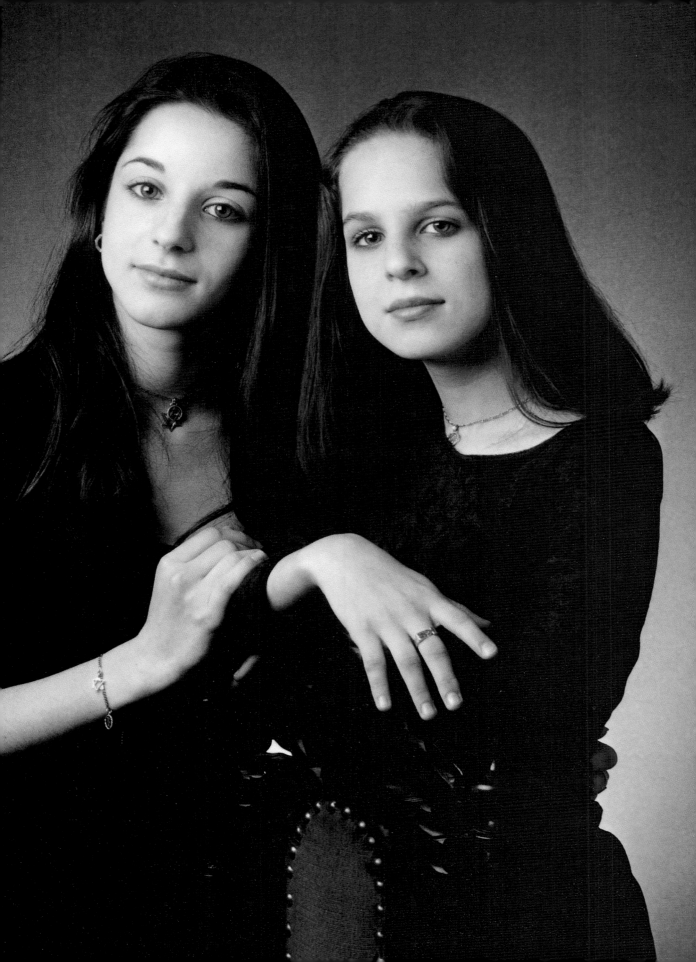

◀ A good relationship between photographer and subjects is evident in this double portrait, in which the subjects look happy and relaxed and seem to be thoroughly enjoying their time in front of the camera.

PHOTOGRAPHER:
Nigel Harper
CAMERA:
6 x 4.5cm
LENS:
120mm
EXPOSURE:
¹⁄₁₂₅ second at f16
LIGHTING:
**Studio flash x 5,
1 with softbox**

◀ Two lights to the left of the camera provided the main illumination for this photograph. The first, just to the left, was fitted with a softbox to give overall, generalized illumination. The other, which was set to a lower output and was slightly more directional, had no diffuser and has produced the brighter highlights you can see. High up and just behind the subjects, a third light provided additional illumination, while fourth and fifth lights behind the subjects provided rim and background lighting.

▲ By arranging all the members of this trio in the same plane, and then employing a mixture of toplighting, diffused three-quarter lighting, and reflectors, this group portrait has managed effectively to capture the boys' impish expressions.

PHOTOGRAPHER:
Gary Italiaander

CAMERA:
6 x 7cm

LENS:
80mm

EXPOSURE:
⅙₀ second at f16

LIGHTING:
Studio flash x 2, 1 with softbox, and reflectors

◄ An additional problem with setting the lights for this group portrait was ensuring that the spectacles of the boy on the left didn't reflect a "hot spot" back toward the camera lens. The toplighting is evident in the slight shadows under the folded arms of the subjects, while the principal light came from a studio flash fitted with a softbox to the left of the camera. Reflector boards to the right of the camera, close in to the subjects, reflected back sufficient light to relieve most of the facial shadows.

◀ The very simple lighting
employed by the photographer
accentuates the striking good
looks of this brother and sister.

PHOTOGRAPHER:
Majken Kruse

CAMERA:
6 x 7cm

LENS:
120mm

EXPOSURE:
⅓₀ second at f22

LIGHTING:
**Studio flash x 2,
1 with softbox,
and reflectors**

▲ The only frontal lighting used
in this set-up was a studio flash
fitted with a softbox just to the
left of the camera. Large reflec-
tors on the right of the camera
produced an enclosed area,
returning most of the light and
ensuring that illumination was
almost equal on both sides of
the subjects' faces. Behind the
subjects, well out of sight of
the camera, another light was
directed at the background
paper to produce the stark
white tone that outlines and
defines their hair.

SPECIAL
EFFECTS

RESTRAINED EFFECTS

When combining portraiture with special effects, often it is best to show some restraint in the techniques you employ, otherwise the emphasis of the image may shift too far away from the original intention. It is all too easy for special effects to have such visual impact that they end up swamping the subject.

The techniques used in the photograph illustrated here are a good example of how relatively small changes in the appearance of the subject can produce eye-catching, and quite intriguing, results. Apart from normal facial make-up, the subject was photographed completely "straight". The crown of silver-coloured antennae, once constructed, proved to be too heavy to be supported comfortably on the subject's head, so it was propped up in position on the end of a broom handle (what the eye doesn't see . . .). The backdrop is a large, painted canvas of a skyscape, which was rendered sufficiently out of focus by limiting the depth of field not to require too much attention to detail. After processing, the resulting print was then gold toned, and the toned print rephotographed to produce a large-format transparency for projection.

▶ Although the only special effect employed in producing this print is a gold-toning process, this – combined with cleverly applied facial make-up, a futuristic headdress, and a painted backdrop – has created a portrait with eye-catching appeal. The framing of the subject's face was largely dictated by the height and spread of the headdress she is wearing.

PHOTOGRAPHER:
Mann and Man

CAMERA:
6 x 9cm

LENS:
120mm

EXPOSURE:
$\frac{1}{125}$ second at f5.6

LIGHTING:
Studio flash x 2

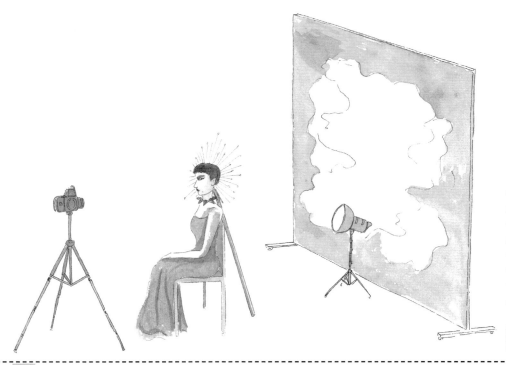

◀ A single studio flash with a wide reflector was used to frontally light the subject and backdrop, while a second light placed behind the subject was used to backlight her and help produce a distinct edge around her head and shoulders. This created the necessary separation between the subject and background canvas.

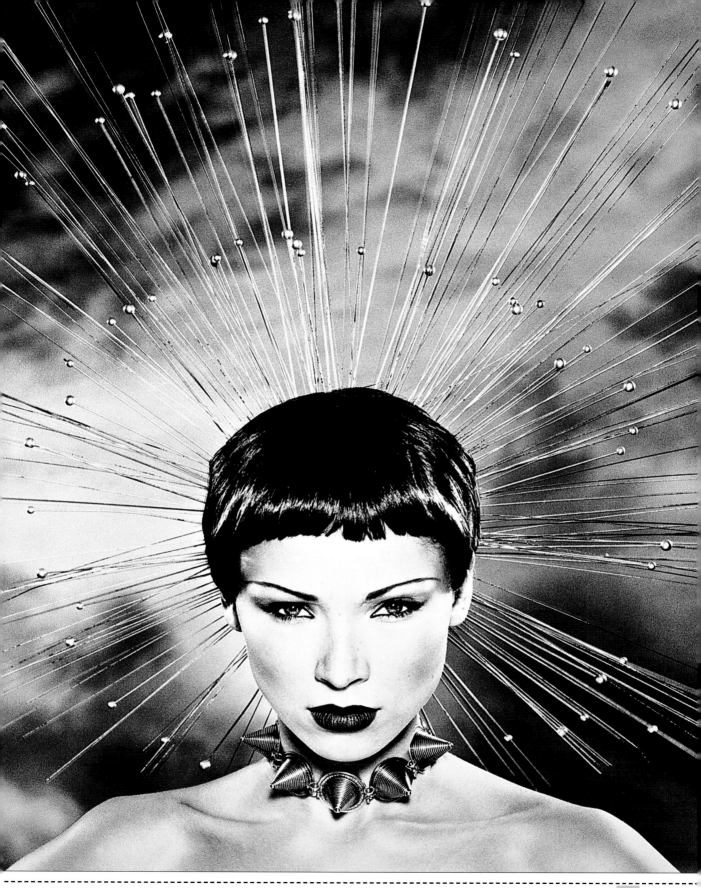

PAINTED EFFECTS

One special effect that has much potential appeal is a mixed-media technique involving photography combined with painting. The first stage of the process involves a traditional photographic session. Several portraits of the client are taken and, after processing, the best, or most appropriate, is selected.

Next, the client describes the type of setting he or she would like to see the portrait photograph combined with. It may, for example, be a particular landscape that was important in the person's childhood, or it could be a room setting or even a fantasy world inspired by literature. The client may be able to supply a photograph of the landscape or room, or an illustration from a book or magazine.

Once the rough for the background has been agreed, the original photographic image is reproduced onto canvas and the background scene is added using traditional oil paints. The complete work is then varnished and framed ready for hanging.

PHOTOGRAPHER:
Gary Italiaander
PAINTER:
Michael Italiaander

▶ Combining photography with oil painting to produce a portrait with a distinctive style.

COMBINING IMAGES

Bizarre juxtapositions of subject matter and subject scale are possible using a technique known as sandwich printing. This darkroom process involves printing two film images simultaneously onto the same piece of printing paper.

If you look at a negative you will see that it shows image densities as being reversed from those of the original subject – in other words, where the shadows of the original subject fell, the negative appears as clear film, and where the subject details were, the film shows varying degrees of density. So,

by aligning the image details of one negative with the shadow area of another, you can produce a print of them both on the same piece of paper.

As well as using negatives, this technique also works with pairs of colour transparencies, although you will then have to print onto positive/ positive paper (paper that produces a positive print from a positive original). Both colour and black and white negatives are suitable for sandwich printing onto negative/positive paper, or you could mix colour and black and white in the same print.

Using a light box, or any other convenient light source, select images that could work well together. If looking at 35mm slides or negatives, you may need to use a magnifying glass. Images that are too dense will not print when combined.

Once you have selected your images, placing them over each other to see that both subjects work together, carefully align both in the enlarger's negative carrier. Use tape, if necessary, to stop them shifting, but only on the film edges, or rebates.

Load the negative carrier into the enlarger, turn off the room lights, and switch the enlarger on. Check the combined image projected down onto the baseboard to see if you are happy with the results. If, so, make a test print to gauge exposure.

PHOTOGRAPHER:
Steve Pyke

CAMERA:
6 x 7cm

LENS:
180mm (silhouette)
90mm (detailed face)

EXPOSURE:
$\frac{1}{60}$ second at f11

EFFECT:
Sandwich printing

▶ *By carefully aligning the silhouetted profile of one subject, which was an area of clear film on the original negative, with the fully detailed face of the other subject, a combination print of the two was made on the same piece of paper.*

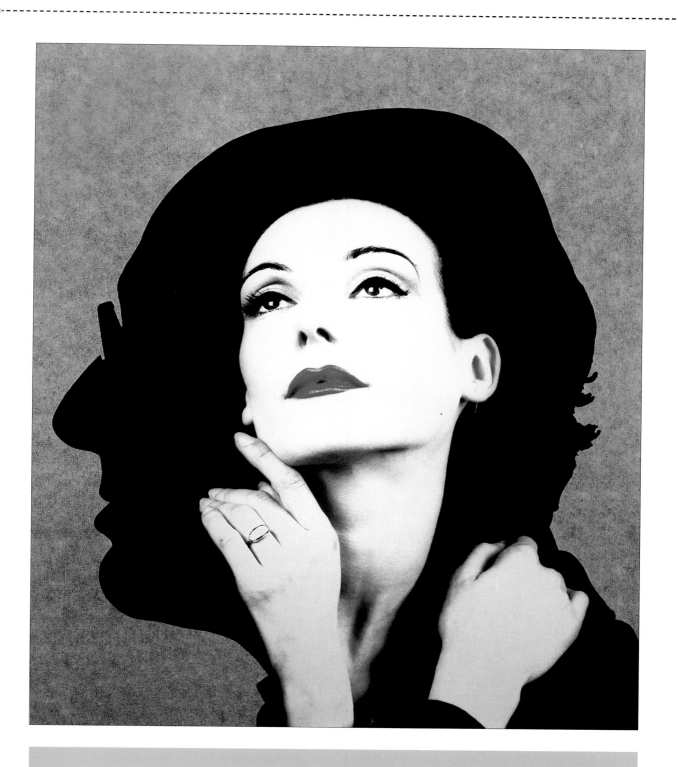

PROJECTION EFFECTS

Some special effects owe as much to the skills of the set builder as they do to any particularly sophisticated camera or darkroom techniques. The first step in creating this "multilayered" portrait was to stick a large, round paper fan to a studio flat and then position the subject in front of it. Next, a framework was built in front of the subject to support more studio flats decorated with paper flowers, tinsel, and coloured paper, leaving a large "porthole" through which the subject could be photographed.

After developing, drying, and mounting, the resulting transparency was projected onto a screen.

At this stage, further embellishments were added by sticking them directly to the screen holding the projected image. For example, extra flowers were added to the periphery of the image, and heart-decorated pins to the woman's eyebrows. As well, tiny beads were stuck to the ends of each projected eyelash. Once complete, the whole image was rephotographed onto transparency film.

▶ The predominantly fiery red coloration of the image and the proliferation of heart motifs would make this an ideal Valentine's Day portrait.

PHOTOGRAPHER:
Mann and Man

CAMERA:
6 x 9cm

LENS:
100mm

EXPOSURE:
**⅕ second at f22
(original image)
⅟₆₀ second at f11
(projected image)**

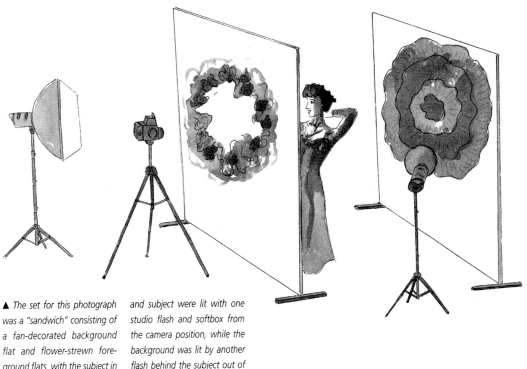

▲ The set for this photograph was a "sandwich" consisting of a fan-decorated background flat and flower-strewn foreground flats, with the subject in the middle. The foreground and subject were lit with one studio flash and softbox from the camera position, while the background was lit by another flash behind the subject out of view of the camera.

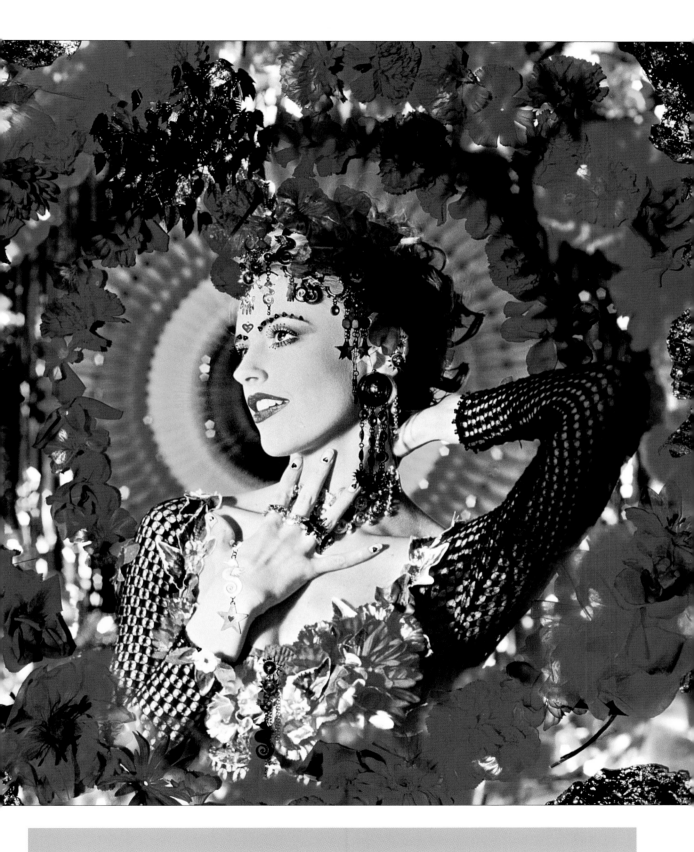

EMULSION STRIPPING

Some specialized film emulsions are made on a special gelatin base that can be dissolved in warm water, leaving the image-carrying part of the film to float free. The tissue-thin membrane of film carrying the image can then be manipulated before being floated back onto another supporting surface and stuck in place with special adhesive. This technique leaves the image open to all manner of interesting distortions, depending on the degree of treatment it receives. Bear in mind, however, that this technique is experimental and therefore results are highly unpredictable and often not repeatable.

▶ To achieve this effect, the thin membrane of emulsion carrying the subject's image was floated off the film original, distorted to produce the cracks, wrinkles, and fissures you can see, and then carefully laid onto a piece of good-quality art paper. It was then photographed to produce a print that could be hand coloured before being rephotographed once more.

PHOTOGRAPHER:
Jos Sprangers

CAMERA:
6 x 7cm

LENS:
120mm

EFFECT:
Emulsion stripping and hand colouring

Alternative technique

Another way of achieving a result similar to the one shown here is to sandwich two thin (overexposed) slides together in the same slide mount, project them, and then rephotograph the result from the screen. Normally exposed or underexposed images are too dense and will not allow sufficient light from the projector through both layers of emulsion for a bright enough image.

PORTFOLIOS

JOS SPRANGERS

Commissioned portfolio of photographs of a civil wedding ceremony. Coverage started on the morning of the wedding service, a few hours before the actual ceremony. The season was early summer and the weather was settled and set fair. The style of the wedding was very informal and the clients wanted this relaxed atmosphere to be reflected in the photography as well. Therefore, most of the pictures of the leading players and the supporting cast, in this case the two young flowergirls, were taken outdoors in a large public garden. Where indoor shots were taken, Jos decided to stay with daylight as the principal light source, again for its natural qualities. Wherever possible, Jos's instructions to the subjects about the poses they should adopt were kept to a minimum and, as a result, the pictures throughout have a semi-candid quality.

▲ The bride with one of her flowergirls. Selective focus and a large aperture has been used to record them sharply while showing the groom and the second flowergirl rendered more softly in the background.

Before the ceremony
To take advantage of the summer sunshine, and to avoid the formality of a studio setting, a large public garden was the setting for a short photography session on the morning before the wedding ceremony. The bride and groom were very definite about the style of pictures they wanted taken, something that can make the photographer's job a lot easier.

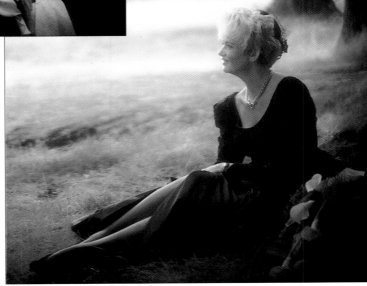

▶ Relaxing under the shade of a tree, using the leaf canopy to interrupt some of the direct rays of the sun.

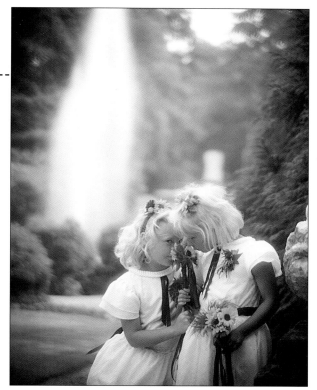

▲ In this indoor shot, frontal flash was used to light the girls' faces to help reduce the contrast created by the intense window light.

▲ One of the colour themes running through this wedding is yellow, which is established in this picture of the flowergirls in secret conversation, hiding their mouths behind the summer yellow of sunflowers.

▼ A similar technique was used here of the groom bending to kiss his wife to be, but the power of the flash was reduced to create a more dramatically lit image.

▲ A change of pace is represented by this close-up detail of the bride's unusual bouquet draped over the knees of a garden statue. A long lens and a wide aperture ensured that only the foreground detail was sharply recorded.

After the ceremony

At some stage during the day, you need to take photographs featuring all those who attended the wedding. This way you can guarantee that nobody is missing entirely from the coverage, which could be disappointing. Often, photographers are not employed to cover the reception, but you can still take a set-piece picture showing the couple with knife poised above the cake as if they were about to cut it.

▲ Even if the reception is not being covered from start to finish, this type of picture can be set up and taken before the actual wedding.

▶ On the steps of the registry office after the wedding ceremony. The newlyweds are centre frame, and practically every face is turned in their direction as they kiss.

MAJKEN KRUSE

Commissioned portfolio of photographs of a formal church white wedding. Time was found a few days before the ceremony for a photographic session with the bride, in line with a detailed picture checklist that had been agreed with the clients. Majken finds that a picture checklist is a great advantage in helping to structure her time in the run up to the wedding and on the big day itself. There is no reason to think that because you know in advance the type and style of photographs wanted that your creativity is in any way stifled – it is still up to you to find the right angles, the best lighting, the appropriate lens, and the most telling moment to press the shutter release.

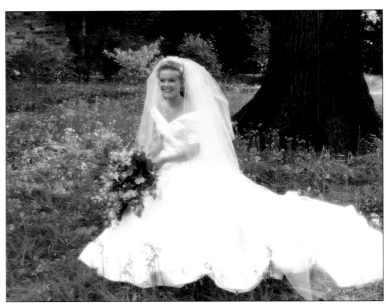

▲ *A field of bluebells in an enclosed garden was the romantic setting for this picture. Although daylight was adequate, Majken used flash directed at the gown to prevent a potential colour cast from the foliage above.*

Before the ceremony

The couple could not be photographed together before their wedding because the bride did not want the groom to see the wedding gown in advance of the ceremony.

▲ *On the day of the wedding outside the church, the groom and his best man pose for a double portrait before the bride's arrival.*

▲ *The bride arrives at the church with her father. This formal grouping shows the bridesmaids and pageboys in the background, just slightly out of focus so as not to compete with the foreground subjects.*

The ceremony

Majken had checked in advance that there was no objection to photographs being taken during the wedding ceremony itself and she knew exactly where she had to be and when to capture the best highlights of the proceedings.

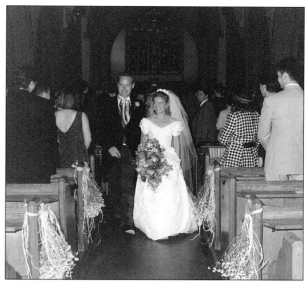

▲ The newlyweds walking up the aisle as man and wife. Both their expressions are wonderful.

▲ Standing behind the priest provided this excellent shot of the ring being slipped onto the bride's finger. Light levels were very low and so flash had to be used.

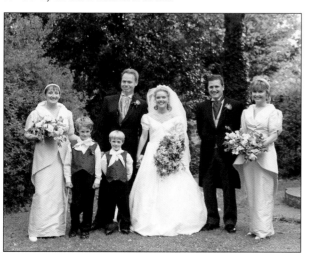

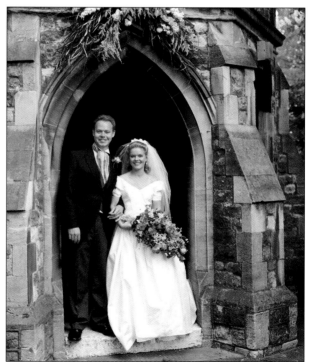

◀ ▲ In line with the prearranged shot list, the couple posed with the bridesmaids, best man, and pageboys. Then the newlyweds posed in the church porch, allowing Majken and all the guests with cameras to take this type of traditional portrait.

After the ceremony

If the transport provided to ferry the couple from the wedding to the reception is particularly photogenic, then make sure it features in your coverage.

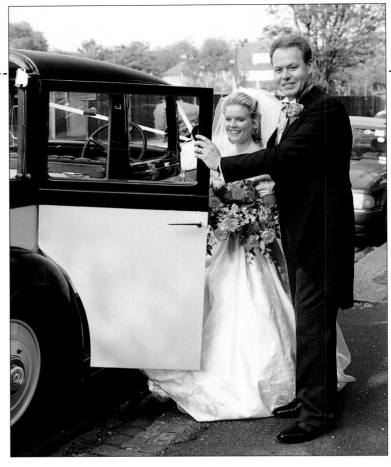

▶ ▼ *The vehicle used by the couple on their wedding day was a magnificent vintage Rolls Royce. Its large windows allowed a good view inside for a picture of the groom kissing his new wife.*

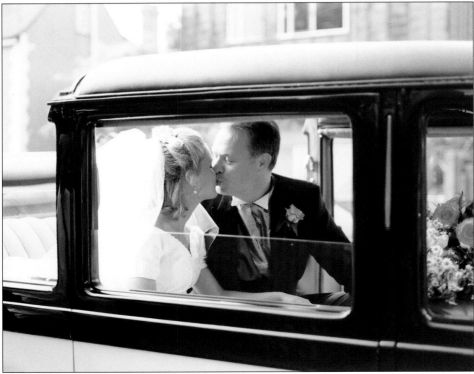

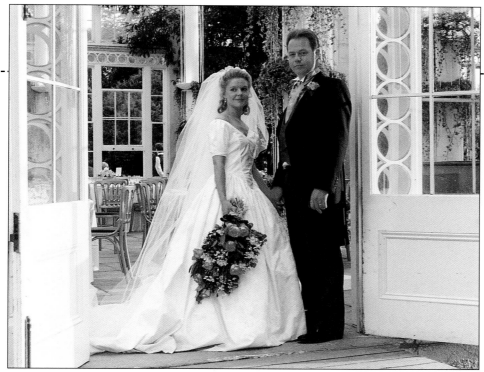

▲ The venue for the reception was a large, extremely ornate Victorian conservatory. The first picture at this location is of the couple, hand in hand, at the doorway with a tantalizing glimpse of the room beyond.

◀ ▲ The next image is of the interior of the conservatory itself, first taken with a wide-angle lens to show the entire area, and then next with a standard lens to bring up the detail of the table settings.

HUGH NICHOLAS

A portfolio of photographs of a church white wedding. Although there were elements of formality about the wedding, the attitude of the couple was orientated to it being a fun day, and this comes through very strongly in the pictures. The couple also wanted a mixture of colour and black and white photographs. In a situation such as this, it is better to have two cameras – one loaded with colour and the other with black and white. Although you can change film partway through a roll with many medium format cameras, it is still time consuming.

The ceremony

Photography was not allowed during the ceremony and so this part of the portfolio picks up on the couple as they are signing the register.

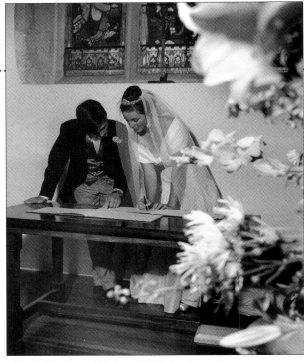

▲ The decision about which shots should be in colour and which in black and white was left to Hugh. This picture was taken with available light and the black and white film had a faster emulsion.

After the ceremony

Sometimes the hardest job a wedding photographer faces is getting the subjects to relax and look as if they are enjoying themselves. Hugh had no such problems at this wedding, and everybody was in a party mood.

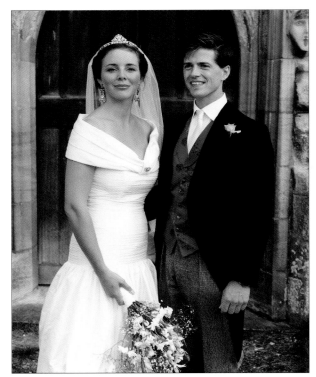

▲ The newlyweds outside the church, using the attractive stone archway and old wooden door as a background.

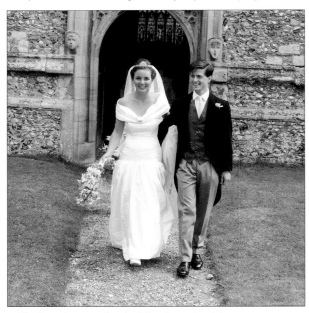

▲ All smiles and no trace of tension left as the newlyweds leave the church and face the assembled crowd of well-wishers.

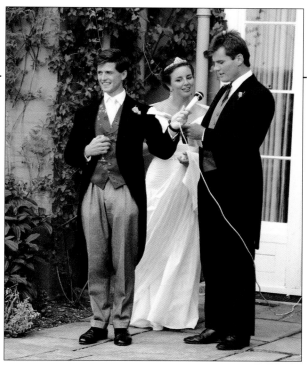

▲ At the reception, where the groom happily takes on the role of a microphone stand in order to help the best man through his speech.

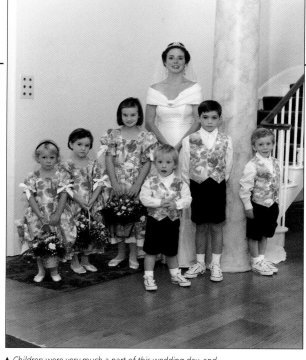

▲ Children were very much a part of this wedding day, and here the bride poses for a rare formal shot with her troop of colourfully clad bridesmaids and pageboys.

▲ Just for contrast, the bride and groom are hoisted aloft as the party mood at the reception intensifies.

▲ Some coverage of the reception was also shot in black and white. A nice touch, and very useful when you want to crop something out of the image area, is to hold light from the enlarger away from the paper during printing to create a soft-edged vignette.

STRAT MASTDRIS

Corporate portraiture is always commissioned and never done on a speculative basis. The main types of client interested in this area of photography are large companies, partnerships, and organizations who want to project a particular type of public image for a specific purpose. Perhaps a company is in the process of producing its annual report for shareholders, for example. Rather than issuing dozens of bland pages of figures that mean very little to anybody without an accounting background, directors may decide to publish a glossy, magazine-style report instead. Accompanying the preamble to the accounts, you may find a brief history of the company with photographs of the company's premises and, more importantly, portraits of the key players in the company, from boardroom level down to the factory floor, with background information on them.

Another use of corporate portraiture is made by companies contemplating a stock issue, when photographically illustrated pamphlets and brochures are used to raise the public's aware-

ness of the company concerned and of those individuals who are asking to be entrusted with shareholders' money. Yet another important application for corporate portraiture is when companies commission photographic essays to accompany a quotation or bid for a major contract for work. In the fiercely competitive business climate that prevails at present, anything that makes a potential client look more favourably at one company's bid as opposed to another's could be critically important.

Corporate portraits are also used by companies to hang on the walls of the public areas of their premises, such as the reception areas, meeting rooms, and offices – in fact, anywhere clients may see them and be impressed by the image they project of the company's "way of doing business". And, finally, another outlet for company portraiture is the business press – newspapers and magazines. A well-composed, thoughtfully lit portrait could be the deciding factor in how much notice the reading public pays to a particular article.

All of the elements that are central to a good portrait picture apply equally to corporate portraiture. You need to look for the best shooting angles, lighting (natural daylight or flash), background, and foreground to show your subject to best advantage.

◀▲ *The first version of this series (left) shows the subject alone behind his desk. In order to fill the frame, the shooting angle is low and there is an expanse of featureless desk in the foreground. In the second version (above), a second subject has been included, and the desk light has also been repositioned so that the bulb is not centre frame, where it was causing a distraction. This inclusion of the second subject demanded a change in shooting position, and now the desk is less of a dominant feature.*

No brochure, prospectus, or annual report can be visually composed solely of corporate "mug shots", and so one of the tricks of the corporate photographer's trade is to somehow use the environment of the client's premises to add extra interest and information to the pictorial content.

▲ *This seemingly candid double portrait was taken from this particular angle to take full advantage of the reflections cast in the indoor pool of water in the lobby area of the client's offices.*

▶ *This is a carefully composed and lit shot of a meeting taking place in the client's offices. Although it looks casual, the foreground elements of the cut-glass decanter, spectacles, printed papers, and fountain pen have been precisely arranged to add interest. The use of a wide-angle lens also adds interesting perspective distortion and helps to ensure that the depth of field is extensive enough to keep everything in sharp focus. It was important not to overpower the natural light entering the room from the rear windows, and reflecting from the framed pictures on the wall, and so heavily diffused flash was directed just at the figures to prevent them appearing as semi-silhouettes.*

◀ Dramatic lighting and imaginative composition are the two hall-marks of this group corporate portrait. Full use has been made of the spill of light from the overhead projector onto the face of the fore-ground subject, while the two subjects seated in the background are framed by the column and head of the projector itself.

▲ To increase the dramatic content of this portrait, all the room lights were extinguished and the illumination coming up from the light box was the sole light used to expose the film.

If the client is involved in any form of manufacturing or testing activities, then another photographic opportunity presents itself. When you are advertising what a company has to offer a prospective client or shareholder, then the photographic coverage has to encapsulate as many aspects as possible.

▲ *The hi-tech nature of this company's activities is portrayed in this laboratory scene. The foreground has been put good effect by using the rows of test jars to direct the viewer's attention to the technician.*

▶ *Although the activity may be mundane, the angle of the shot, which is low down and uses the machine to frame the subject, and the high-contrast lighting, which has thrown the surroundings into total darkness, has real eye-catching appeal.*

▲ The framing of this double portrait, with the subjects positioned in the lower corner of the picture, has immediate impact. The unusual nature of the setting has been reinforced by angling the camera slightly to create a strongly diagonal composition.

STEVE PYKE

Steve Pyke sees himself essentially as a portrait photographer, although the physical appearance of his subjects is only one part of what he hopes to record. Through dialogue with those he photographs, he tries to establish some insight into, and gain some understanding of, the experiences that they have gone through, the things in their lives that have shaped and moulded them. The outcome of this process is that he sees the photographic images he produces more in terms of ongoing conversations, rather than merely static records of what people looked like at a particular time.

Steve first picked up a camera in 1981, and at about the same time he happened to see a photograph of a group of old men, a picture of the last survivors of the Battle of Waterloo. It was this incident that really brought home to him the potential of photography as a means of documenting a particular era through the faces of those who are an integral part of it.

Much of Steve's work, although by no means all of it, is thematic in nature. One series of photographs is exclusively on philosophers, for example, another on veterans, and uniforms were the inspiration for a third. His series entitled "Forgiveness" was photographed in Northern Ireland. All of those pictured are people who talked to him of their personal or family experiences of the horror of the troubles in that war-torn province. Steve's latest book called *Acts of Memory*, which was produced in collaboration with a writer, deals with the subject of migration, and it includes images spanning his photographic career.

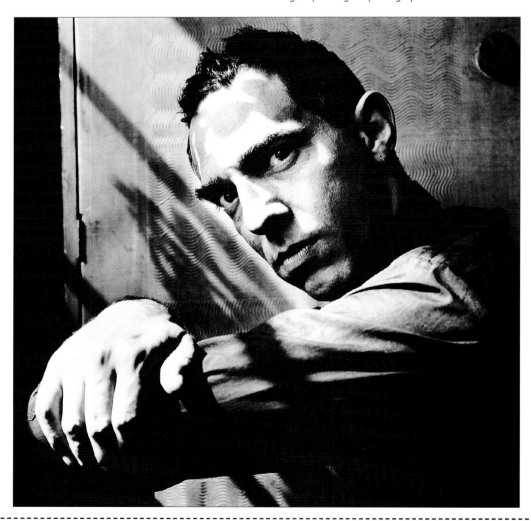

◀ **Derek Jarman, 1984**

This photograph of the film-maker Derek Jarman is a wide-angle portrait from early on in Steve's career. It was taken with natural window light in Jarman's home, using an aperture of f8 and a shutter speed of ⅛ second. The shadow in his forehead is cast from a potted cactus on the window sill. "Jarman was then, and always will be, a great influence on me."

▲ **Shabba Ranks, 1993**

For somebody who is known for being outspoken, what Steve captured in this portrait of Shabba Ranks, one of Jamaica's leading rappers, is a moment of perfect quiet. The session was in a hotel room, where Ranks arrived wearing much gold and surrounded by bodyguards, and lighting was from a studio flash and softbox. The colour effect is the result of processing slide film in colour negative chemistry.

▲ **Justin Watrin, 1993**

This portrait of Justin Watrin, a World War I combatant, is part of Steve's "Veterans" series of photographs. The photograph was taken in northeast France using an aperture of f8 and a shutter speed of ⅛ second. The lighting was natural daylight. "I remember that the location was very stark and smelled strongly of disinfectant, but what impressed me most was this man's dignity and bearing."

▲ Quentin Crisp, 1993

Steve had been wanting to meet and photograph the writer Quentin Crisp for years, and after much correspondence they finally met at his favourite diner in the Bowery area of New York. "After we'd eaten I spent an engrossing two hours as Quentin walked me around his New York." This photograph was taken on the sidewalk outside his apartment, using an aperture of f5.6 and a shutter speed of ⅙₀ second.

▶ **Kristin Scott-Thomas, 1992**
"I was in the process of setting up the lights for a session with my assistant when the model Kristin Scott-Thomas walked in and sat down on the edge of the bed behind me. The moment was very natural. I turned around, guessed the f stop, and shot a couple of frames. Not a word was spoken." The colour effect is the result of cross processing slide film in chemicals designed for colour negatives.

▲ Phillipa Foot, 1990

*What immediately came across when Steve met philosopher Phillipa
Foot was her vivacity. "I photographed her by natural light outside the
back door of her home. I remember that at this point she was relating
her wartime experiences with her friend Iris Murdoch. 'We were more
scared of the advances of the American soldiers than we were of
Hitler's Luftwaffe.'" An aperture of f8 and ⅛ second were used.*

▲ **CLR James, 1989**

At the time Steve met and photographed the historian and political activist CLR James he was living above a bookshop in London's Brixton area. "I met him in 1989, very close to his death, and due to illness he was unable to speak. I feel this is one of my most important photographs." The lighting is natural daylight and the picture was shot at f8 using a shutter speed of ⅛ second.